Spirited
Journeys

Spir

SELF-TAUGHT TEXAS

Jour

Exhibition and publication supported in part by funding from

the National Endowment for the Arts, a federal agency

the Texas Commission on the Arts, a state agency

the Fifth Avenue Foundation of Fort Worth

and the Archer M. Huntington Art Gallery Exhibitions Endowment

the Lorraine O'Gorman Gonzalez Creative Crafts Fund

the Archer M. Huntington Museum Fund

ARTISTS OF THE TWENTIETH CENTURY

ited

Lynne Adele

Exhibition organized by the

Archer M. Huntington Art Gallery

College of Fine Arts

The University of Texas at Austin

neys

for Tom

ISBN:0-935213-42-2

Distributed by University of Texas Press

Design by Barbara Jezek

The text type is Courier and Helvetica

Printed by Clarke Printing, Inc., San Antonio

The paper is Vintage Velvet text and cover

Binding by Universal Bindery, San Antonio

COVER ILLUSTRATION: Rev. Johnnie Swearingen,
The Creation of the World, 1970s
Oil on masonite, 30 x 96 in.
Collection of Gaye Hall, Houston

Contents

Lenders
to the
Exhibition

Claude Albritton, Dallas

Archer M. Huntington Art Gallery, The University of Texas at Austin

Art Museum of Southeast Texas, Beaumont

Lynn P. Castle, Beaumont

Cavin-Morris Inc., New York, NY

Thomas Beall Chatham, Jr., Corsicana

Henry Ray Clark, Beeville

Rebecca and Gary Cohen, Austin

Dallas Museum of Art

Tom De Nolf, Dallas

Livia Fernández, Austin

Marina García, Austin

Mrs. Sally M. Griffiths, Dallas

Gaye Hall/The Gypsy Savage, Houston

Chapman Kelley, Chicago, IL

The Harmon and Harriet Kelley Collection of African American Art, San Antonio

The Menil Collection, Houston

Jehan Mitchell, Austin

Museum of Modern Art, New York, NY

Leslie Muth Gallery, Santa Fe, NM

National Museum of American Art, Smithsonian Institution, Washington, DC

Lisa Nuñez-Hancock, Los Angeles, CA

George and Beverly Palmer, Dallas

Dr. and Mrs. Joseph A. Pierce, Jr., San Antonio

Chuck and Jan Rosenak, Tesuque, NM

Mary Sanger, Austin

Murray Smither, Dallas

Stephanie and John Smither, Houston

The Spelce Family, Austin

William Steen, Houston

Lisa and Marshall Twinam, Dallas

Valley House Gallery, Dallas

Eric S. Vogel, Dallas

Bruce and Julie Webb, Waxahachie

Webb Gallery, Waxahachie

Whitehead Memorial Museum, Del Rio

Bernard and Wanda Williamson, Magnolia

The Witte Museum, San Antonio

Several years ago a member of the studio art faculty at The University stopped me to say that she had invited Huntington Art Gallery educator Lynne Adele to speak to her class on self-taught artists and that the students had very much enjoyed the informal lecture. She went on to say that art students today are eager to see and learn about the work of self-taught artists, in part because from it they can draw insight into the sources for artistic inspiration and the ways artists respond to the world around them. The work of self-taught artists is now considered to be an important movement in 20th-century American art, and the reaction of these students reflects a growing nation-wide interest among many contemporary artists in the work of their self-taught colleagues.

This encounter led me to ask Lynne Adele if she would like to organize another exhibition for the Huntington. In 1989 she organized an important and very well received exhibition entitled *Black History/Black Vision* for the Gallery. She is a leading authority on self–taught artists and has lectured and published nationally on this topic. When I approached her she said yes, she had been thinking about an exhibition on self–taught artists in Texas. Thus the exhibition *Spirited Journeys: Self–Taught Texas Artists of the Twentieth Century* began.

This exhibition includes 150 works by 35 Texas artists and shows the outstanding quality of work being produced by self–taught artists in this state. *Spirited Journeys* includes the work of artists with national reputations as well as those who have never before been included in a museum exhibition. The majority of the works were borrowed from important private Texas collections, but pieces were also borrowed from the Museum of Modern Art, New York; the National Museum of American Art, Smithsonian Institution, Washington, DC; The Menil Collection; the Dallas Museum of Art; the Whitehead Memorial Museum, Del Rio, Texas; and the Witte Museum, San Antonio. We thank these institutions and individuals for their generosity in lending to this exhibition.

This exhibition takes on special significance because although important works by self–taught artists are held in public collections, to date there is no institutional collection focusing on self–taught Texas art. *Spirited Journeys* brings together work by some of Texas' finest self–taught artists and ensures that it will receive wider public attention.

The mission of the Huntington, as the teaching museum of a major research university, focuses on research and the education of students. This exhibition and the accompanying catalog will contribute much needed scholarship in this field and will further the education of

and provide inspiration for faculty and students at The University of Texas at Austin, as well as for the local and scholarly communities.

The works in this exhibition are humorous, inspiring, thought provoking—they seem to cover the entire range of human experience and emotion. It is a show that holds something for everyone. I know you will walk away from it enriched by the experience.

Jessie Otto Hite
Director
Archer M. Huntington Art Gallery

I t has been my good fortune and great pleasure to curate the *Spirited Journeys* exhibition. But the success of the project has also depended on the efforts of many others from beginning to end. My colleagues at the Archer M. Huntington Art Gallery deserve recognition not only for their enthusiastic support of this exhibition, but for the ongoing professionalism with which they undertake their daily work toward realizing the museum's mission, caring for the Gallery's permanent collections, organizing special exhibitions, and planning and implementing educational programs and other special events.

I wish to thank the Gallery's director, Jessie Otto Hite, who offered me the opportunity to organize the exhibition, believed in my ability to do it, and provided the support necessary for its completion. I am grateful to Susan Sternberg, Curator of Education, who gave her continual support and encouragement, and generously allowed me time away from my duties within the education department in order to work on the project. I also wish to thank Tiffany Rasco, Coordinator of School Programs, Tours, and Resources, who capably assumed those responsibilities in my absence. Annette DiMeo Carlozzi, Curator of American and Contemporary Art, and Patricia D. Hendricks, Curator of Exhibitions, generously shared their guidance and expertise.

Others within the Gallery helped immeasurably. Sue Ellen Jeffers, Registrar, and Meredith Sutton, Associate Registrar, arranged for the shipping of works of art and coordinated details related to the exhibition's travel; Patricia Tristan, Registrar's Office Assistant, prepared loan forms and labels for the objects; Tanya Walker, Business Officer, and David Johnson, Assistant Business Officer, assisted with all matters relating to finances; Tim Reilly, Curatorial Associate, prepared works on paper for exhibition; Sara McElroy, Conservator; Tracy Grimm, Conservation Technician; and Martha Simpson Grant, Objects Conservator, attended to the conservation needs of works of art. James Swan, Head of Installation, and technical staff members John Sager, Patrick Sheehy, Tim Hicks, James Van Arsdale, Konstantino Stamatou, and Alladin Mammoudeh, designed and installed the exhibition. Paige Bartels, Assistant Director for Public Affairs; Samantha Cheek, Public Relations Assistant; Suzanne Najarian, Membership Coordinator; and Anna McCourt, Membership Assistant; worked to develop public awareness of the exhibition and planned the opening reception and member activities; and Rosana Garcia, Assistant to the Curators, made travel arrangements and prepared exhibition labels.

Susan Sternberg, Curator of Education, worked with me to develop educational programs in conjunction with the exhibition, and she was joined by education department staff members Donna Vliet, Museum/School Educator; Tiffany Rasco, Coordinator of School Programs, Tours, and Resources; and Kerri Madden Curtis, Education Intern; in planning and implementing museum/school programs. I also thank the docents of the Huntington Art Gal-

lery who volunteer their time in order to fulfill the Gallery's educational mission by bringing our exhibitions to life for visitors of all ages.

I am grateful to Barbara Jezek for her design of the exhibition catalog and publicity materials. Barbara and I first worked together when she designed the catalog for *Black History/Black Vision*, which I curated in 1989, and I have enjoyed the opportunity of working with her again. I believe that her sensitivity to the artists and their the work is evident in this publication. I wish to thank George Holmes, Photographer, for his care and dedication in photographing works of art for the catalog. Jane Henrici shared her research and contributed the catalog essay on artist Alma P. Gunter. Christina M. Harrison and Tiffany Rasco standardized the footnotes, bibliography, and appendix and proofread the catalog manuscript; Kerri Madden Curtis and Tom Maddox helped to organize photographs for the catalog.

When undertaking any project relating to self-taught art I am always moved by the extreme generosity and dedication of those involved in its study. Recognition is due those who support the artists day to day and promote their work. Because self-taught artists often lack a connection to others who share or understand their artistic endeavors, it is often through the efforts of collectors and dealers that they are discovered and receive the materials and encouragement necessary to making art. Individuals and institutions who agree to lend objects also deserve great credit for their generosity in parting with objects for extended periods of time in order to share the work with others and to give the artists public exposure. I wish to extend my deep appreciation to each lender for his or her important contribution to the project.

Many people outside the museum shared their time and expertise and provided information, archival materials, and photographs. I regret any errors of omission in the following list, for everyone who participated deserves credit. I am indebted to Bruce and Julie Webb, Webb Gallery, Waxahachie, for their dedicated efforts on the part of self-taught artists and for their ongoing support of this project. I also wish to thank the following individuals for their contributions: Greg Busceme, The Art Studio, Inc., Beaumont; Lynn Castle, Art Museum of Southeast Texas, Beaumont; Shari Cavin, Cavin-Morris Inc., New York; Tom Chatham, Corsicana; Livia Fernández and Marina García, Austin; Sally M. Griffiths, Dallas; Mary Kadish and Julie Bakke, The Menil Collection, Houston; Michaele Haynes and Kim Peel, The Witte Museum, San Antonio; Jehan Mitchell, Austin; Leslie Muth, Leslie Muth Gallery, Santa Fe; Chuck and Jan Rosenak, Tesuque, New Mexico; Grace Skrivanek, Caldwell; Murray Smither, Dallas; Stephanie and John Smither, Houston; Bennett and Neal Spelce, Austin; William Steen, Houston; Susanne Theis, The Orange Show Foundation, Houston; and Kevin Vogel, Valley House Gallery, Dallas.

Art exhibitions and publications are increasingly costly to produce, and funding is an ongoing concern to those of us who work to make them happen. I wish to express gratitude to the funders of *Spirited Journeys* for their support of the project: National Endowment for the Arts; Texas Commission on the Arts; Fifth Avenue Foundation; the Archer M. Huntington

Museum Fund; Huntington Art Gallery Exhibitions Endowment; and the Lorraine O'Gorman Gonzalez Creative Crafts Fund.

Through its travel to other museums, *Spirited Journeys* will serve an expanded audience. I am grateful to the following individuals for their efforts in bringing the exhibition to their institutions: Teresa Jones, Administrative Director, and Claude Albritton, McKinney Avenue Contemporary, Dallas; Wendell Ott, Director, Tyler Museum of Art; Donald Bacigalupi, Director, and Nancy Hixon, Assistant Director and Registrar, Sarah Campbell Blaffer Gallery, University of Houston.

It is the presence of those closest to us that brings joy and meaning to our lives and makes any labor easier. I have been blessed with supportive friends and a loving family. My husband, Tom Maddox, is a constant source of joy and inspiration in my life. He gave his unwavering support and encouragement throughout the project, traveled with me when possible, and contributed ideas and suggestions.

Finally, it is the inspired efforts of the artists and my desire to make their work better known and understood that motivated me to undertake this project. It is my hope to have realized an exhibition that serves each of them honestly and fairly and reflects the true spirit of their work.

Lynne Adele
Curator
Spirited Journeys

The study of recent American self-taught art has been described as "one of the last frontiers in twentieth-century American art."[1] Throughout the 1980s and 1990s, a number of pioneering investigations were launched into the creative efforts of self-taught artists. The research spawned exhibitions and publications that expanded public awareness of this important segment of twentieth-century American culture. During this highly charged period artists were discovered at an astounding rate, a number of important private collections were formed, and museums began to take an interest in exhibiting and collecting the work. The work of self-taught artists became a hot commodity, evidenced by soaring prices in the art marketplace.

There was no question that self-taught art had aroused mainstream public interest when in 1993 the television news magazine, *60 Minutes*, aired a segment that raised questions about the conduct of certain members of the art establishment in their dealings with self-taught artists. Meanwhile the artists continued to make art, for the most part uninfluenced by the excitement and controversy they had unwittingly ignited in the art world.

A tedious debate over terminology ensued among academicians: the terms "primitive" and "naïve" were no longer considered appropriate in describing the work of self-taught artists, but should the work be labeled "folk," "outsider," "isolate," or "vernacular" art? The argument over terminology, still unresolved, has been replaced to some extent with discourse concerning the issues of aesthetics, ethics, economics, and the politics of marginalization as they relate to self-taught artists in our society.

Academically trained artists were among the first and most ardent admirers of self-taught art, and many have looked to it in their own searches for new sources of inspiration. In 1992 the Los Angeles County Museum of Art organized the exhibition, *Parallel Visions: Modern Artists and Outsider Art*, which traced the influence of self-taught art as a "crucial strain underlying the development of mainstream art" through the work of five generations of modern artists. This issue was examined as it related to Texas artists in the exhibition, *Outside/In: Outsider and Contemporary Artists in Texas*, organized by the Texas Fine Arts Association and held at Laguna Gloria Art Museum, Austin in 1994.

Although these groundbreaking studies were successful in proving the powerful influence that self-taught artists have exerted on twentieth-century art, contemporary folk art is still routinely excluded from university level courses teaching the history of twentieth-century American art. Attention to self-taught art continues to grow along with our understanding of its important and integral role in the history of American art—not only as an influence on contemporary academic artists, but as an important movement in its own right.

SELF-TAUGHT ARTISTS

Self-taught artists stand apart from their academically trained counterparts most notably in their original intent, which is generally not, at least initially or consciously, to make "art" for a perceived audience. Working outside the artistic mainstream, either unaware of or uninfluenced by contemporary art movements or academic traditions, they respond to an inner drive to express themselves visually. Because they are drawn to artmaking for very different reasons and because their frames of reference are linked to personal experiences and in direct response to cultural stimuli rather than to an academic art tradition, self-taught artists also differ from each other greatly in their modes of expression.

It should be noted that many artists who lack formal schooling are very much concerned with current trends in contemporary art; other artists who have advanced degrees adopt a consciously "naïve" style or are greatly influenced by self-taught artists. Still other artists fall into a "gray" area somewhere between trained and self-taught, and sometimes it can be difficult to determine into which category an artist belongs. The artists selected for this exhibition are individuals whose work represents a unique vision and style developed on their own, uninfluenced by other artists, trends, or formal art traditions.

Self-taught artists may be urban or rural and come from a wide variety of cultural, regional, ethnic, socio-economic, religious, and educational backgrounds. They pursue distinctly different careers and lifestyles, and they are motivated to create art by an equally diverse range of forces. They may be operating from a strong desire to share their memories, document the past, or preserve a view of history they fear will be forgotten. Indeed, memory is one of the most significant and widespread influences among self-taught artists, evidenced by the great number of autobiographical works in which artists depict their nostalgic reminiscences of times past.

Frequently these works portray the daily events of rural life and serve as valuable historical documents of activities that have become outmoded by technological advancements, and often they appear to extol the virtues of the past. Inspired by their experiences, self-taught artists may wish to make powerful visual statements intended to enlighten, educate, or challenge the viewer. Their art may express popular culture, historical events, or political figures. Their work may relate to cultural traditions and religious practices, and often it promotes certain values or teaches moral lessons.

One of the most profound influences on self-taught artists is the visionary experience. While all gifted artists can be said to have a strong inner artistic vision, true visionary artists rely on dreams, visions, or religious revelations as their inspiration for making art; or they may be compelled or commanded by an outside force—usually God—to produce art. For some, artmaking begins following a single, life-changing revelation, while for others visionary experiences persist throughout their lives. The visionary impulse ranges from inspiration to obsession, is geographically widespread, and is especially evident in the work of African American artists, who often speak of visions as the principal force that leads to the creation of their art.

Other artists may be responding to their physical environments, fulfilling a need to create something beautiful, expressing their own vivid imaginations, or simply putting available

materials to good use. In many cases self-taught artists work in relative isolation, their creative activities misunderstood by those around them. Often they turn to art as a means of coping with a personal loss or while recovering from an illness, and frequently the artistic journey begins late in life during a period of reflection upon past events and life experiences. The resulting objects reflect the wealth of sources that inspire their makers, but they also reveal a unity of common concerns, themes, and issues that confront the artists.

Wherever the starting point, self-taught artists create works of art that document their unique and sometimes eccentric views of the world, and yet somehow speak to the viewer in a universal language. But if these works of art sometimes appear accessible—even simple— to the viewer, they do not always reveal themselves on first glimpse, and the work is frequently deceiving, mysterious, and complex.

SELF-TAUGHT ART IN TEXAS

If the study of self-taught art is a frontier, Texas has remained at its outermost boundary. An extensive study of self-taught art in Texas has remained conspicuously absent from the growing body of scholarship generated during the past two decades. Texas, by virtue of its location and history embracing aspects of both the South and the West, its vast geographic area, and its large and ethnically diverse population, has long been fertile ground for a vast amount of creative production on the part of self-taught artists. However, their work has received relatively little scholarly attention compared with that of other geographic regions. Several exhibitions have focused on self-taught art in Texas, but to date there has been no substantial scholarly publication on the subject and public exposure to the work, especially outside the state, has been relatively limited. Yet the profusion and calibre of Texas folk art called for serious investigation, documentation, and dissemination.

Recognizing the need for scholarship in this area, the Archer M. Huntington Art Gallery, the art museum of The University of Texas at Austin, offered me the opportunity to organize an exhibition surveying contemporary self-taught art in Texas. The objective of the project was, through the finest examples of objects created by the most outstanding artists, to explore the work within a cultural and art historical framework; to consider the uniquely Texan qualities of the work; and to place work created in Texas within the broader context of twentieth-century American folk art.

ENVIRONMENTS

In addition to painting, drawing, and sculpture, *Spirited Journeys* addresses the important area of environmental work. Folk art environments are site-specific outdoor constructions of monumental scale created by individuals who work with available materials, unconventional construction methods, and great dedication to realize their artistic visions. Environmental artists differ from those who work in other media in that, rather than creating a number of works in a certain style, they manifest their creative energy through a single great work on which they typically work over a long period of time.

Like other self-taught artists, environmental artists create their work for a variety of reasons. The environment may be a private utopia designed for the solitary reflection, devotion,

or pleasure of the maker. But unlike their counterparts who work in other media, environment builders often consciously strive to make public statements intended to influence, educate, or simply to delight an intended audience.

These works are inherently fragile. Made of recycled materials with improvised construction methods, they are forced to withstand the extremes of the Texas climate and are vulnerable to acts of vandalism. Often they suffer misunderstanding by neighbors, and typically they are dismantled or destroyed upon the relocation, illness, or death of their creators. Although Texas is fortunate to have individuals and groups such as the Houston-based Orange Show Foundation engaged in the documentation and preservation of folk art environments, these works must be considered ephemeral, and their ongoing study essential.

Because environments are by definition site-specific and thus create difficult challenges in presentation, they are largely overlooked in exhibitions. But they are a vital form of self-taught expression in Texas and throughout the nation. Several Texas environments are among the great examples of this phenomenon in the United States. They have been selected for representation in the exhibition through an ongoing slide presentation and, where possible, through the installation of selected objects.

MATERIALS AND THE "ART" OF RECYCLING

The diversity of backgrounds, artistic impulses, and forms of expression inspiring self-taught artists to create are equalled by their diverse use of materials. Long before the general population embraced the concept of recycling, self-taught artists were avid recyclers. Throughout their work we find that the absence of traditional materials does little to impede the creative impulse, and in some cases may actually inspire it. Whether improvising with available materials or finding new uses for unwanted objects, in the hands of self-taught artists virtually anything can be made into art.

Frank Jones, who began making art while an inmate in the Texas Department of Corrections, initially relied upon the discarded pencil stubs of prison bookkeepers, red on one end and blue on the other, to make his drawings. Even after he was provided art materials by a Dallas art gallery, Jones continued to use red and blue as his colors of choice. The colors held symbolic meaning for Jones that derived from African American aesthetic traditions.

Houston painter Naomi Polk eschewed store-bought art supplies in favor of her own scavenged materials which included discarded ceiling tiles, old window shades, scraps of wood, and cardboard. The artist's daughter stated,

She wasn't much on throwing things away. She wanted to see something come out of nothing, to make something out of nothing. This was part of her, her whole being. I think that was part of the creative process with her—to be able to create something from nothing, that someone else had thrown away.[2]

Environmental artists rely extensively on salvaged materials in order to realize their artistic visions. It would be difficult to find a more extraordinary recycling effort than that of John Milkovisch of Houston, who transformed the outside of his home into a glittering testament to his unique vision—and in the process created one of this country's great folk art

environments—using an estimated 50,000 beer and soft drink cans he collected over a seventeen year period.

Beaumont environmental artist Felix "Fox" Harris, acting on a religious vision, collected discarded objects including scrap metal, old barbecue grills, broken pottery, and table utensils, recycling them in his art. Following the example of God, he "took nothin' and made somethin'"[3] when he created the sculptures that filled his yard.

The unabashed willingness of self-taught artists to consider discarded and unwanted objects commonly viewed as trash to be suitable art materials often gives their work the "raw" character and unconventional appearance that has come to be associated with self-taught art. However, despite their remarkable ingenuity, works made with unorthodox materials can present serious conservation concerns and many of them face an uncertain future.

SPIRITED JOURNEYS

The work in this exhibition is challenging in that it provokes the viewer to set aside preconceptions about art and artists and their relation to academic traditions, inviting us instead to consider the objects and their makers within their own contexts. The greater our familiarity with these contexts, the deeper is our understanding of the work. Drawing upon the innermost part of the self best described as spirit, each artist has embarked on a private journey of self-expression. Along the way, he or she has created objects unique and enduring to mark the course of the journey.

Through the *Spirited Journeys* exhibition and this publication my goals have been to broaden public awareness of self-taught Texas art produced in the twentieth century; to undertake serious documentation of the subject upon which future researchers can build and which will serve as a vital and lasting contribution to the study of American self-taught art; and to deepen our understanding of the unique contributions that self-taught artists in Texas have made to our nation's cultural heritage.

[1] Jane Livingston, "The Art of the Self-Taught/The Art of Our Time," in Alice Rae Yelen, ed., *Passionate Visions of the American South: Self-Taught Artists from 1940 to the Present* (New Orleans: New Orleans Museum of Art, 1993), 28.

[2] Rosalie Taylor, interview with the author, Houston, October 8, 1988.

[3] Pat Carter, "'Fox' Harris: A Forest of the Spirit," *Spot* [Houston Center for Photography], Spring 1991, 12.

The Artists

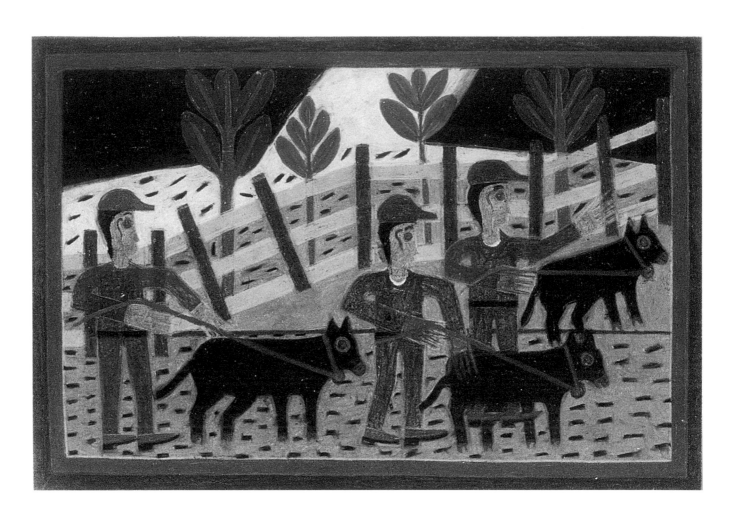

Untitled (Three Men with Harnessed Dogs), 1971

Eddie
Arning

Carl Wilhelm Edward Arning was born January 3, 1898, the son of German immigrants Christoph and Lena Arning, in Germania, a farming community in Austin County, Texas. His early years were spent with his parents and his four siblings in his grandmother's home, where German was spoken. In 1905 the family relocated to a farm near Kenney, Texas. Eddie's formal education consisted of six years of school and one year of confirmation class.[1]

Eddie Arning lived and worked on his father's farm until he was thirty. As a young adult he began exhibiting symptoms of mental illness, including periods of depression and episodes of violent behavior. After attacking his mother, Arning was declared dangerous by reason of insanity and in 1928 he was committed to the Austin State Hospital. He returned home the following year, but his problems continued and in 1934 he was again hospitalized. Diagnosed with schizophrenia, Arning spent the next thirty years in the Austin State Hospital.[2]

In December 1964 Arning's doctors determined that he had recovered from his illness, and Arning was furloughed to a nursing home. His art career began the same year when he met Helen Mayfield, a summer employee of the State Hospital. She had provided a group of elderly men including Arning with coloring books, and noticed that Arning's pictures stood apart from those of the others in the group. Arning added his own design elements, and his imaginative use of color was distinctly different from that of the others. One day Mayfield provided Arning with a blank sheet of paper, and his distinctive style began to emerge.[3]

Shortly after Arning began drawing, Mayfield arranged for a public showing of his work at the University of Texas Methodist Student Center. Among those in attendance were Robert Cogswell, an Austin artist, and Alexander Sackton, an English professor at The University of Texas at Austin. Subsequently Cogswell began cataloging Arning's work, a task soon taken over by Sackton, and together with Mayfield they shared the responsibilities necessary to support Arning's artmaking, providing him with art materials and encouragement.

Arning's earliest works were memory inspired drawings based on his rural experiences before his hospitalization. Subjects included barns, farm implements, and barnyard animals drawn in wax crayon on colored papers. In these works objects are typically positioned in the extreme foreground of the composition where they fill the picture frame and confront the viewer directly. While they are representational drawings, through Arning's geometricized forms and exaggerated use of color they also suggest abstraction. The undated *Texas Windmill* and *Four Cows and Hay*, 1967, are examples of work drawn from Arning's memories of

Untitled (Four Cows and Hay),
1967

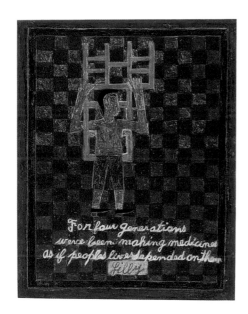

Lilly: Four Generations, 1986

farm life. In the latter we see his characteristic disregard for both perspective and gravity as two of the cows appear to float in space above the others. The awkward figures seem to have little or no awareness of each other or the world outside the confines of the picture.

Around the year 1966 Arning began looking at magazines available to him in the nursing home, transforming the images he found into drawings. Beginning with printed sources that included advertisements, photographic illustrations, and cartoons, Arning created new and powerful works. Due to the efforts of the late Alexander Sackton, with few exceptions the printed sources for these works have been preserved, enabling us to study Arning's unique process of artistic translation.

Three Men with Harnessed Dogs, dated 1971, is an excellent example of Arning's work from printed sources. Working from a black-and-white magazine illustration, Arning brought the figures into the foreground and turned the fence into an energetic diagonal. Unlike the levitating cows in his earlier work, the figures in this drawing submit to gravitational forces and forms are overlapped to suggest three-dimensional space.

Also in 1971, Arning made the drawing, *"Lilly: For four generations we've been making drugs as if people's lives depended on them" (Boy with Chair Over Head).* In this work a solitary figure appears to be confined within a flattened space created by a checkerboard pattern. The ambiguity of the setting and the figure's puzzling relationship with the overturned chair lead the viewer to draw unsettling inferences about the meaning of the picture, especially given the fact that Arning spent so many years in a psychiatric facility. When compared with its printed source, however, we find that Arning's primary interest in his subject matter was visual. While the compositions were dependent upon their printed sources, the narrative content was always secondary to the visual elements—shapes, colors, and patterns—that Arning found within them and to which he responded in his drawings.

Boy and Girl with Banjo, 1973, is based on a magazine advertisement, but in Arning's interpretation the figures seem oblivious to one another. His many years of institutional living certainly must have affected his views of human relationships. But as tempting as it may be to examine the emotional detachment present in his work within the context of his illness and the many years he spent in a psychiatric institution, the awkward interactions are probably best understood as the result of his unique style of artistic representation rather than as evidence of his personal isolation.

Six months after the completion of *Boy and Girl with Banjo,* Arning was forced to leave the nursing home for refusing to obey the rules or to cooperate with staff. He went to live with his widowed sister in McGregor, Texas, and within a year he stopped drawing.[5] He died twenty years later on October 15, 1993 at the age of ninety-five as one of Texas' most celebrated self-taught artists. In the brief decade of Arning's art career, he worked prolifically, producing a remarkable body of work estimated at more than two thousand drawings.

[1]Alexander Sackton, *Eddie Arning: Selected Drawings 1964-1973* (Williamsburg, Virginia: Abby Aldrich Rockefeller Folk Art Center, 1985), 8.

[2]Ibid.

[3]Alexander Sackton, "Eddie Arning: Texas Folk Artist," in Francis Edward Abernethy, ed., *Folk Art in Texas* (Dallas: Southern Methodist University Press, 1985), 189-191.

[4] Sackton, Eddie Arning, 17, 10.

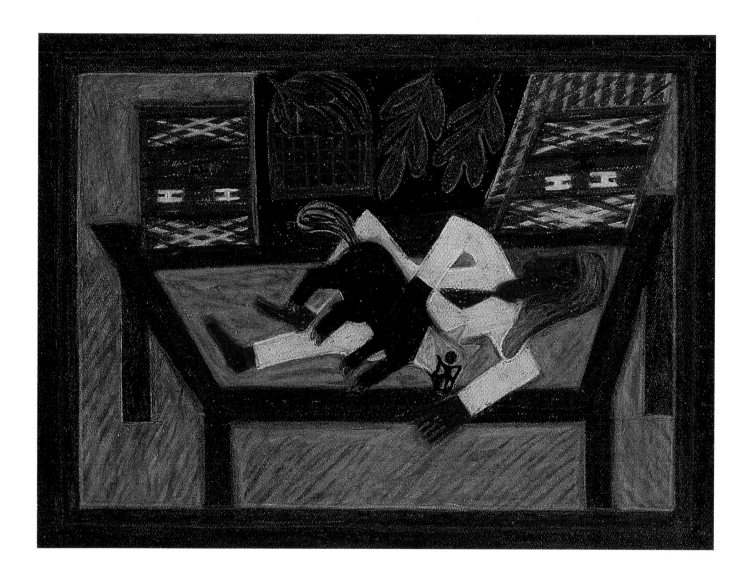

Untitled (Woman Seated with Dog), 1972

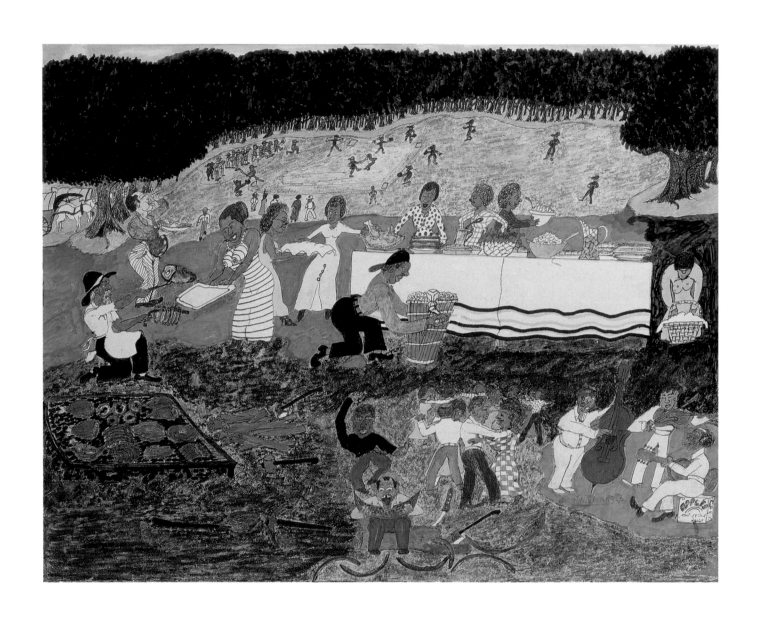

Juneteenth Celebration, 1983

John
Banks

1912–1988

John Willard Banks was born November 7, 1912 near Seguin in Guadalupe County, Texas to Cora Lee McIntyre and Charlie Banks. In 1917 the family moved to San Antonio, where John attended the Holy Redeemer School and began his favorite pastime, drawing pictures on his Big Chief tablet. He recalled, "As a kid I used to lie flat on my stomach, drawing and drawing. . . . My mother had to kick me off the floor to sweep."[1]

When John was nine years old his parents divorced and in 1923 he moved to a farm with his grandparents, Ada and Ben McIntyre, in Sweet Home, a black community thirteen miles south of Seguin. For the next five years he continued his schooling and helped to farm the eighty-seven acres of cotton, watermelon, and sugarcane fields. Banks's grandfather was an important influence on his life. "My life didn't start until he took me to live with him," He explained. "We was poor, but we were independent. It's a happy memory for me. It's nothing about it I regret."[2]

John Banks's first career goal was to become an undertaker, an interest developed through his practice of providing funerals for cats on the farm. As a young man he returned to San Antonio and throughout his working life he held a variety of jobs. Following military service during World War II Banks worked as a custodian at Kelly Air Force Base, at Fort Sam Houston, and at a San Antonio television station. He was devoutly religious and enjoyed music, and for a number of years he sang in a gospel quartet.

John Banks married Edna Mae Mitchell in 1928, and the couple had three sons and two daughters. In 1960 the marriage ended in divorce. In 1963 he married Earlie Smith in a union that would last until his death twenty-five years later.

Banks began making art seriously in the year 1978 while recuperating from an illness. Shortly thereafter, Mrs. Banks secretly took two of the drawings to a laundromat where she displayed them and offered them for sale. There his work was discovered and he began to receive support and encouragement from a number of individuals, most notably, Kay Rogers and Joseph and Aaronetta Pierce. Banks's first one-man show was held at San Antonio's Caroline Lee Gallery in 1984. The same year his work was exhibited in an exhibition with fellow Texan artist George White, Jr. at Objects Gallery in San Antonio. Interest in his work took Banks by surprise. "I never thought one time anything about it," He stated. "I was surprised anyone would pay any attention to it. . . . I never knew anyone valued this kind of thing."[3]

Picking Cotton in South Texas Year 1923, 1986

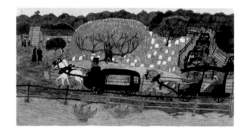

Old Time Funeral, n.d.

In 1982 the Corcoran Gallery of Art in Washington, DC organized the exhibition *Black Folk Art in America, 1930–1980*. This exhibition traveled to Houston, and Joseph Pierce took John and Earlie Banks to see the exhibition. Pierce wanted Banks to see at first hand that he was not alone in pursuing his art, that it could stand among the best in the field, and that there was a serious interest in it. According to Mrs. Banks, the exhibition greatly inspired her husband, particularly the works by Clementine Hunter, whose style he especially admired. After viewing the entire exhibition, he returned again to view Hunter's work. Banks left Houston with a new confidence in his own work.[4]

Outlining figures first with pencil, then with ballpoint pen on paper or posterboard, Banks added color with magic marker, watercolor, colored pencils, and crayon. He expressed many of his feelings and opinions in his work, whether tackling the issue of slavery or depicting idyllic scenes of Africa in which he portrayed man living in perfect harmony with nature. Occasionally his work revealed such religious visions as the Second Coming of Christ, and in at least one work he depicted an apocalyptic vision that he experienced while in a trance-like state. But more frequently his work was inspired by the memories of his youth, celebrating significant events and everyday activities of rural life. Baptisms, funerals, and church services provided subject matter for his work. A road or a river often winds through the scene, guiding the viewer through the work.

Banks considered virtually any human pursuit as worthy subject matter for art, and his work includes representations of such humble activities as doing laundry, hog butchering, picking cotton, and ordinary street scenes. Through his work Banks left invaluable documents of life as it was for black Texans in the early twentieth century. A lighthearted sense of humor prevails in his drawings depicting daily life and the foibles of his fellow man, but they also deliver biting social commentary.

In the drawing *Picking Cotton in South Texas*, black sharecroppers labor to fill their sacks with cotton, their humble cabins contrasting with the majestic home of the white land owner which looms in the background. Banks was aware that not all African Americans appreciated his representations of slavery and sharecropping.

Young people downs me for drawin' these pictures . . . but it's history. It's the truth and I want to draw it. . . . The Negroes lived in that style for years. Many don't want to admit it today. Some people . . . don't want to talk about it. The truth is the truth. This was part of our life. Why deny things that you lived? Picking cotton is no shame. People had to do that. If I had to pick cotton today, I'd do it.[5]

John Banks died April 14, 1988 in San Antonio at the age of seventy-five, leaving a large number of drawings that reflected his own deeply-held religious beliefs, his respect for nature, and his desire to document broader history as well as his own life experiences.

[1]Mrs. John Banks, interview with the author, San Antonio, October 30, 1988; Michael Mott, "Johnny W. Banks, Black, Man, Texas, Artist," in Francis Edward Abernethy, ed., *Folk Art in Texas* (Dallas: Southern Methodist University Press, 1985), 179.

[2]Banks, private communication; Mott, "John W. Banks," 179; and Susan Lindee, "The World of John W. Banks: A Primitive Artist's View of Rural Texas Life,"*San Antonio Light,* April 29, 1984, 24.

[3]Lindee, "The World of John W. Banks," 24.

[4]Joseph A. Pierce, Jr., private conversation with the author, July 25, 1988; and Mrs. John Banks, telephone conversation with author, November 9, 1988.

[5]Mott, "Johnny W. Banks," 181; and Lindee, "World of John Banks," 182.

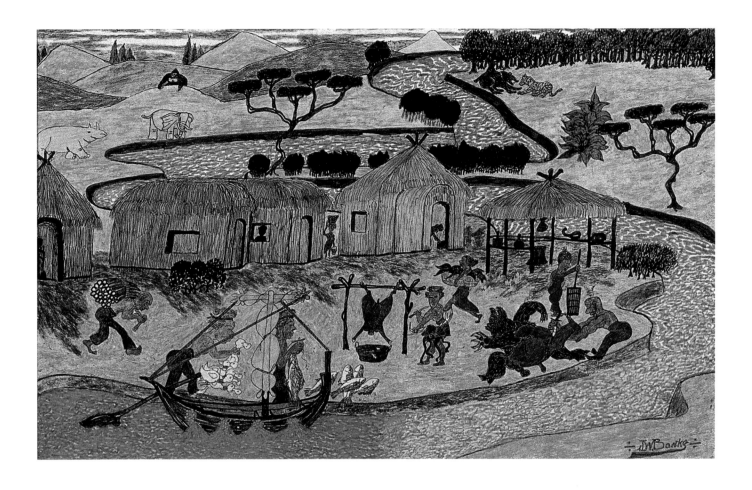

The African Life on the Safaria,
1982

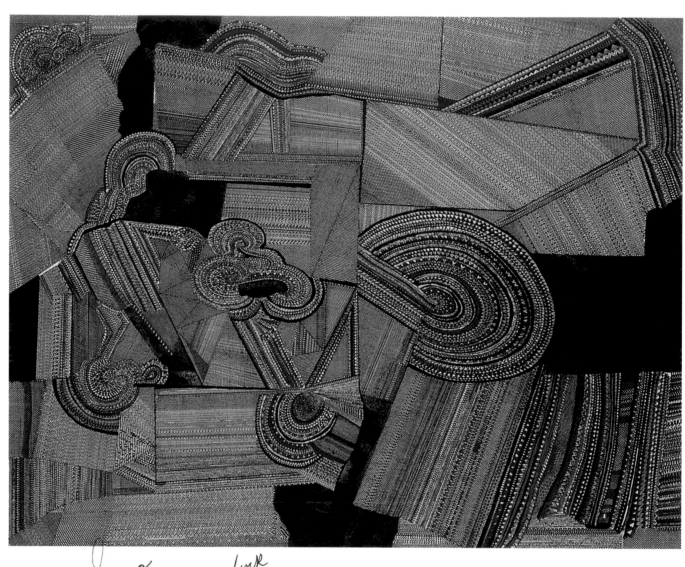

To Cudith Segura
Best Wishes & Good luck
Hector Alonzo Benavid
Thank you for your patronage

Untitled, 1996

Hector

Alonzo Benavides

b. 1952

Hector Alonzo Benavides[1] was born September 2, 1952 in Laredo, Texas, the youngest of three children of Juan Manuel Benavides, Sr. and Maria Eliza Richér Benavides. He grew up in the town of Hebbronville, where his father was a rancher. As a child Hector's two main interests were coin collecting and drawing. "He always had a pen, and made little drawings on napkins and notebook paper. He always did a lot of doodling as a little boy," his sister recalled. Hector graduated from Hebbronville High School and following his father's death in 1970 he moved with his mother to Laredo.

After high school Benavides went to Tyler, Texas, where he studied to become an optician. Following the completion of his training he returned to Laredo where he took a job as an optician and lived with his mother. For a time he worked for the Catholic Diocese radio station in Laredo.

In 1983 Hector Benavides began to pursue his art with increasing conviction. He explained, "I used to sulk in my room until I started these drawings. I wanted to do something for myself and make a name for myself. So I started praying to God and He gave me the inspiration. He told me what to put down and so I just put it down."[2]

Feeling alone and desiring to make a change after his mother's death in 1996, Benavides relocated to San Antonio. Since experiencing this great personal loss, he has struggled increasingly with obsessive-compulsive disorder. The drawings help him to channel his thoughts and feelings. His sister believes that "you can tell his moods from his drawings. The darker ones, you can tell he is troubled, or having deep thoughts. The brighter colors he does when he is happier."[3]

From a distance Benavides' drawings resemble pieces of woven fabric arranged together in a quilt-like fashion. Upon closer examination intricate designs reveal complex topographies created by minute dots, squares, and triangles drawn in ballpoint pen. The triangles, he explains, represent the Father, Son, and Holy Spirit of the Holy Trinity. The squares are added to "bring out the triangles, to make them stand out." He often uses gold and silver pens, because "gold and silver are the most precious metals on earth."[4]

Benavides is part owner of the family ranch run by his older brother, and he supplements his income with a job as a security guard. It is his hope to one day be able to make a

Untitled, n.d.

Untitled, 1996

living through his art. "I'm a perfectionist. I take great pride in my work. I love what I do. I work real hard on it. I really want to make a go of it with my drawings," he explained.[5]

Benavides' work came to the attention of the Webb Gallery in Waxahachie in 1993. At the Webbs' first meeting with Benavides, he told them, "I'm the most obsessive-compulsive person you will ever meet." Through his art Benavides has transformed what could have been his greatest personal obstacle into a great asset. Julie Webb describes him as one of the most dedicated artists with whom they work.[6] His work has been included in several exhibitions at commercial galleries. *Spirited Journeys* is the first museum exhibition in which his work has been shown.

Hector Alonzo Benavides now dedicates all his drawings to his late mother. He stated, "This is what I can give to her, in her memory. She told me to continue. She has been my inspiration. She was everything to me."[7]

[1]Biographical information, Hector Alonzo Benavides, telephone conversation with the author, May 28, 1997; Maria Eliza Gonzalez [the artist's sister], telephone conversation with the author, May 28, 1997; and Julie Webb, "Hector Alonzo Benavides," unpublished, Webb Gallery, Waxahachie, n.d.

[2]Hector Alonzo Benavides, telephone conversation.

[3]Maria Eliza Gonzalez, telephone conversation.

[4]Hector Alonzo Benavides, telephone conversation; Bruce and Julie Webb, conversation with the author, Austin, June 5, 1997.

[5]Ibid.

[6]Julie Webb, telephone conversation with the author, June 9, 1997.

[7]Hector Alonzo Benavides, telephone conversation.

Untitled, 1996

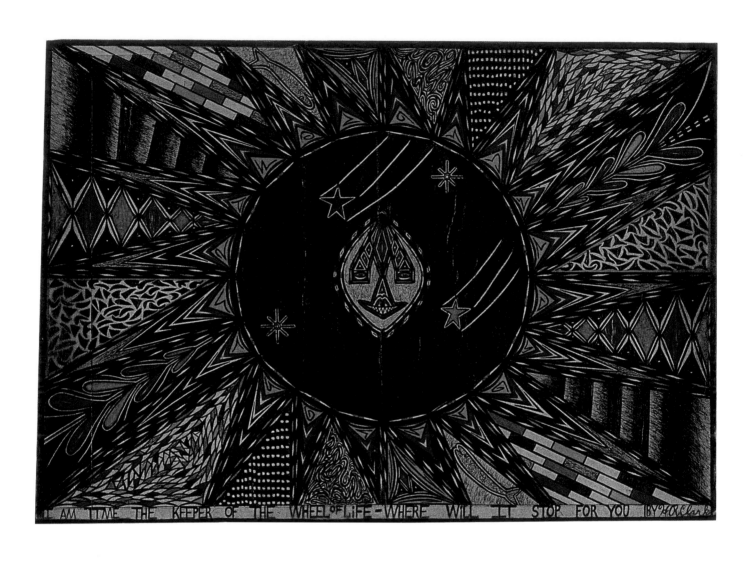

*I Am Time the Keeper of the Wheel
of Life—Where Will It Stop for You,*
1996

Henry Ray
Clark

b. 1936

Henry Ray Clark was born October 12, 1936 in Bartlett, in Williamson County, Texas to Lucille Young and Lee Clark. Three years later the family relocated to Houston. His parents separated when Henry Ray was twelve years old. Lee Clark, a general contractor, relocated to Fresno, fifteen miles south of Houston, and Henry Ray remained in Houston's Third Ward with his mother, who worked as a housekeeper. After completing the sixth grade at Douglas Elementary School, Clark dropped out of school.

Occasionally Clark worked for his father's construction company and held a variety of other jobs including plumbing, carpentry, plastering, cement mixing, and warehouse work.[1] But he found street life more appealing, and eventually he settled into a lifestyle that included gambling and drug dealing. He explained, "I just seen something a little bit brighter on the other side of the fence that I wanted. And I went at it. . . . [O]n them streets I had everything I wanted that money could buy—cars, clothes, ladies, jewelry. I got off into a groove that I enjoyed and I felt that I was very successful."[2] Clark became known on the streets as The Magnificent Pretty Boy, a name he claims he received due to his great popularity with women.

Clark's first criminal conviction came in 1977 for attempted murder over a gambling dispute, for which he served thirteen months in prison. While in prison he made his first drawing. "I didn't really have nothing else to do, but I didn't know I could draw. . . . When I picked up that pencil my hand just started going crazy. Man, I was drawing things and I didn't know where they were coming from," he explained. Clark believes that his work is divinely inspired, stating, "I truly believe that God helps me draw those pictures. I know I don't know anything about art. I feel like something or somebody is guiding my hand for me."[3] Using manilla envelopes, prison forms, the backs of letters—whatever materials he had access to in the prison—Clark drew with pens and pencils, designing intricate geometric patterns that often included figures ranging from Jesus Christ to animals to extraterrestrial creatures. The partial paralysis of his drawing hand from a previous gunshot wound did not impede his ability to draw.

After his release from prison Clark returned to the streets of Houston, where he stopped drawing and resumed his old activities. Five years later he was arrested and

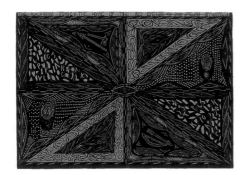

The Black-Board Jungle The Home of the Red Eye—The Only Thing That Can Predict the Future of Mankind, 1996

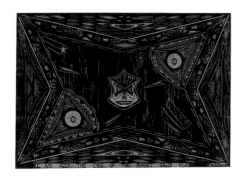

I Am Azer, The Eyes of a Planet Called Klar, 1996

charged with possession of a controlled substance and sent back to prison. Again he drew pictures to pass the time, decorating the walls of his prison cell with his drawings. He worked obsessively and intuitively, describing his working method as follows: "When I sit down to draw, I don't know what it's gonna be. It just starts flowing. Man, I mean, it just starts flowing, and it don't stop. Sometimes I don't wanna even get up and eat or go to the bathroom for fear I miss something while I was gone."[4]

Released after thirteen months in prison, Clark returned to Houston and again he quit drawing. Five years later he was charged with possession of narcotics, and in January 1988 was handed a thirty-year sentence as a habitual criminal. Within the rigid structure of prison life and removed from the destructive influences of the free world, once again Clark turned to drawing to occupy his time.

In May 1989 the Texas Department of Corrections planned its sixteenth inmate art exhibition. Clark's work was entered in the show and judges selected it to win first prize. Subsequently Clark's work began to be exhibited and collected in the outside world.[5]

In January 1991 Clark was paroled from prison. He married Rhonda Denise Clark, the mother of his daughter, Dominique. The following year he received a commission to paint a mural on the exterior wall of the studio of Houston artist, William Steen, who also serves as Clark's agent, and he also created work for a mural at Project Row Houses.

In July 1994 Clark opened a fast-food stand, the Magnificent Burger, in Houston's Third Ward. The building was decorated by Clark himself with signs and images celebrating the Magnificent Burger. Unfortunately, Clark's attempt at running a legitimate business was short-lived. In August 1994 he was arrested for failing to report to his parole officer, an appointment he claims he simply forgot. However, it was his third violation of the terms of his parole, and accordingly Clark was sent to the Harris County Jail to await transfer back to prison. Again he resumed making art. Working with a limited palette of red and black pens on manilla envelopes—the only materials to which he had access—Clark created the body of work represented in *Spirited Journeys* while in the Harris County Jail. In late 1996 Clark was sent back to prison and it appears unlikely that he will be released in the foreseeable future.

Many of Clark's drawings allude to the unknown powers of the universe. In numerous works female figures in alluring costumes confront the viewer. Their physical attributes symbolize sexual power while halos around their heads suggest a spiritual power. These figures frequently assume a frontal stance, arms akimbo, indicating that they are forces of great authority. In other works heads of extraterrestrial beings float in space surrounded by cosmic entities and texts written in unknown alphabets. These texts suggest the presence of special powers and knowledge beyond our understanding. The brightly colored, complex geometric patterns set against black backgrounds with which Clark typically surrounds the figures or which make up the designs of the drawings suggest mandala designs symbolic of the universe.

Like the artist Frank Jones, who also began making art while an inmate in the Texas Department of Corrections, Clark creates drawings that represent private universes of his own design. The work of both artists is characterized by geometricized, highly ordered set-

tings inhabited by supernatural figures with special powers. For both Jones and Clark, making art was an act of empowerment. But unlike Jones, who created art in an attempt to establish control within a spiritual realm which in his perception already existed, Clark constructs imaginary, kaleidoscopic worlds to which he can retreat from the limitations imposed upon him by his physical surroundings. Through his art Clark is transported far beyond the prison walls to distant and exotic places designed for his own reflection. "I have my own private galaxy out there, and it has nothing to do with you-all's world," Clark has explained.[6]

*Stop Look and Listen, Drug Will
Kill You Fool,* 1995

Recently his work has included serious messages, such as *Stop Look and Listen, Drug Will Kill You Fool.* But more frequently the work depicts extraplanetary beings such as "the Twin Gladiator from the Planet Eve," "Damitrius from the Planet of Darkness," or "Elvira, from the Planet Weird," and occasionally it refers to such famous earthlings as Michael Jackson.

In prison, Clark spends his time drawing and daydreaming about becoming a "great novelist, songwriter, and inventor," believing that some of his inventions "will revolutionize the whole world." At one point he planned to support himself by designing and marketing burglar bars in order to achieve his goal of becoming two dollars wealthier than Donald Trump. Henry Ray Clark's own words best describe his motivation for making art: "As long as my mind can create something beautiful to look at, I am a free man, and I will live forever in my art."[7]

[1]Chuck and Jan Rosenak, *Museum of American Folk Art Encyclopedia of Twentieth-Century American Folk Art and Artists* (New York: Abbeville Press, 1990), 73.

[2]Susan Chadwick, "Con artist: Prison unlocks wealth of talent in convict," *The Houston Post,* November 13, 1989, Sec. C, 1, 3-4.

[3]Warren and Sylvia Lowe, *It'll Come True: Eleven Artists First and Last* (Lafayette, Louisiana: Artists' Alliance, 1992), 58; and Henry Ray Clark, "Artist's Statement," n.d., unpublished.

[4]Warren and Sylvia Lowe, *It'll Come True,* 58.

[5]Chuck and Jan Rosenak, *Encyclopedia of Twentieth–Century American Folk Art,* 74.

[6]Susan Chadwick, "Pretty Boy now a prisoner of the market for his art," *Houston Post,* June 1991.

[7]Chadwick, "Con artist," 4; Clark, "Artist's Statement."

*I Am Michael J. I Bought My Own
Planet, I Name It After Me—The
Greatest,* 1996

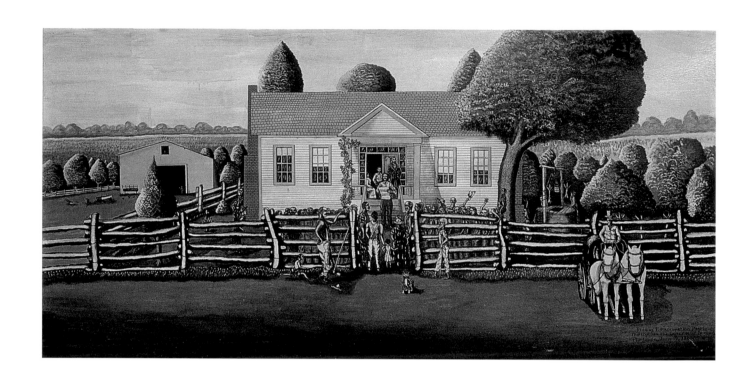

*Reading the Emancipation
Proclamation on the Governeur
Stroud Plantation, June 19, 1865,*
n.d.

Walter F.
Cotton

1892-1978

Walter Frank Cotton[1] was born December 27, 1892 in Limestone County, Texas, the first of Jesse and Lela Jones Cotton's seven children. Walter's family had been slaves on the Stroud Plantation six miles west of Mexia in Limestone County for several generations. Walter's father, Jesse, was born there just three years before emancipation. His great-grandfather, Giles Cotton, became a member of the 12th Texas Legislature following the Civil War.[2]

Walter Cotton was interested in art from an early age. He recalled,

I used to draw pictures on the ground with a nail when I was a child. . . . My teachers let me draw on a slate. I drew hundreds of pictures. . . . It's a hobby. I guess you might say it's the same kind of recreation as fishing is to others. I'm a natural. . . . I guess that's what you would call me. I believe being able to paint is inborn.[3]

Walter attended Limestone County schools at Rocky Crossing and at Mexia's Dunbar. He earned a bachelor of arts degree at Samuel Huston College (now Huston-Tillotson) in Austin and a master of science degree at Prairie View College (now Prairie View A & M University). Cotton was a veteran of World War I. After completing his education, Cotton began a long career as an educator. He taught history and was principal of Corsicana's Jackson High School for eighteen years and served as Superintendent of Mexia's Woodland Schools for six years. When Woodland and Mexia schools were consolidated in 1965, he became principal of Woodland High, the school attended by the district's African American students.

In 1919 Cotton married Veola Ross, and the couple had two sons, Belva and Rod Ell. In 1958 he married Willie Pearl Smith. At the time of Cotton's death, he had eight grandchildren and eight great-grandchildren.

In the 1940s Cotton developed an interest in painting. He described the beginning of his artistic venture.

I'm a Methodist. . . . And once I was in Chicago and went inside a big Catholic church and saw many fine paintings on the walls. I thought it would be good if we had some paintings on the walls of our little church. But I knew we could never pay what those Catholics paid for their paintings. So, I painted some myself for our church. People admired them very much. . . . All people are endowed with a certain talent. . . . My talent happened to be painting and drawing.[4]

Cotton returned to Texas and began painting Biblical scenes, historical events, and portraits of African American leaders and family members. For many years the paintings hung in the Woodland School and in the Jones Chapel Methodist Church in Mexia, which his father had constructed in 1922 and where Walter taught an adult Sunday School class. His work was unknown outside the African American community. Cotton recalled, "Friends were always asking me to paint them a picture. And I did. . . . I love to paint. I get more pleasure out of it than the other fellow does. Funny thing about it, most people here at Mexia don't even know I can paint."[5]

Cotton's painting *Reading the Emancipation Proclamation on the Governeur Stroud Plantation, June 19, 1865* hung in the hall in the Jones Chapel for many years. It portrays plantation overseer E. E. Rogers reading the document to the slaves. Behind him stands plantation owner Logan Stroud, brother of the late Governeur Stroud. His portrait was inspired by the figure of Prince Albert on a tobacco can—according to a former slave, the two shared a similar likeness. Cotton depicted his father as the child running toward the action at the center of the painting. The story goes that Jesse Cotton, then three years old, saw a crowd congregating and, assuming that watermelon was about to be served, ran to join in the celebration. He was disappointed to find that the cause of the great commotion was only the reading of the Emancipation Proclamation. This painting was the most well known of Cotton's works, and was apparently reproduced in Texas history textbooks. Cotton said of it, "Something historic happened here. . . . Out on the Stroud Plantation, on the 19th day of June in 1865, my grandparents were freed from slavery."[6]

One spring day in 1965, Thomas Beall Chatham, Jr. was driving with his mother near the Woodland School when their car had a flat tire. Chatham went to the school to telephone for help, and met Walter Cotton. The two became friends and Chatham became a great supporter of Cotton's art, organizing the first public showing of his work outside the Jones Chapel.

Cotton wrote two books on local African American history, *History of the Negroes of Limestone County from 1860 to 1939*, and *Missing Links*, which he dediated to his friend, Tom Chatham. He illustrated the books with his own drawings and paintings. He felt a deep concern for the preservation of history, believing that " . . . without this knowledge we are

orphans in an everyday changing society. An awareness of our roots will give us the strength to get where we want to be."[7]

When the Jones Chapel relocated in the 1970s to a new, brick church renamed St. Luke's Methodist, the paintings were no longer wanted, and they went to Tom Chatham. Chatham continued to promote Cotton's work, and arranged for a solo exhibition of thirty-two paintings at Southern Methodist University in 1970. Outside of the exhibition at SMU and occasional exhibits of his paintings in Limestone County, Cotton's work has remained relatively unknown.

Walter Cotton died in Mexia July 25, 1978 at the age of eighty-five, leaving a body of work in which he fulfilled his desire to preserve history. He had addressed this concern eloqouently years before in a letter to the Mexia newspaper: "To look backwards and marvel at the progress made is altogether fitting and proper. And we should remember, since remembrance is the only paradise out of which we cannot be driven. . . ."[8]

[1] As the *Spirited Journeys* catalog was going to press, Bruce and Julie Webb brought to my attention the artist Walter F. Cotton. I am grateful to them and to Thomas Beall Chatham, Jr. for providing me with biographical information on the artist.

[2] Tom Chatham, "A Juneteenth salute to the late Walter Cotton," *The Mexia Daily News,* June 20, 1980, n.p.; and Chatham, "1889 Confederate park hosts African-American art show," *The Mexia Daily News,* August 26, 1992, n.p.

[3] "Mexia Schoolman-Artist Receives Compliments On Latest Painting," *The Mexia Daily news,* April 3, 1966, n.p.

[4] Frank X. Tolbert, "Tolbert's Texas," *The Dallas Morning News,* June 30, 1969, n.p.

[5] Ibid.

[6] "Leon Hale: "Something Historic Happened. . . ," unidentified newspaper article from the files of Tom Beall Chatham, Corsicana.

[7] Tom Chatham, "1889 Confederate park hosts African-American art show."

[8] Walter Cotton, Letter to the Editor, *The Mexica Daily News,* n.d., 1965.

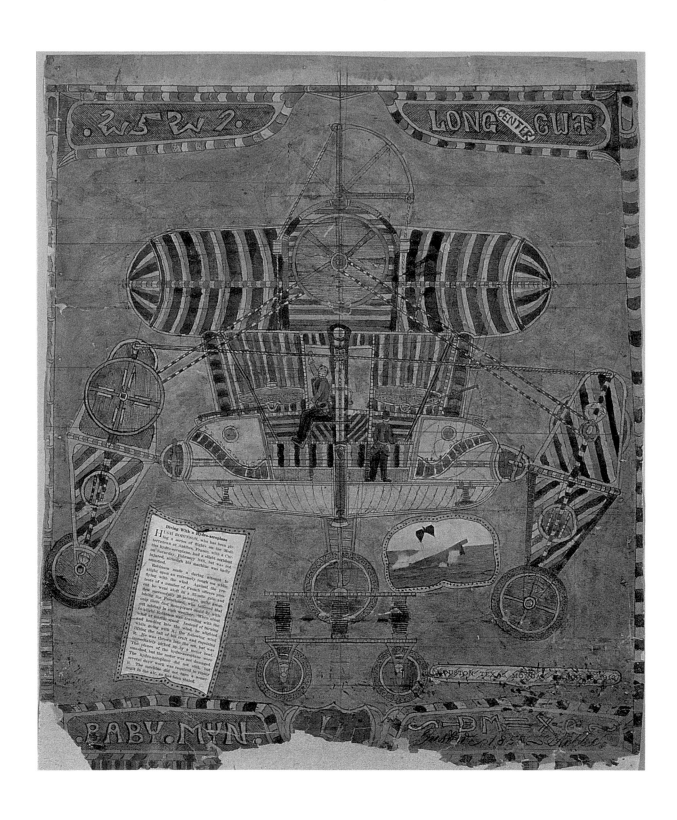

Baby Myn, Long Center Cut, 1912

Charles
Dellschau _____

1830–1923

Charles August Albert Dellschau was born June 4, 1830 in Brandenburg, Prussia to Frederika Wilhemina Franke and Heinrich Adolph Dellschau. In 1850, at the age of twenty, Dellschau came to the United States, entering through the port of Galveston, Texas. Six years later he applied for U.S. Citizenship in Harris County.[1]

In 1861 Charles Dellschau married Antonia Hilt, a widow with a five-year-old daughter named Elizabeth. The following year Antonia gave birth to a daughter, Mary, and the couple had two more children: a second daughter, Bertha in 1866 and a son, Edward in 1871. Documents show that Dellschau was a veteran of the Civil War. In 1865 his occupation was listed as butcher and his residence as Richmond, in Fort Bend County, Texas. The family continued to reside in Richmond for the next decade. By the year 1875 Dellschau's step-daughter, Elizabeth, had left home to marry Anton Stelzig, a saddlemaker, and the couple lived in Brenham.[2]

The year 1877 was one of tragedy for Dellschau. His wife Antonia died in August and less than two weeks later his six-year-old son, Edward, died. Dellschau's daughter Mary went to live with Elizabeth and Anton, and Charles and his daughter Bertha remained in Richmond. In 1887 Dellschau joined the Stelzig family in Houston, where Anton founded the Stelzig Saddlery. Dellschau worked as a clerk for the Saddlery. After Anton Stelzig died in 1893, Dellschau continued living with the family in a house on Clay Street and working in the Saddlery until retiring in 1900 at the age of 70. In 1908 the family relocated from Clay Street to a house on Stratford Street.[3]

At some point Dellschau began the construction of a series of scrapbooks in which he affixed his mixed-media drawings of primitive flying machines. Helena Stelzig, daughter of Elizabeth and Anton, recounted, "He was my mother's stepfather. He lived with us. . . . The drawings were a hobby. He didn't talk much, he just made those drawings."[4]

Dellschau first drew grids onto paper over which he drew the flying machines, or "aeros," in ink and watercolor. In many of the drawings he also added collage from newspaper clippings of the day. The clippings were articles relating to aeronautics and other scientific discoveries which he collected from the *Houston Chronicle*, the *New York Times*, and *Scientific America*, as well as from German language newspapers. He called his drawings "*press blumen*," or "press blooms."[5] Each flying machine was identified by name, and often specific designs were attributed to an original designer along with notes regarding their his-

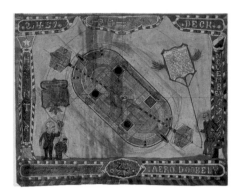

Aero Doobely, Deck View, 1911

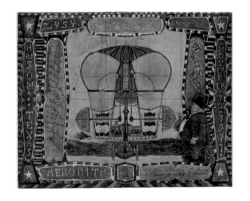

Aerocita, Broad Center, 1911

tory. The drawings featured aeros shown from various angles, and they also included texts written by Dellschau in German and English as well as strange symbols that apparently comprised a secret code. Together the books of drawings represent an artistic vision of great consistency and effort. Helena's nephew, Leo Stelzig, Jr., had looked through Dellschau's scrapbooks as a child, and said, "His thinking was like Buck Rogers. . . . He did not draw about going to the moon but he was far thinking. He had the knack of knowing what was going on in the future."[6]

Each drawing was meticulously numbered and dated with the month, day, and year of its execution. The earliest extant drawings are dated 1908, the year of Dellschau's move to Stratford, and the latest are dated 1921, two years before his death. Assuming that he began the scrapbooks sometime after his retirement in 1900 there may have been earlier drawings that either did not survive the 1908 move, were destroyed in a reported fire at the Stratford house around the year 1967, or were not recovered at the time the others were found. Based on Dellschau's own numbering system of the drawings which begins in 1908 with the number 1,601, at least six and possibly as many as twenty additional books may once have existed and are lost or missing.[7]

Charles August Albert Dellschau died on April 20, 1923. For more than forty years after his death, his scrapbooks remained unknown, apparently stored in the house on Stratford. In 1967 twelve scrapbooks were found by "a man at a junkyard. . . in a trash pile along with letters, cancelled checks, etc., belonging to the Stelzig family."[8] They were purchased by Fred Washington, owner of Fred Washington's O.K. Trading Center, a used furniture and junk shop in Houston. There they lay covered by a tarp which protected them from a leaking roof for approximately two years. In 1969 they were discovered in the shop by students from Houston's University of St. Thomas and were included in *The Sky Is the Limit*, an exhibition focusing on flight, held at the University in May and June of that year.

At the time of their discovery Dellschau's scrapbooks were in extremely fragile condition, and were described as follows:

The books are about 22" x 22" and varying thicknesses. The "plates" or pages are bound between covers of heavy cardboard, reinforced with more cardboard along the edges, and sewn together with heavy thread. The binding is held together with shoelace material. One of the books has a heavy string with a metal washer tied to the end [that] may have [been] intended as a book marker. The covers, inside and out, were lined with purple or green-colored cheesecloth (which was later removed as it had deteriorated completely). The material in the covers came from cardboard boxes and corrugated cardboard. In some books, the laces were inserted on the covers, near the binding, for use as a handle. Shoe laces were also used for keeping the books closed by tying them at several places along the edges of the covers.[9]

A representative of The Menil Collection purchased four of the volumes from Washington's shop in October 1969 and the remaining eight were purchased by P. G. Navarro, a Houston "UFOlogist" who had been among the visitors to the exhibition at St. Thomas. Ten years later in 1979, the San Antonio Museum Association purchased four of the books in Navarro's possession. Dellschau's work was subsequently included in several exhibitions focusing on Texas folk art and was known to members of the Texas museum community, but for the most part it remained in museum storage.

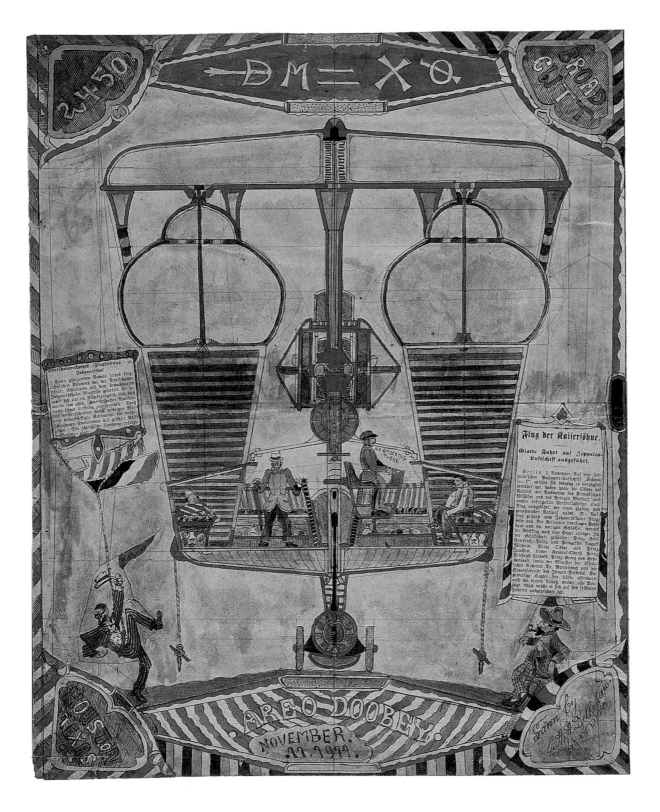

Aero Doobey, Frontal View, 1911

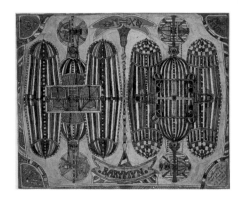

Babymyn, 1912

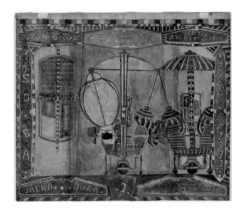

Aero Dora, Center Front or Rear,
1911

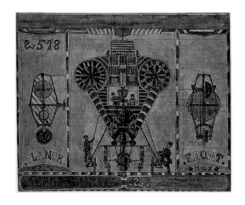

Aero Babymyn, 1912

Dellschau's work was first shown outside the state in 1996 when the American Visionary Art Museum mounted the exhibition, *The Wind in My Hair.* In January 1997 a number of the works came onto the market through a New York gallery. Astronomical selling prices reflected the importance and rarity of the work, and Dellschau was launched from obscurity to folk art marketing phenomenon.

What is not known about C.A.A. Dellschau is perhaps more intriguing than the sketchy facts that are known about his life. Since their discovery Dellschau and his enigmatic drawings have become the subject of scrutiny for a current generation of amateur scientists, inventors, and individuals with interests ranging from physics to paranormal and extraterrestrial phenomena, and they are at the center of a mystery involving a secret society and reported UFO sightings in the late nineteenth century.

After purchasing eight of the books Navarro, interested in their relation to UFOs, began a personal quest to unravel the meaning of the books and their contents. Navarro found that the existing books contain designs for more than one hundred distinct aircraft.

Not only were the general shapes and layout of the interior[s] different in each case, but these designs show dozens of different techniques for transferring the "supe," or liquid propellant to the converter which changed it into a hot gas. There were also dozens of different styles and constructions of converters. There were different methods of inflating and deflating the gas bags. And even before the gas reached the gas storage bags, it was used in later designs to operate various and sundry pieces of equipment including "air-press motors," navigational devices, powered wheels for land travel, inflatable pontoons and/or side paddle-wheels for water travel. Some craft even displayed gas nozzles for propelling the craft along.[10]

Navarro undertook an effort to break Dellschau's code, and then he translated the deciphered code from German to English. When he accomplished this task, an incredible story began to unfold. According to Navarro, the drawings of fantastical flying machines were more than mere designs for inventions; apparently Dellschau claimed in his texts that some of them had actually been built and flown before being dismantled. In his writings Dellschau stated that he was part of a group of approximately sixty individuals who gathered in the 1850s in Sonora, California where they formed an "aero club," constructing and flying heavier-than-air vehicles. The Sonora Aero Club consisted mostly of German immigrants like Dellschau, but it also included "at least two Spanish or Mexican members, a Frenchman, and three or four Englishmen." The Club "worked in secrecy and its members were not permitted to talk about their activities or to use the aircraft for their own purposes."[11]

Apparently the Sonora Aero Club was part of a larger secret society identified as "NYMZA," believed to have been based on the east coast. The meaning of the initials remains unknown, but apparently orders came to Dellschau and his group from their superiors at NYMZA. Navarro and fellow UFOlogist Jimmy Ward believed that fear may have induced Dellschau to keep his drawings secret and to write in code, since divulging any information was strictly forbidden by the Society, and they also hypothesized that the Society may have feared government interference lest their inventions be used for military purposes.[12]

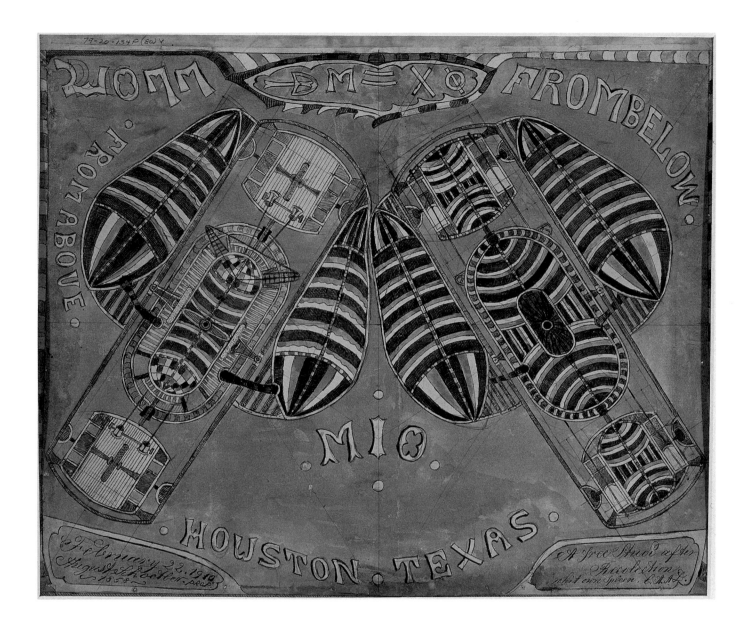

Aero Mio from Above and Below,
1910

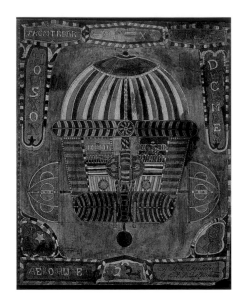

Aero Hunter, Front Rear, 1910

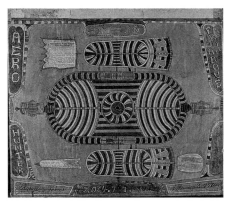

Aero Hunter from Above, 1910

It is difficult to imagine any of Dellschau's contraptions as having any real aerodynamic capability. But the inventions of Dellschau and his colleagues supposedly did not rely upon such conventional gases as helium or hydrogen generally used in balloons or dirigibles. Dellschau's books claimed that the Society had discovered a substance called "NB," also referred to as the "Supe," which had the ability to negate weight. This antigravity substance was said to consist of green crystals distilled from coal through a secret process known only to a single member of the group, Peter Mennis. When these crystals were added to ordinary water the reaction created a hot gas with extraordinary lifting capability.[13] UFOlogists posit that the Sonora Aero Club aircraft, fueled by NB, may have been the "progenitors of the mystery airships that were observed flying over Oakland and other points in California and in the southwestern part of the country in the 1890s."[14] After the death of Mennis, the supe recipe was lost forever, and the surviving members were unable to continue their experiments.

The discovery of Dellschau's drawings created a mystery that remains unsolved. Whether they were designs for actual aircraft or the fanciful creations of the artist's imagination, it is certain that the drawings of Charles Dellschau represent an artistic achievement of great vision and importance and serve as valuable documentation of one man's obsession with flight.

[1] Biographical data compiled from Kathryn Davidson and Elizabeth Glassman, "C.A.A. Dellschau, A Visual Journal," 1977, The Menil Collection Archives, Houston; P. G. Navarro, "Dellschau's Aeros: An Attempt to Solve the Riddle of Dellschau's Books," Archives of The Menil Collection; William Steen, "C.A.A. Dellschau Chronology," unpublished, 1996. The research of these authors is based on census reports and other documents that have not been verified individually by this author.

[2] Steen, "C.A.A. Dellschau Chronology."

[3] Ibid.

[4] Sarah Peterson, "Rescued From The Dump," *Houston Chronicle*, June 1969.

[5] Davidson and Glassman, "C.A.A. Dellschau, A Visual Journal."

[6] Peterson, "Rescued From The Dump."

[7] J. Ward and P.G. Navarro, "The Riddle of Dellschau and His Esoteric Books" (Mesquite, Texas: KeelyNet , 1992), 2.

[8] Notes in C.A.A. Dellschau files, Archives of The Menil Collection, Houston.

[9] Ward and Navarro, "The Riddle of Dellschau and His Esoteric Books," n.p.

[10] Ibid., 2–3.

[11] J. Ward and P.G. Navarro, "Dellschau and Other 'Aeronauts'" (Mesquite, Texas: KeelyNet, 1992), 1.

[12] Jimmy Ward, "NYMZA Aeros: The Airships of the 1850's" (Mesquite, Texas: KeelyNet, 1992), 2; Ward and Navarro, "Dellschau and Other 'Aeronauts,'" 5.

[13] Jimmy Ward, "Alternative Energy? What about "those little green granules?", Mesquite, Texas: KeelyNet, 1993), n.p.

[14] Ward, "NYMZA Aeros," 2.

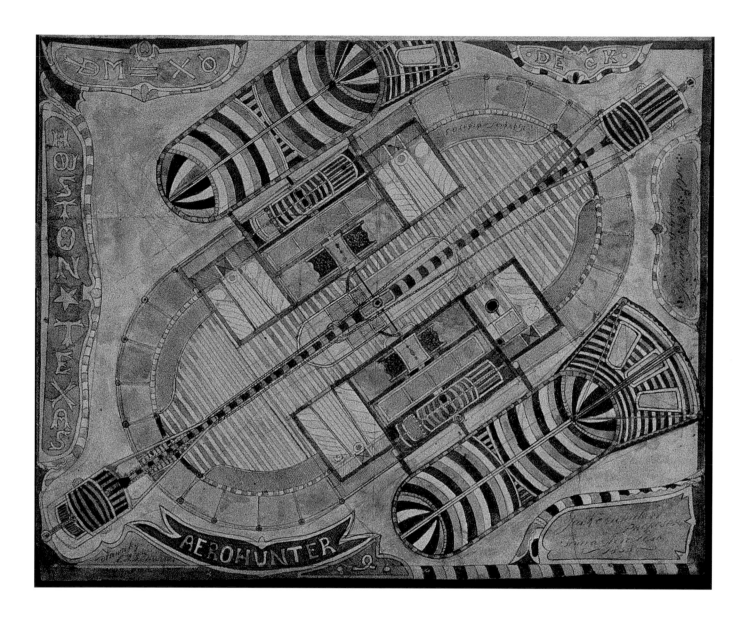

Aero Hunter, 1910

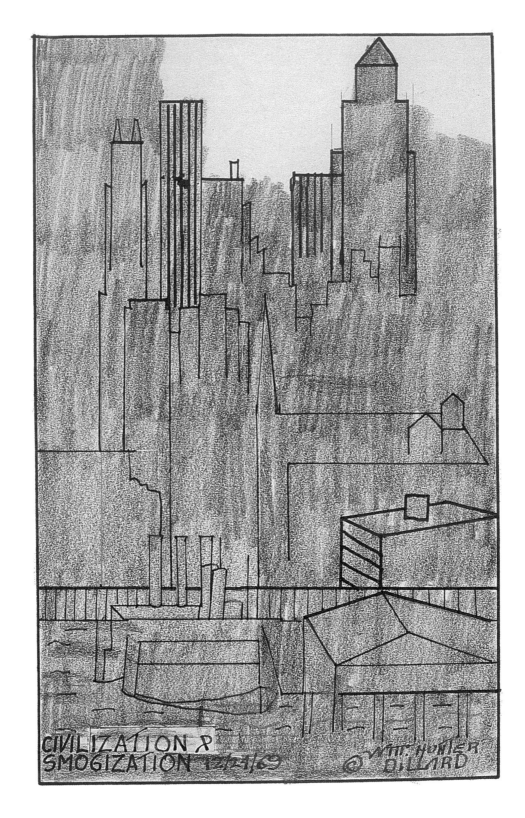

Civilization & Smogization, 1969

William Hunter
Dillard

b. 1905

William Hunter Dillard[1] was born in Bogalusa, Louisiana in 1905. He spent his childhood moving from place to place with his family throughout the Mississippi River delta. Around the year 1920 Dillard moved to New Orleans, where he lived with an aunt and finished school. From approximately 1924 to 1929 he worked in the lumber and logging industries, living in New Orleans and Lake Charles, Louisiana and Beaumont, Texas.

In 1930 Dillard joined the U.S. Coast Guard and was stationed on the east coast. In 1933 he married, but the marriage ended in divorce several years later. It is believed that the couple had a son and a daughter. Following his divorce Dillard returned to Louisiana and in 1937 he moved to Houston where he founded a consulting business, Directors of Houston Business Research Service, which researched South Texas business trends and published articles, statistics, and directories.

In 1940 Dillard enrolled in drafting and engineering courses at the University of Houston, and the following year he went to work for the City of Houston water engineering division, then involved in the construction of the Lake Houston system. In 1949 he left the City of Houston and the following year he reopened his business research service.

Around the year 1962 Dillard began making drawings in which he documented his views on a variety of subjects and revealed his plans for the betterment of society. A group of drawings which he titled "Rhythm Series," completed in 1970, combined Dillard's visionary architectural plans with his deep concern over the pollution of the environment. The drawing *Smogscraper* from this series was Dillard's design for a building up to 110 stories high in which he suggested "some minimal reforms in current boxey designs of skyscrapers in the U.S.A." Another drawing from this series is sarcastically titled *Rhythmns [sic] (& Stains) by Courtesy of Smoggenheimer National Industries Corp.* In this drawing smokestacks spew thick, dark smoke into the air, creating a cloud of pollution that hovers over them, producing a rain of black particles. *Five Boxey Skyscrapers in Metropolitan Smog—Houston, Texas* depicts a cityscape engulfed in a great cloud of smog drawn with the side of a pencil. Finally, in *Civilization & Smogization*, the city skyline has been all but obliterated by dense smog. The absence of human figures in these works suggests that the devastation of the environment has made it unsuitable for supporting human life.

Dillard's unfavorable views of women also provided subject matter for a number of

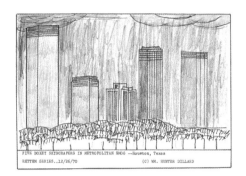

Five Boxey Skyscrapers in
Metropolitan Smog (Houston,
Texas), 1970

American Realism . . . Females,
1975

drawings, including such works as *Her Complex Problem* and *Spoiled Rotten, Cold, Stubborn*. The drawings contained quotes or made statements about proper female behavior and included such topics as frigidity, bossiness, and nagging. He claimed his attitudes were supported by the Bible which, he believed, "has some definite ideas about what a woman should do and should not do." He produced a series of 100 works in which he depicted what he considered the various traits of women, including *Sex Symbol*, *Slave of Fashion*, *Jail Bait*, *Femme Fatale*, *Gold Digger*, *Flirt*, *Harlot*, and finally, the *Woman Who Makes A Man So Happy He Places Her Upon A Pedestal*.[2]

In his "Beautiful but Damned" series from 1970 Dillard depicted *The Wilted Flower: The Shapely but Ineffectual Woman* who, due to "broken promises, dates, [and] play[ing] hard to get, . . . has no husband or regular suitor." Dillard accused her as "vain, proud, [and] ineffectual as a pretty doll," and determined that she was lacking Vitamins A to Z. The figure is surrounded by a mirror and a peacock, symbols of her vanity; a flower stem is shown both before and after it has wilted, a symbol of her fate as Dillard saw it. Dillard's misogynistic streak probably resulted from the circumstances surrounding his divorce, from which he apparently "never quite recovered."[3]

Around the year 1980 Dillard began producing three-dimensional works in which he addressed some of his favorite issues. Working with scrap wood, paper, and other found materials, he made angular constructions including *King Rhythm*, from 1981, a throne for one of his favorite formal art elements. In *Old and New Styles*, Dillard again referred to his concern for the manmade landscape, which seems to have served as his metaphor for the ills of society. *Success: Step by Step, Ambition, Action!* completed in 1983 makes a literal reference to climbing toward success.

In 1969 Dillard had begun holding a series of exhibitions on the front porch of his home in a working class Houston neighborhood. He advertised his front porch exhibitions with handmade flyers which he posted around the neighborhood. In 1982 through one of these flyers Dillard's work came to the attention of Mark Lombardi, a Houston artist and independent curator. When Lombardi decided to investigate he met Dillard, "an elderly, retired man who had researched the formal properties of art throughout his life, was doing drawings, and holding exhibitions on his front porch. He was kind of a homespun philosopher who liked to talk about his drawings and tell tall tales of his exploits." In 1983 Lombardi organized the first public exhibition of Dillard's work at the Gallery of the University of St. Thomas in Houston.[4]

As the 1980s progressed Dillard's health began to deteriorate and he became increasingly incoherent. Finally, Lombardi received word that Dillard's house was vacant. Dillard was nowhere to be found and his art work had been removed from the house. It is assumed that Dillard died and that a large portion of his work may have been destroyed by his son,

The Wilted Flower: The Shapely but Ineffectual Woman, 1970

who lived in the Houston area. Dillard's inspiration for making art was related to his observations of life, his desire to improve the world, and to share his ideas with others. Through the drawings that survive, William Hunter Dillard's unique views have been preserved.

[1] I am grateful to Murray Smither for bringing the work of William Hunter Dillard to my attention; and to Mark Lombardi, for providing biographical information on the artist.

[2] William Hunter Dillard, flyer announcing front porch exhibition, May 17, 1969.

[3] Mark Lombardi, telephone conversation with the author, May 19, 1997.

[4] Ibid.

The Crucifixion of Jesus Christ,
1996

Carl
Dixon

b. 1960

Carl Dixon[1] was born September 29, 1960 in Jackson, Mississippi, the second of Jimmy and Bessie Dixon's two sons. Carl was interested in art from childhood, and he played basketball throughout junior high and high school. After graduating from high school Dixon enrolled at Hinds Junior College in Raymond, Mississippi, where he studied brick masonry.

Dixon began woodcarving around the year 1978, initially collaborating with a friend. He chose to work in wood because of its durability. "It's a way of petrifying art. It's easy to store and you don't have to worry about it being broken. It's enduring. A normal picture won't take a lot of wear and tear like wood will. You can even mail it and not worry about it breaking," he explains.[2]

Around the year 1980 Dixon relocated to Houston, where he lives today. He is single, and has a daughter who recently graduated from the eighth grade. Dixon's devout religious beliefs are reflected in his art. "I study the Bible . . . and try to share a great thought and catch a great moment. . . . Understanding the Bible is a way of life, and I want people to get the complete message. That's why I leave nothing out. My pictures include the frame and a copy of the manuscript."[3]

Carl Dixon has developed his own system for making art. Before he makes a picture, he begins with a "blueprint," a sketch that he creates on paper. Using a T-square and protractor, he draws the layout "just like I'm doing a house. I draw it out, center it, name it, sketch it, and look at it. If it's a Biblical story, I read the story and meditate on it. Then I read it again, and pray. Then I put it all together."

Dixon has used a chisel, hammer, and leather crafting tools to carve wood, but he prefers power tools including a jig saw, router, and industrial drill to carve his figures because it saves him time. He estimates that by using power tools he can complete a work in six to eight weeks that would take him a year to construct if he used hand tools. "I flash them to the degree I want them to work for me. That's the purpose of tools—they work for you. You got to be able to see the vision in order to get them to work for you." After the carving is complete the piece is painted with water based, oil based, or acrylic paint. Finally, a lacquer is applied to give it a "protective shield." In addition to these materials, Dixon's "heart and soul goes into each picture—that's part of me that's captured."[4]

Early in 1991 Carl Dixon had a dream in which he saw the vision of doctors working on

Martin Luther King, n.d.

him. The dream perplexed him, because he has always been athletic and believed himself to be in perfect health. Five months later he was diagnosed with colon cancer, for which he underwent surgery. Regarding his illness, Dixon believes that "God has a purpose for it. I have to count it all joy. The Lord is my strength. I think about Job. He was so faithful. He's one of the heroes of the Bible. God gives an insight into things. I'm going to magnify God's name as my healer and provider."[5]

The role of religious faith in healing is the subject of Dixon's carving, *The Woman with the Issue of Blood*, in which he illustrates the story told in Mark 5:25-34. A woman who has hemorrhaged for twelve years touches the garment of Jesus, and through her faith she is healed.

Dixon tries to do a picture of Martin Luther King, Jr. every year. Each carving is a different interpretation of one of his great religious heroes. In this work he portrayed the civil rights leader in a contemplative pose, and accentuated his eyes by inserting marbles into the carved wood.

Carl Dixon's religious faith and his art are the driving forces of his life. He has explained, "You need gas for the body, gas for the mind, and gas for the soul." He views life as an unfolding journey. "Any time you walk with the Lord, it's a fantastic voyage. I trust God in the things that I do as my life leads me through His willingness."[6]

[1] Carl Dixon, telephone conversation with the author, May 24, 1997.

[2] Ibid.

[3] Chuck and Jan Rosenak, *Contemporary American Folk Art: A Collector's Guide* (New York: Abbeville Press, 1996), 237-238.

[4] Carl Dixon, telephone conversation with the author.

[5] Ibid.

[6] Leslie Muth, "Carl Dixon, Texas relief carver," Leslie Muth Gallery, Santa Fe, n.d., and Carl Dixon, telephone conversation.

Woman with the Issue of Blood, St.
Luke 8:43-48, n.d.

Untitled, 1976

Peter Paul

Drgac "Uncle Pete" _____

1883–1976

Peter Paul Drgac[1] was born July 21, 1883 in New Tabor, a Czech farming community near Caldwell in Burleson County, Texas. His parents, Josef Drgac II and Anna Mynar Drgac, were Czech immigrants who were among the first settlers in the area. Drgac, the youngest of their nine children, attended the Shady Grove School in Cook's Point, Texas through the seventh grade. After leaving school he worked on the family farm, and did carpentry and housepainting. Drgac was proud of his Czech heritage and spoke his native language fluently. He joined the Brethren church at New Tabor and remained a member throughout his life.[2]

In 1905 Drgac married Frances Mrnustik, also from Cook's Point, and the couple ran a small grocery and bakery in Caldwell for six years before relocating to Rosenberg. In 1922 the Drgacs opened their own grocery store in Rosenberg. In addition to working fourteen to sixteen hour days operating his business, Drgac also baked bread and made many of his wife's clothes. Although the couple had no children of their own, Drgac loved children and received the nickname "Uncle Pete" from his nieces and nephews.

After retiring in 1955, the couple returned to Caldwell. Peter Drgac had a great interest in gardening, and he was known for growing spectacular fruit trees, flowers, and vegetables. In 1962 Frances, his wife of fifty-six years, died. Drgac consoled himself by focusing on gardening, church work, and reading.

At the age of eighty-five Drgac found a new passion. After building a flower box, he decided that it needed painting. He painted some flowers on it, but was not satisfied with the results. That night as he lay in bed he worried over how to improve his painting, he mentioned it in his prayers, and finally reached a conclusion. "Now, some folks might laugh at this, but I felt the assurance that if I would practice, I would be able to draw those flowers and anything else I wanted."[3] He began decorating every imaginable surface–furniture, light bulbs, soda bottles, egg cartons, and flower pots–until eventually his house was nearly filled with his decorated objects. During the next eight years he also produced hundreds of paintings on posterboard.

Drgac's method of working has been described as follows:

Untitled, 1972

Uncle Pete worked rapidly. He sometimes applied his enamel paint directly to the posterboard (usually about eleven by seventeen inches in size, covered with a wash), but, more often, he would draw his designs on drafting paper and then trace them onto the posterboard with a pencil before painting. . . . Painting became his most enjoyable activity, and he would spend many hours at it, sometimes producing several paintings in a day. He completed hundreds of them. The year before his death, 1975, was perhaps his most prolific.[4]

Drgac's paintings appear to be visual inventories, perhaps inspired by his many years of arranging objects in rows on grocery store display shelves. Objects, animals, figures, and plant forms appear as flat, stylized shapes placed randomly within a two-dimensional space, without consideration for perspective or attempt to create a naturalistic setting. The unnatural scale of the objects and the mysterious relationships they assume causes them to relate to each other spatially in unexpected ways.

Drgac took pleasure in giving his paintings to relatives and friends. He showed no interest in selling his work and only accepted payment based on the estimated value of materials. However, he enjoyed receiving visitors in his home and showing his work to them.

Drgac attributed his longevity to his active lifestyle, explaining,

. . . [I]t appears to me that when most folks start drawing that pension, they just sit down and quit living, and I also think people nowadays have too much money and too many luxuries. With the coming of the automobile and television, people seemed to lose personal contact, withdraw into themselves, and became spectators instead of doers.[5]

Peter Paul Drgac died November 12, 1976 in Caldwell, Texas at the age of ninety-three. After his death some of the several hundred drawings he had created in the last eight years of his life were distributed among his surviving relatives. Subsequently Drgac's work was brought to the attention of Leslie Muth, who first introduced the work to the public in her Houston gallery.

Untitled, 1976

[1]Biographical data compiled from Grace Skrivanek, telephone interview with the author, May 15, 1997; *Tree of Life*, (Baltimore: American Museum of Visionary Art, 1996), 192; Clinton Machann, "'Uncle Pete' Drgac, Czech-American Folk Artist," in Francis Edward Abernethy, ed., *Folk Art in Texas* (Dallas: Southern Methodist University Press, 1985), 173-177; and Chuck and Jan Rosenak, *Museum of American Folk Art Encyclopedia of Twentieth-Century American Folk Art and Artists,* (New York: Abbeville Press, 1990), 110-111.

[2]Clinton Machann, in his article, "'Uncle Pete' Drgac, Czech-American Folk Artist," in Abernethy, ed., *Folk Art in Texas*, 173-177, explains that "New Tabor (Nov´y Tabor) is . . . named after Tabor, Bohemia, a city built by followers of the religious leader and martyr Jan Hus in the fifteenth century. The Unity of the Brethren denomination, organized when several independent Czech Protestant churches in Texas merged in 1903, traces its origins to the original Czech Unity of the Brethren and the legacy of Hus."

[3]Melva Wick, "Uncle Pete: 92 Years Young," unidentified newspaper article, n.d.

[4]Clinton Machann, "'Uncle Pete' Drgac, Czech-American Folk Artist," 175.

[5]Melva Wick.

Untitled, 1976

Untitled, n.d.

Vanzant

Driver _____

b. 1957

Vanzant Driver[1] was born in 1957 in Taft, Texas, fifteen miles north of Corpus Christi—a town he described as having "3,000 people, 15 cattle, and 20 chickens." Driver was one of seven children in a religious family. He recounted creating his first art work as a child.

I made my first piece with glass when I was a kid. One day my brothers and sisters and I were playing baseball outdoors. We were called inside, but continued to play the game. I threw the ball and accidentally broke one of my mother's vases. I had some glue from school, and when I cleaned up the glass I made a sword from some of the pieces. Ever since I was a kid, I have had a vision. When you have no power there are only dreams and prayer. Art work is a release for me. . . .[2]

Driver attended Taft High School where he excelled at basketball and track. In his senior year he was selected for the all-state basketball team and the Hall of Fame all-star team, and after high school he attended Laredo Junior College on an athletic scholarship.

In 1978 Driver moved to Houston and found work as an oil-rig roughneck. He married, but the marriage ended in divorce in 1982. Nine days after his divorce, the fingers on his right hand were crushed when 600 pounds of steel fell on his hand. Driver was told that he would only regain about fifty percent usage of his fingers. Following these traumatic events Driver said he "saw the importance of having a relationship with God," and religion became an important part of his life. Soon he regained the use of his right hand, which he considered a miracle.

Around the year 1980 Driver had begun making glass sculptures for his own enjoyment and to give as gifts to family members. In October 1983 he was laid off a construction job. "Being unemployed was a blessing for me," he explained. "For the first time in my life I could say, 'What do I want to do?' . . . I started to watch the reactions of people who came to my apartment and looked at my sculptures. I began thinking, well maybe I should get them more out into the public."[3] Driver had taken up residence above the Christ Evangelistic Church in Houston's Fourth Ward where he served as a deacon, and there he began to explore his glass sculpting more seriously. During the next two months he completed five pieces which he initially planned to sell at a Houston flea market.

In January 1984 Driver made an appointment to show his work to the manager of a hospital gift shop. Although he received praise for his work from a number of people who saw him as he carried the sculptures to and from his car that day, his work was ultimately rejected by the gift shop manager. Driver took the sculptures back to his car and recalled, "I

was a little disappointed that day, a little down in spirit, and I said, 'Lord, what am I going to do now. I guess I'll just take them back home and let them collect dust.' But as I drove two blocks there was something that came into my mind that said go to the museum." Although he had never been to Houston's Contemporary Arts Museum, he drove there that day and met Sheila Rosenstein, who coordinated the sales and rental gallery. He explained to her that "The Lord has blessed me with a talent people have told me is very unique." Rosenstein agreed, and Driver found a place for his work where it was received enthusiastically.[4]

Working with discarded automobile windshield glass that he found at automotive shops and other bits of broken glass and mirror salvaged from dumpsters in his neighborhood, Driver's practice was to shatter the glass with a hammer. Carefully arranging the broken pieces of glass and cementing them in place with Elmer's glue, Driver began to build miniature churches. Often the interiors were lined with pieces of mirror, enabling them to be viewed through their small openings. The elegant and extremely fragile churches are symbols of Driver's religious devotion. As his way of thanking God for giving him "a talent that people appreciate," Driver decided to make only churches for the first year. "What God has allowed me to do is to get items that were outcasts and bring them together to create these sculptures. Just like I take trash and make something out of it, God can take people that society might consider trash and make them into something beautiful," he explained.[5]

Driver built his churches on wooden bases, which he left unpainted because he chose not to "camouflage beauty." He explained, "I don't title any of my pieces and I don't sign my pieces. . . . This is another way I want people to really see the message. I don't want my name to get in anybody's way because I want my work to get all the attention."[6]

Driver's work was collected by artists, dealers, and museum professionals. Prior to his discovery, Driver explained, "I had not been in any environment that valued what I made or saw it as art. It is my belief that the Lord blesses you to create. I have always felt that gifts came from God. I allow Him to use me, and He allows me to be."[7]

Vanzant Driver's whereabouts today are unknown. A note dated 1991 in The Menil Collection archives states that there was no known address or telephone number for Driver, and that the State of Texas Attorney General's Office was apparently looking for him for failure to pay child support.[8] The small body of work he produced before disappearing represents a unique vision and style that distinguished him as a visionary artist of great authenticity and promise.

[1] Biographical information, Bonnie Gangelhoff, "An Artist with a Touch of Glass," *The Magazine of the Houston Post,* July 22, 1984, 12–13.

[2] "Vanzant Driver," *Inquirer* [Houston], February–March 1986, n.p.

[3] Bonnie Gangelhoff, "An Artist with a Touch of Glass," 12.

[4] Ibid., 12–13.

[5] Ibid., 13.

[6] Ibid., 13.

[7] "Vanzant Driver," n.p.

[8] Mary Kadish, Menil Collection Associate Registrar, telephone conversation with the author, May 15, 1997.

Igloo Church, 1985

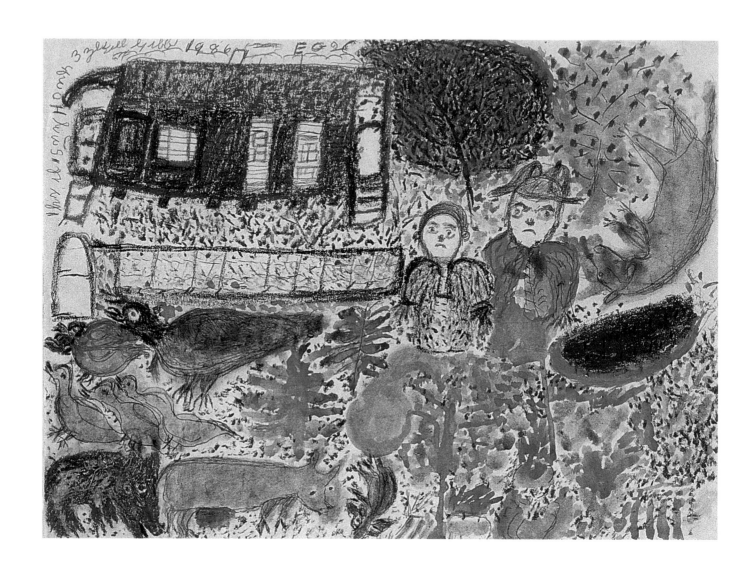

Untitled, 1986

Ezekiel
Gibbs

E zekiel Gibbs was born April 15, 1889[1] near Richmond in Fort Bend County, Texas. Gibbs was told that his father came from Africa to the Houston area "around the end of slavery times," and that his mother was Cherokee. Gibbs was orphaned as a young child, and went to live with an uncle. He received no formal education.

The Houston of Gibbs's childhood was much different from the city of today. Bayous were populated abundantly with alligators and other wildlife. His first home was a log cabin with a dirt floor, and the first church he attended was a brush arbor—a simple, tent-like structure covered with brush. Later, a log church with a thatched roof was constructed in its place. Brush arbors were once common throughout Texas, and today many black churches are located on the original sites they once occupied.

In 1910 at the age of twenty-one, Ezekiel Gibbs began his sixty-two year marriage to Josephine Johnson. The couple raised nine children. By the end of his life, Gibbs's family had grown to include some twenty grandchildren and twenty great-grandchildren. Gibbs made his living as a sharecropper, and remained in the Houston area throughout his life. He was a religious man, and served as a deacon at the Missionary Baptist Church where he was a member for more than fifty years.[2]

Gibbs's art career began after the death of his wife in 1972. Lonely and depressed, he began attending a senior citizen center. His daughter explained,

He wasn't a dominoes player; he wasn't a cards player. . . . He thought all that was sinful, because he was a deacon in the church. And he would be sitting there [at the center] talking bad about the people playing dominoes. So they said, well we just need to get him busy doing something.[3]

In 1976 Gibbs enrolled in a class sponsored by the Older Adult Art Program at the Houston Museum of Fine Arts' Glassell School. From the beginning he worked prolifically and earnestly, using whatever materials were available to him. With watercolors, pencils, wax crayons, and oil pastels, Gibbs transformed scraps of paper, the backs of old letters, and grocery bags into works of art. His work was first shown in *A Survey of Naive Texas Artists*, organized by The Witte Museum, San Antonio in 1978. In 1980 he was included in *The Eyes of Texas: An Exhibition of Living Texas Folk Artists*, held at the University of Houston.

When he wasn't making art, Gibbs enjoyed gardening. His lifelong closeness to the

Untitled, n.d.

Untitled, c. 1990-1992

earth and his awareness of the subtle rhythms of nature are reflected in his art. His drawings speak to nature's bounty in a lyrical style that celebrates color, form, memory, and motion. Gibbs's many memories of farming, family members, friends at the senior citizen center, and his vegetable garden provided subject matter for his work. He explained his desire to make art as follows: "I want people to know how I lived my life. I always worked. I worked hard, and that meant something. Maybe if people can see that, they will know that their lives mean something too—because they can do something for themselves."[4]

Perspective and gravity were unimportant to Gibbs. Objects and figures in his works assume enigmatic relationships as they float in undefined spaces, unrestrained by laws of physics. In Gibbs's dreamlike visual recollections, it appears that the process of remembering was more important to the artist than the exact rendering of the memory. His unrestrained use of color added to this ethereal quality and to the joyous appearance of the work.

Gibbs began his drawings by carefully outlining each object or figure in pencil. After completing the main subject, he began to add color to the drawings with oil pastels. Rhythmically tapping the paper with the pastels, Gibbs made marks that represented vegetables, flowers, and trees. He continued in this manner until the work was completed. In Gibbs's garden every available space was cultivated, and he approached his art with the same vigor.

Some of Gibbs's drawings appear to be completely abstract, with no recognizable subject matter, but the obsessive, pointillistic designs which fill every space within his compositions are actually impressionistic renderings of vegetation. Other works are replete with objects and figures, and still others combine both figural and abstract qualities. He employed a hierarchical scale to emphasize important objects. Often these objects and figures sprout at various angles among the abstracted vegetal forms, adding to the ambiguous space. He often included his self-portrait, always representing himself wearing a hat.

Ezekiel Gibbs continued making art until the end of his life, and when he ran out of paper he began decorating the walls of his home. He explained, "I've painted just about everything I ever did or ever saw. I've painted it over and over. Sometimes, when I think I'm just about played out, I sit down and rest awhile. Then I just go to it again. You just have to keep on doing whatever you're doing."[5] At the time of his death in 1992 at the age of 103, Gibbs was believed to be the oldest living and working self-taught artist in America.

[1]Biographical information, Gaye Hall and David Hickman, *The Eyes of Texas: An Exhibition of Living Texas Folk Artists* (Houston: University of Houston, 1980); Ezekiel Gibbs, interview with the author, Houston, October 9, 1988.

[2]Gibbs, interview with the author.

[3]Mattie Young, quoted in Shaila Dewan, "Ezekiel's Trust," *Houston Press*, March 6–12, 1997, 12.

[4]Hall and Hickman, *The Eyes of Texas*, n.p.

[5]Ibid., n.p.

Untitled, n.d.

Primaveral (Spring), c. 1970

Consuelo "Chelo"
González Amézcua

1903–1975

Consuelo González Amézcua was born June 13, 1903 in Piedras Negras, in the state of Coahuila, Mexico across the Rio Grande from Eagle Pass, Texas. Her parents, Jesus González Galván and Julia Amézcua de González, were originally from Monclova, also in Coahuila; they were both teachers. Consuelo or "Chelo," as she was called, had four brothers and a sister.[1]

In 1913, when Chelo was ten years old, the family relocated to Del Rio in Val Verde County, Texas. The rugged countryside of Val Verde County is rich in history. Deep canyons created by millions of years of erosion provided shelter to native people some 9,000 to 12,000 years ago, and the canyon walls there contain some of the oldest rock paintings in the United States. In this environment, Chelo developed a love for history and an interest in other cultures. She remembered her childhood fondly.

My parents were poor, but they always tried to create happiness for us. They played the guitar and sang with joy. This family of mine took care of me as if I were something special to them. I did not play with other children; my family was enough. I used to sit under the trees by the San Felipe River where I went to swim and watch nature, especially birds. My father and mother told me stories, and my dear sister Zaré, who took special care of me, sang to me and was the inspiration of many of my musical compositions. I was always a dreamer, and I am still painting my dream visions.[2]

Although it was her dream to further her education at the Academy of San Carlos in Mexico City—where the artists José Clemente Orozco, Diego Rivera, and David Siqueiros had studied art and where Rivera later served as director—Chelo received only six years of formal education. After her father's death in 1932 Chelo and her sister, Zaré, continued to live with their mother, and Chelo went to work at the S. H. Kress store in Del Rio selling popcorn and candy. In the early 1940s Chelo's mother, Julia, died. Neither Chelo nor Zaré married, and the two sisters continued to live together in the family home in Del Rio for the rest of their lives.[3]

Chelo's niece, Marina García, remembers her aunt as "a happy, gay person, who enjoyed life and loved music, laughter, parties, and bright colors." Her many talents included singing and dancing, and she played guitar, piano, tambourine, and castañets. "She sang in a small, pure voice and accompanied herself on the tambourine which she played with such skill that I had the sensation of hearing almost a full orchestral accompaniment. Her whole

America's Relic, n.d.

attitude was captivating," wrote Amy Freeman Lee of her musical ability. She also wrote poetry and songs in both Spanish and English, and throughout her life she included poems and sketches in letters to her loved ones. Her friendly and outgoing nature made her well known and loved in her community.[4]

Around the year 1956, without any formal art training, Chelo began carving stones which she collected from a ranch on the banks of the Pecos River. She referred to the stones used in her carvings as *"Piedra Concha* (shell stone) Jewels of our Texas." She often gave the carved pieces as gifts to friends and family members.

The carvings are delicately incised, as drawings in stone. She sought to convey the sense of history she found within the stones, choosing to leave the rocks in the shapes in which she found them. Carving the surfaces, she created works that appear to be broken fragments left from a past civilization. Their resemblance to ancient petroglyphs, created by geometric motifs and faces reminiscent of ancient gods, is reinforced by the titles she incised into the stones: *Maya, Art Relics,* and *America's Relic.*

González wrote a poem about her carvings in which she expressed her love of the rocks and the beauty she found within them.

> *Texas Rock, my* Piedra Concha
> *you are not rude, you are semisoft.*
> *I'll caress you with my chisel*
> *to transform you into a jewel box.*
> *And a fine lace I am carving—*
> *[It] is your dress I am designing*
> *And wherever you'll be placed*
> *I promise you will be shining.*[5]

González continued carving stones for eight years from 1956 until 1964 when, suffering from breathing problems caused by inhaling the dust created when she carved, she was forced to stop. Her creative energies undaunted by having to give up carving, she began to focus instead on drawing. She called her drawings "Texas filigree art."

Initially executed in black ballpoint pen on white cardboard, she sometimes added the colors red, green, and blue to her compositions, creating highly detailed and elegant drawings from her imagination. She referred to her work as *"mental recordatorio*—mental drawing."[6] Her work reflected her Mexican American heritage and her love of history and mythology. Repeated patterns unfold in the work, and from within them emerge recognizable subjects—birds, flowers, architectural forms, human hands, and women dressed in lace mantillas and flowing skirts. Within the drawings mystical worlds are hidden and then revealed.

Her drawing technique was described by Jacinto Quirarte with whom she corresponded during the last seven years of her life:

Maya, n.d.

Chelo did not make any sketches or carry out research prior to working on a drawing. She did, however, devote much thought and concentration to her work. She worked from an idea which she thought out thoroughly before putting anything down on cardboard. . . . She worked in a very meticulous and painstaking manner. She worked an average of 18 days on each drawing: three to five hours a day, usually in the late afternoon and evening.[7]

The nature of artistic inspiration is the subject of *Creative Hands*. The artist's hands reach out to receive the gift of creativity, represented as a radiant energy emanating from the heavens. At the center of the drawing a hand holds a scroll upon which is drawn a chalice surrounded by grapes and wheat, representing the wine and host of the Eucharist. Elsewhere in the drawing are stars and other celestial entities representing the heavens, and butterflies, birds, fish, and flowers, symbols of beauty and creation.

In *Deba—the Girl from Fulbe*, González portrays a girl from "a city near the River Niger and at the right side of the Nile . . . [whose] faith was so great that she raised a garden on dry land." Deba, dressed in middle eastern costume, is accompanied by mideastern motifs, architectural arches, and Christian crosses. Through prayer she accomplishes the impossible, growing a garden in the desert.

In *Abundance*, González personified the concept of abundance as a beautiful female figure. Like Justice, she is blindfolded so she will "never see whom she favors." In each hand she holds a cornucopia from which gold and silver coins pour, filling the picture.

In 1968 González' drawings were brought to public attention in an exhibition at the McNay Art Museum in San Antonio. The artist's niece, Livia Fernández and her husband ran Galerias Paco, an art gallery in New York, and there her work was shown for the first time outside of Texas.

As the years passed, González began to suffer increasingly from heart problems. A nephew who was a doctor in Mexico City would visit her, urging her to follow her own doctor's instructions. She would politely agree to do so, but she did not like going to doctors and often failed to follow medical advice. Consuelo González Amézcua continued making art throughout her life, completing her last drawing only three days before her death June 23, 1975 at the age of seventy-two.[8]

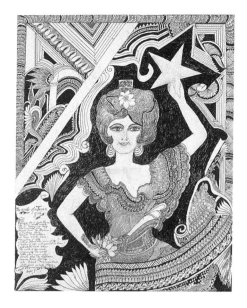

The Smile of a Texan Girl, n.d.

[1] Livia Fernández and Marina García [the artist's nieces], interview with the author, Austin, Texas, March 18, 1997.

[2] Amy Freeman Lee, *Filigree Drawings by Consuelo González Amézcua* (San Antonio: Marion Koogler McNay Art Institute, 1968), n.p.

[3] Ibid., n.p.; Fernández and García, interview with the author.

[4] Ibid.

[5] Consuelo González Amézcua, in *Mystical Elements/Lyrical Imagery: Consuelo González Amézcua 1903–1975* (Del Rio: Del Rio Council for the Arts, 1993), n.p. Jacinto Quirarte notes that she wrote "rude" for "*rudo,*" Spanish for "rough" or "harsh."

[6] Freeman Lee, *Filigree Drawings,* n.p.

[7] Jacinto Quirarte, in *Mystical Elements/Lyrical Imagery,* n.p.

[8] Livia Fernández and Marina García; and Cecilia Steinfeldt, *Texas Folk Art: One Hundred Fifty Years of the Southwest Tradition* (Austin: Texas Monthly Press, 1981), 141.

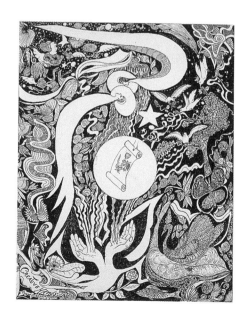

Creative Hands, c. 1970

South Fork Ranch, 1996

to My friend
Judith
from
maRk
GReeNe

Mark Cole Greene

b. 1955

Mark Cole Greene was born December 19, 1955 in Abilene, Texas, the second of Texas writer A. C. Greene and Betty Greene's four children. Due to a minor birth injury, Mark was developmentally delayed. Childhood tests predicted that Mark "would never be able to read, be coordinated enough to ride a bicycle, nor be able to distinguish colors." Far surpassing these expectations, Mark has "worn out three bicycles" and is an avid reader. His art stands as testament of his ability to distinguish colors.[1]

When Mark was five years old the Greenes moved to Dallas, and Mark began attending the first special education classes offered in that city. After graduating from Thomas Jefferson High School, Mark worked for a grocery store chain for several years but was forced to leave when the store came under new management. He then relocated to a Texas Department of Mental Health Mental Retardation facility in Keane, near Cleburne, where he resided for six years. In March 1995 he moved to a private group home in Corsicana, but returned to Cleburne the following year.

As is the case with many self-taught artists, Mark Greene began making art after experiencing a series of great personal losses in his life. Within a brief time span, he experienced the death of his paternal grandparents in an automobile accident, the death of his maternal grandmother, his own mother's death, and the tragic double murder of a close high school friend and her mother. Within a year of these deaths Greene began making art, probably as a way to express his deepest inner feelings, to deal with the great sense of loss he felt, and to document his unique views of the world. His father believes that making art was his "attempt to repossess or reproduce a world that was so shockingly denied him." He stated that, "Mark's emergence as an artist was very unexpected and very sudden, [and it was] as much a surprise to Mark as it was to me."[2]

Greene's first drawing was a depiction of the Dallas skyline, followed by a portrait of his father which Mark presented to him as a Father's Day gift. Next he went on to nature pictures based on places he has visited in Texas. His art is based on his own experiences and imagination, as well as events he has read or heard about.[3] He often works in series. For example, he has made a series of drawings based on the sinking of the Titanic; another inspired after seeing *Phantom of the Opera* on a visit to New York; and a group of drawings created after reading the book *The Hunt for Red October*.

Lighthouses, 1996

Although in some cases his works appear abstract, Greene can identify each form as a specific object. Whether depicting the famous Southfork Ranch from the defunct television series, *Dallas*; portraying the mysterious setting of a mine shaft; or celebrating the flow of light from a lighthouse, Greene reveals the forms, colors, and patterns that he finds within objects from daily life. The fact that he sometimes signs his drawings, "from the brain powered mind of Mark Cole Greene," reveals his awareness of his unique view of the world around him.

In the MHMR facility where he lives, Greene participates in routine activities, but is allowed two days each week to devote completely to his art. His other interests include listening to classical music, which he does while he is drawing; traveling to visit his brother and sister in New York City; and reading.[4]

For fifteen years Mark Greene's father and stepmother, Judy, collected his work. Eventually they were guided by friends to the Webb Gallery in Waxahachie where it was first exhibited. *Spirited Journeys* is the first museum exhibition in which Mark Cole Greene's work has been shown. Greene exemplifies the continuing evolution of self-taught art in Texas. Through the emergence of new artists whose art reflects the changes of popular culture and society, the field experiences constant renewal as we approach the twenty-first century.

[1]Webb Gallery, "Mark Cole Greene," December 26, 1994 (unpublished artist biography).
[2]A.C. Greene, telephone conversation with the author, November 6, 1995.
[3]Ibid.
[4]Ibid.

The Mine, 1996

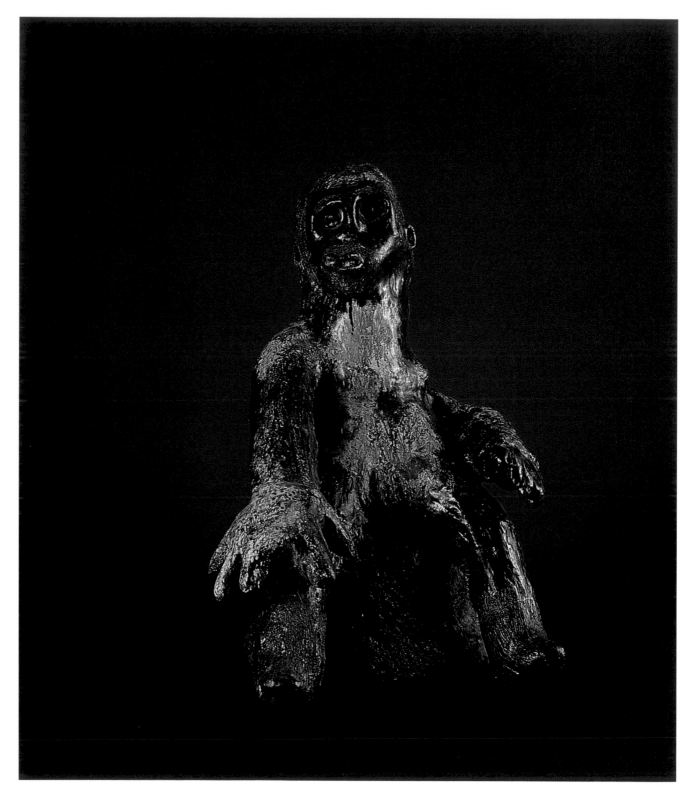

Untitled, n.d.

Michael

Gregory

1951-1995

Michael Dwayne Smith Gregory[1] was born September 24, 1951 in Woodville, in Tyler County, Texas, one of five children of Emerson Alton Smith and Margie Ruth Gregory Smith. He grew up in the small East Texas town of Woodville. Gregory was visually impaired, legally blind from birth. After graduating from Kirby High School in 1970, he moved to Lufkin. He relocated to Beaumont in 1981. He was married to Dorothy Gregory, and the couple had two sons.

Gregory became known around Beaumont as the "Can Man," a name he received from his practice of riding through the downtown area on a bicycle loaded down with cans. "Hustling cans," as he called it, provided his source of income for many years. One day while collecting cans, Michael Gregory met Greg Busceme, the director of The Art Studio in Beaumont. Gregory recounted the beginning of their friendship:

Greg would find him a quiet spot outside near the kiln and sleep with his feet propped up. I'd be in the dumpster looking for cans and wait for him. When I knew he was there I'd bump around in the dumpster and rise up out of there covered in garbage and clay dust and scare him. He'd run me off but I'd come back in a few days and do it again. When I finally changed my personal circumstances several years later I went to Greg and told him I was home, find me a studio space. My daddy was dying and he said, "Son, you're not happy. I want you to do three things. Leave Woodville, have a family and settle down." Well, I've done two of those things—now I'm settling down. I found home.[2]

At The Art Studio Michael Gregory began working with clay, creating powerful sculptures with profoundly spiritual presences. Emotionally expressive human forms modeled with rough features seem to rise out of the clay, as in Biblical accounts of man's creation. Examination of photographs of the artist suggest that the figures were based on self-portraits, displaying the hair, goatee, and general physical features of the artist. Some appear to reach out for consolation.

The Crucifixion was a repeated subject in Gregory's work. Clay coils form the figure of Christ, which merges into a single form with the cross. As with the other figures, eyes are portrayed by deep sockets into which balls of clay are inserted, especially significant considering the artist's own visual impairment. The pieces are glazed and raku-fired, areas of dripping glazes contrasting with charred, unglazed surfaces. He also sometimes applied shoe

polish and wax to the surfaces. The rawness of the pieces and their somber colors emphasize the haunting character of the figures.

Gregory found his place at The Art Studio, becoming a resident artist and developing an extended family among the other artists he encountered there. During the next four and a half years in this supportive environment Gregory excelled at his art. He explained,

I work strictly out of feeling. If I feel like an ass that day, I make an ass. Clay is a good motivator. It builds morale. I've always worked twice as hard. I have two strikes against me. One, I'm legally blind since birth, and two, I'm black." I grew up with a powerful inferiority complex—I was never good enough. But clay—I found something I can express myself with. With clay you have to make it so it will go through the fire. If you don't try you don't know what you can do. If you haven't gone through the fire, it's the same thing. You have to be able to take it to make it.[3]

Soon Gregory's art became noticed. He won Best of Show two consecutive years in an exhibition sponsored by the Orange County Mayor's Committee for Persons with Disabilities, held at Lamar University in Orange. He received a Minority Artists in Residence Grant from the Southeast Texas Arts Council through The Art Studio, to teach at the Beaumont State Center. He was featured in a segment of the television program, *Texas Country Reporter*, and in numerous newspaper articles.[4]

Michael Gregory had a quiet and pleasant manner, and he enjoyed talking with people, especially about the Lord and his art. He was an active member of the Pleasant Green Baptist Church in Beaumont. Deeply religious, he had often said, "I'll be ready when the Lord calls me."[5]

Michael Gregory's brief art career ended with his tragic and untimely death January 23, 1995 at the age of forty-three. Gregory, riding his bicycle, was waiting for a train at a Beaumont railroad crossing when suddenly he was pulled under the train. He died instantly. In the last four and a half years of his life, the visually impaired artist discovered his talent and explored his creativity through the medium of clay. At the time of his death he was working on a number of sculptures, which were left unfinished.[6]

[1] I am grateful to Stephanie Smither for bringing the work of Michael Gregory to my attention, and to Greg Busceme, The Art Studio, Inc., Beaumont, for sharing biographical information and photographs.

[2] The Art Studio, Inc., "Michael Gregory," artist biography, n.d.

[3] Ibid.

[4] "Michael Gregory," newspaper obituary, n.d.

[5] "Homegoing Services for Michael Dwayne Smith Gregory" (Woodville: Pleasant Hill Baptist Church, January 28, 1995), n.p.

[6] Greg Busceme, telephone conversation with the author, May 14, 1997.

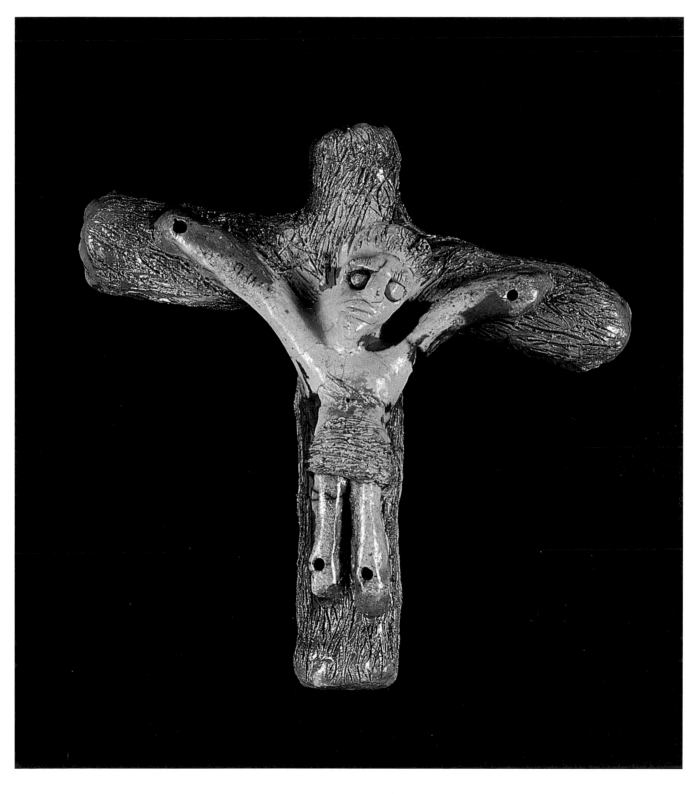

Crucifix, n.d.

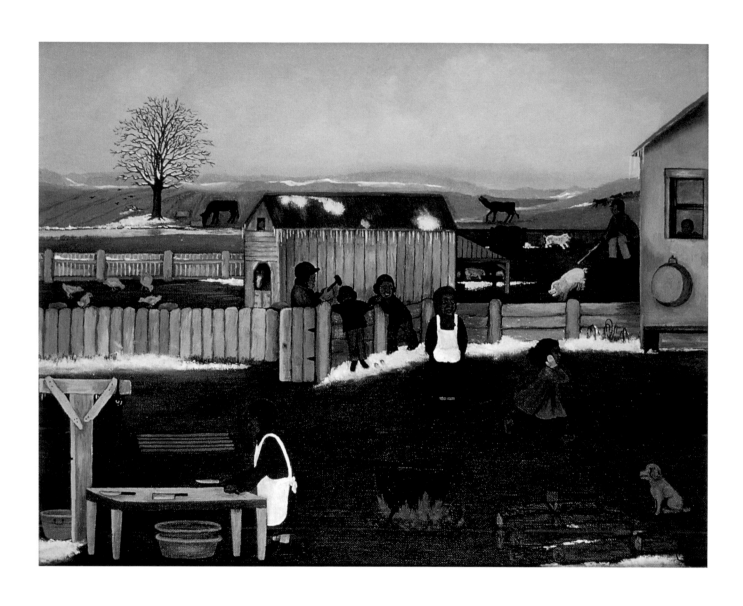

Winter Cry, 1979

Alma Pennell

Gunter

Alma Pennell[1] was born in 1909 in Palestine, Texas, the third of John Henry Pennell and Flora Gardner Pennell's six children. The Pennell family moved to the countryside near Palestine when Alma was nine years old. Mrs. Pennell encouraged resourcefulness, and intended that the family would supplement their income from her husband's work with the railroad by eating food they raised themselves.

Drawing and painting were not encouraged when Gunter was a child; as she remembered it, they were simply ignored. The idea of pursuing art as a profession was unacceptable within her community in Palestine. "I knew I wanted to be an artist which, in those days, was like saying 'I want to be a call girl.' My mother wouldn't hear of it, the art career."[2] After graduating from Palestine's Lincoln High School in 1927, she worked instead as a domestic, a self-employed seamstress, a hairdresser, and a café dishwasher. Finally, Alma Pennell traveled in 1936 to Prairie View College to study for a degree in nursing.

Soon after arriving at school she ordered a Sears and Roebuck art manual and a set of oil paints and brushes. Although academic and student nursing responsibilities filled most of her time, she began to teach herself to paint and won an art contest sponsored by a college society. This encouragement was meaningful to her, but other obligations caused her to give up painting between the years 1938 and 1960.

Her family moved back into the town of Palestine in 1939 or 1940, while Alma stayed at Prairie View and worked in the college infirmary after graduating with honors. She married in 1941 and moved with her husband to Riverside, California where he was stationed during World War II. He was re-stationed in San Francisco when the war ended and there she continued nursing. Although the Gunters had no children of their own, Alma helped her husband raise his daughter by a previous marriage. In 1960 Gunter's father died. She recalled,

I found that I could blunt the edge of pain and grief with a paint brush. Also, a deep inner feeling seemed to invest my paintings with something they never had before and I began to paint in earnest, really paint. I still didn't have much time for it and did very little but I was proud of what I did now.[3]

Asthma forced her retirement from nursing in 1961. After her husband died of cancer in 1964 she began to draw and paint unsystematically but frequently, covering paper, paper plates, and even a wall of her San Francisco house. When her sister died in 1970 Gunter returned to Texas to care for her mother and nephew. She was once again too busy to paint.

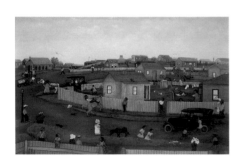

Mama's Day Out, 1979

Then, in 1974, her nephew left for college and her mother's illness worsened. Gunter responded with another surge of painting that did not end until her own death nine years later. Gunter entered the 1978 annual art show of the Palestine Negro Women's Business and Professional Club held during February, Black History Month. She entered the Palestine Art League's exhibit held the following month in conjunction with the annual Dogwood Trails tour. In that exhibit she received a prize in the folk art category and sold her first painting. The following year she won first prize in the folk art category in the League show, and also attracted the interest of Sally Griffiths, a collector in Dallas who became Gunter's friend and a promoter for her paintings. In 1980, Jack and Nancy Lockridge decided to turn a portion of their home in Palestine into an art gallery and asked Gunter if she would like them to represent her work. She accepted since she already considered them as friends and felt strongly that she wanted her art distributed from Texas, although she had other offers.

I am like that story, you know, they tell about the gal who went to the party and she says, "I'm gonna dance with the guy who brung me here." That's the way I feel. . . . I feel sentimental about the whole thing. About Palestine, about Texas, about the people, about my family, about my growing up here, . . . the people that I grew up with, all of it, all of them.[4]

Alma Gunter was impeded much of her life from her desire to communicate visually, but once she found the opportunity to paint, she sought to ensure that her message would not be misunderstood.

I just wanted to put down on something what I was looking at. . . . I don't know why I wanted to be [an artist], I just wanted to be, just like there was something inside of me. [Today] I want to put down something that I have seen, but, at the same time, I want to give it the meaning of the things that I have learned by seeing these things.[5]

Before beginning a painting, Gunter drew with a pencil in her sketch pad each composition she intended to paint. She bought pre-stretched and primed canvases and used acrylics since oil paints required solvents that aggravated her asthma; Gunter said that she found an additional advantage to using acrylics in that their quick-drying property forced her to teach herself to mix colors. For small details she used pointed-end brushes called "spotters." She held the brushes like a pencil or pen and wore out their bristles quickly.

I paint the subject matter that I do, I think partly it's nostalgia for times gone past. Some of the things that I do . . . are things that are gone that people today never see and would not see, but they were in this time a common thing.[6]

My sentiments are more of the black community since I grew up a part of that community and there was not that exchange with whites that there is today. There are certain limitations of status that are applied, and implied, and everyone knows what they are, and everyone has respect for them whether they agree with them or not. You knew you were a part of your community and yet you had exchange with the other, but you felt more a part of your own, black community.

[T]he work that I do is categorized as folk art and I can't put a label on it that says that it's "black art," although the people within my paintings are black. . . . Since they are based on experiences that I had as I was growing up they would just about have to be black. . . .[7]

Each of Gunter's paintings tells through a multiple-point perspective the story of a

remembered or envisioned event. Her art consists of images of Palestine's early 20th-century African American community as well as the artist's critical and sometimes whimsical commentaries about contemporary society.

Her painting *Winter Cry* (1979) is based on a memory from her childhood.

We had meat and lard from hogs, the subject of Winter Cry. . . . *Hogs were killed during the first "hard" freeze of winter—the cold weather seemed to get the meat preservation off to a good start. They were felled with a sledge-hammer (note man at gate) blow. (I ran into the house to keep from hearing this.) Next they were placed on the slatted boards where with scalding water and sharp knives the hair was scraped off. Then, they were hoisted to remove the viscera and put on the table for dissection. (Later the meat would be "salted down" in wooden boxes. After the "salt cure" some would be hung to smoke.) The scraps of fat were placed in the now empty wash pot, and "rendered" into cracklins and lard. (Now I came back outside.)*[8]

Gunter's "statement" paintings depicted hypothetical situations or memories that she altered to better reflect the artist's sense of community and Methodist Christian values.

I don't hear a voice, exactly. And yet . . . yes, I guess I do. Because it's like a voice that says, "No, don't do that, put it here." It's almost like the words are in my mind or my consciousness somewhere. And the voice might tell me to change something after I've started painting.[9]

It doesn't worry me too much that . . . [I've been told] my paintings that have more figures sell faster. I know that for my own satisfaction I must, at times, do what they call "statement" pieces, because they push into your mind and they have to have expression, and I have to do that.[10]

Gunter chose to live her last years alone, enjoying the solitude in which she could make her art. Alma Pennell Gunter died in Palestine May 13, 1983 at the age of seventy-three. The subject of her final and unfinished piece was a little boy eventually becoming an old man. *Full Circle*, as a "statement" piece, had its accompanying narrative written first. It was about the cycle of life in which the old often end their lives as helplessly as they'd begun. During the last twenty years of her life, Gunter expressed her observations and feelings through images that resonate with humor, conviction, and thought. Through her art Alma Gunter revealed her memories and visions, and portrayed people in some of their most complex contexts.

—Jane Henrici

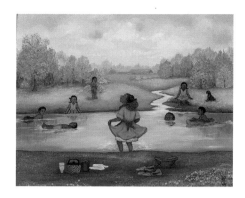

Saturday Afternoon, n.d.

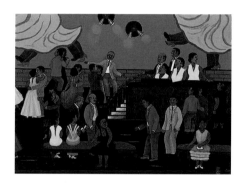

Pretty Mama, 1981

[1]Unless otherwise mentioned, all information about Gunter's biography and artwork comes from interviews with the artist conducted in her home and studio October-November 1982.

[2]Alma Gunter, autobiographical statement recorded by Reagan Street Gallery owner Nancy Lockridge, 1980.

[3]Alma Gunter, unpublished journal, 4.

[4]Alma Gunter, interview, October 15, 1982.

[5]Alma Gunter, interview with the author, November 13, 1982.

[6]Ibid.

[7]Alma Gunter, interview with the author, October 15, 1982.

[8]Alma Gunter, interview with the author, November 13, 1982; artist's written narrative accompanying painting.

[9]Alma Gunter, interview, November 13, 1982.

[10]Alma Gunter, interview, November 14, 1982.

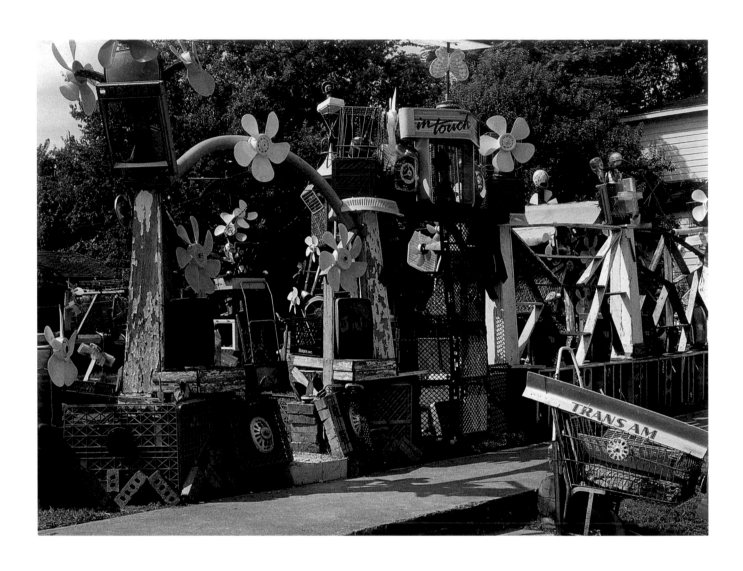

Robert
Harper

1935–1995

Robert (Bob) Harper was born in Houston in 1935, the fourth in a family of five sons. His father, Willie Harper, was a construction worker; his mother died when he was four years old. Harper grew up in the Houston area, living in Houston's Third and Fifth Wards and in Pasadena, Texas. Willie Harper remarried, and Robert and his brothers were raised by their stepmother. Harper's formal education ended in the fifth grade and he took his place with his father and brothers doing construction work, where he developed a reputation as a hard worker. Two older brothers were killed in separate construction accidents.[1]

When Harper was seventeen, he was hired by the Bob Hammond Show, a traveling carnival company. For the next fifteen years he traveled with the carnival, setting up, operating, and tearing down rides. During the winter months he returned to Houston and worked in construction. After leaving the carnival business he worked as a self-employed tamale salesman, making and selling as many as "three or four hundred dozen hot tamales" from his car "on a good weekend" before city health officials ordered him to close his operation. He then went to work for a small grocery store.[2]

Around the year 1980 Robert Harper settled into a rented house on a corner lot in Houston's Third Ward. He decorated the inside of the house by covering the walls with vinyl records. The ceilings were covered with straw planters placed closely together. Next he built a shrine-like structure which housed his television and a radio.

After completing the interior Harper began to construct an outdoor environment beginning with a sitting area for himself and his friends. Soon he added a tower with additional seating from where he could enjoy cool breezes and view the neighborhood without being noticed. Inside the tower he placed carpeting, chairs, a radio, and television, and on top of the tower he placed a female mannequin in seated position. After completing the tower he began to build an improvised fence around the yard with cast off objects that included brightly colored plastic bread trays, old oven doors, plastic bottles, grocery carts, and broken television sets. Old window fans and fan blades, spinning references to the continual motion of the spirit world, were the source of Harper's nickname, the "Fan Man."

Television sets inserted in the fence reflected the surrounding street and the shotgun

houses across the street. TV screens also lined a walkway within the yard. Discarded television sets appear repeatedly in African American yard decoration, where they represent not only the planned obsolescence of our consumer culture, but are also one of several popular references to communication with the spiritual realm. In an article about African American yard decoration, Grey Gundaker explained,

". . . TV sets create linkages between the word 'television,' the vacant screen/eye of the picture tube, and other forms of vision, including visionary experience. Because televisions are receivers that create a visible image from unseen signals, they are apt material metaphors for communication with spiritual powers."[3]

Prominently placed in the fence was a sign that gave the work its title, "The Third World." Harper explained, "It's just a different world. That's all I can say."[4] Behind the fence he built large-scale abstract constructions that included sofas and chairs from which he could enjoy an elevated view of the entire scene.

During the following years Harper's environment was in continual development, with Harper adding objects and rearranging the composition. He claimed that the installation was accidental. "I just wanted to build something, I'll put it like that," he said. On another occasion he explained, "I build for the Lord. Everybody can look at what I build and know that there is a God up above, because I get my ideas from the blue sky."[5]

One Sunday evening in January 1992, while Harper was at church, a gas heater in his home exploded, igniting a tragic fire that leveled his home and destroyed much of his art. Harper's stepmother, asleep inside the house at the time, was severely burned in the fire, and she died from her injuries two days later.

After the fire Harper moved to a house in the Fifth Ward owned by his brother Quincy, and he began to design and construct a new environment. But shortly thereafter he was diagnosed with cancer, and his health rapidly declined. Robert Harper died in December 1995. His environment was documented and pieces from it were moved into safe storage through the efforts of the Orange Show Foundation.

[1]David Theis, "Welcome to the Third World," *Houston Press*, June 2–8, 1994, 6–13.

[2]Ibid.

[3]Grey Gundaker, "What Goes Around Comes Around: Temporal Cycles and Recycling in African-American Yard Work," *Recycled Re-Seen: Folk Art from the Global Scrap Heap*, Charlene Cerny and Suzanne Seriff, eds. (New York: Harry N. Abrams, Inc., 1996), 78.

[4]Susan Chadwick, "Houston's Fan Man Humbly Rejects the Notion His Decorated Home Is Art," *The Houston Post*, May 18, 1990, E-6.

[5]Ibid.; David Theis, "Welcome to the Third World," n.p.

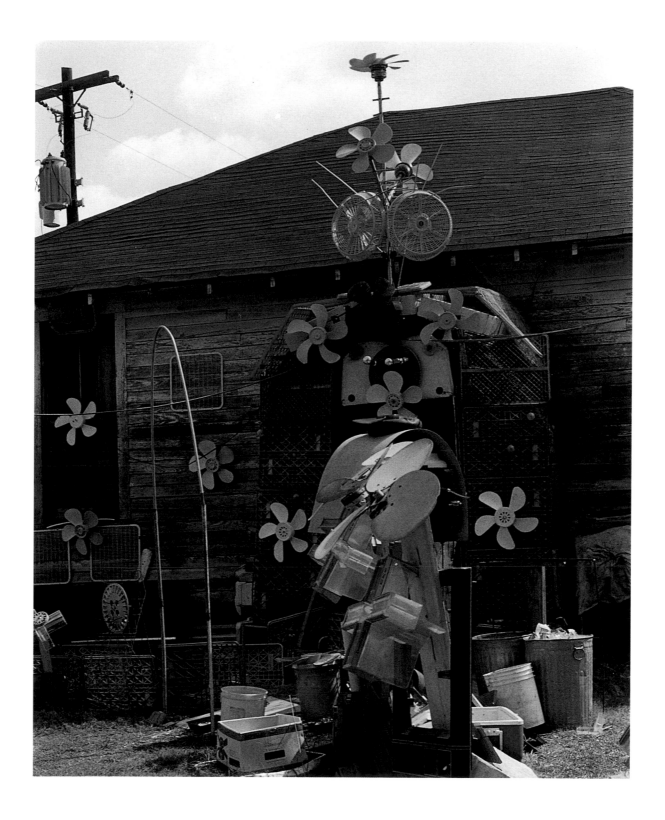

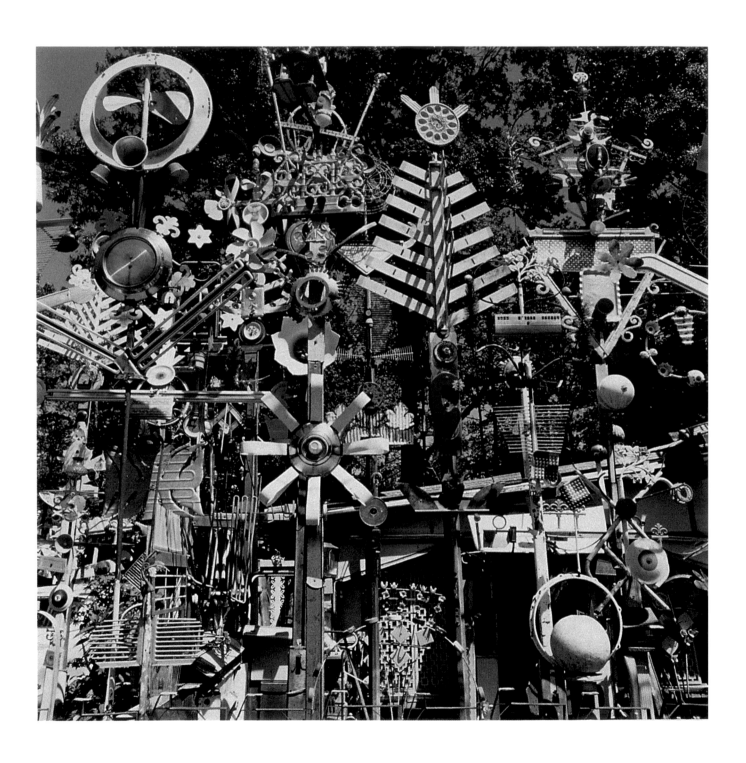

Felix "Fox" Harris

1905–1985

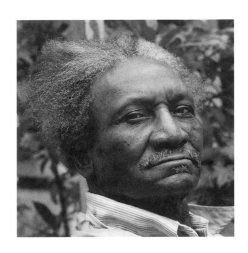

Felix Harris was born December 24, 1905 in Trinity, Texas, one of seven children. He received little, if any, formal education and was illiterate. Harris received the nickname "Fox" as a child when

. . . [O]ne day [he] strayed from home, wandering until suddenly he was confronted by a white man riding a "blaze face" horse. . . . He turned and ran, pursued by the man on horseback. Outrunning the horse, he managed to reach home, where he hid and listened. . . [as the man] instructed [his] father to keep his boy at home, saying the boy must be "quick as a fox" to outrun his horse.[1]

In adulthood "Fox" Harris worked at a variety of jobs including a stint as a logging foreman in Diboll, Texas and another as a foreman supervising the laying of railroad track. He also did construction work. In his free time Harris enjoyed drinking and playing barrelhouse-style piano. He had been married, but was widowed. In the late 1930s or early 1940s he settled on a "narrow dead-end street" on the north side of Beaumont, building a small house for himself with found materials.[2]

Some time after the year 1960 Harris had a vision which changed the course of his life. In his vision the Lord told him to quit drinking, and took the taste for alcohol from his mouth.

God appeared to him. . . holding in one hand a sheet of brown paper and in the other hand a sheet of white paper. God spoke to him of the sorrows and struggles of his life, which were symbolized by the brown paper. God laid that paper aside, telling Fox that his own life would be laid aside also. Then He told Fox that he would receive the gift of new life, and held out the white paper as a sign. As Fox himself put it, "God took nothin' and made somethin'."[3]

Inspired by his vision, Harris began to collect discarded objects—"car parts, bits of broken appliances, bent table forks, scraps of tin." He worked in a shaded area on the side of his garage, behind which he kept his "stockpile" of found materials. Working in all but the most inclement weather, Harris took nothing and made something. Using the humblest of materials, he created objects of extraordinary beauty.

The sculptures are best described as totems, ranging from ten to fifteen feet in height. The vertical beams are made of steel conduit, angle iron, or old water pipes. Onto the beams Harris attached various found objects including cast off barbecue grills, broken pottery, and hubcaps. Many are decorated with cut-out metal designs, and some have kinetic parts.

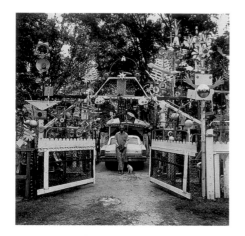

Harris' tools were also recycled and improvised. His method of creating the sculptures is described as follows:

For his metal cut-outs he preferred to use an ordinary butter knife whose blunt tip he kept sharpened. The top of the knife handle had been flattened by countless taps with a small ballpeen hammer. For the cut-outs he made a stencil with pencil and paper or cardboard, traced it onto the metal, then painstakingly cut out the design by placing the sharpened knife tip along the line drawn and gently tapping with the hammer. "You gots to hit this just right," he would say.[4]

During the next two decades Harris continued to make sculptures and to arrange them outdoors in the yard of his Beaumont home. Harris' environment gave him a reputation among local teenagers as the "voodoo man." One of these teenagers took his mother, writer Pat Carter, and her husband, photographer Keith Carter, to view the yard, and they discovered "a fantastic forest alive with color and movement and infused with vision and spirit. . . . a work of great power and authenticity." The Carters befriended Harris and documented his environment. Pat Carter described Harris as standing "well over six feet, with big, gnarled hands and strong facial features. His gray hair swept back from his face."[5]

Although Harris' work resulted from a divine revelation, he did not discuss its spiritual qualities. Carter believed his environment represented "a very personal communication between him and God."[6] In his recent book, *Gardens of Revelation*, John Beardsley described the significance of Harris' work.

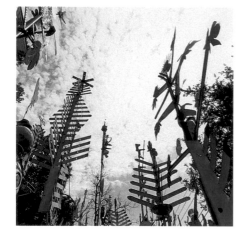

Harris' environment displayed a number of the principles of the classic African American yard show, including motion, in the form of hubcaps, wheels, and moving parts; figuration, both in cut metal and in found objects like jack-o-lanterns; and communication, in the recurrence of bristling antennae and grills. . . . He called one assemblage with cutout hands and arms his "Mojo Hands."' The term refers to the medium through which spiritual changes—hexes or healing—are worked in the practice of voodoo, a religious sect derived from Africa and still pervasive in the Mississippi delta.[7]

Harris enjoyed viewing his environment from a platform he built high in a tree, which he accessed by climbing rungs he nailed to the tree trunk until his advanced years prevented him from doing so. He also liked to walk among the objects on wooden stilts he built for this purpose. He called the stilts his "tom walkers." The stilts allowed him to work on his sculptures after installing them and to view them from above. It has also been suggested that Harris' practice of walking on stilts was related to "a Caribbean stilt-dancing carnival character with African origins known as 'Moco Jumbie'"—a magic healer who "protects people from evil." Pat Carter described Harris' stilt-walking as follows: "To see him nine feet tall, striding on those tom walkers through his incredible forest, was a heart stopping, unforgettable sight."[8]

Felix "Fox" Harris died of cardiac arrest in May 1985 at the age of seventy-nine. His great-nephew, Elray Wolfe, donated 120 objects created by Harris to the Art Museum of Southeast Texas in Beaumont. In 1987 the museum moved into its new facility, and sixty-seven of the Harris sculptures were to be installed on the grounds. Based on photographs

documenting the environment before it was dismantled, the works were arranged as closely as possible according to Harris' original design.

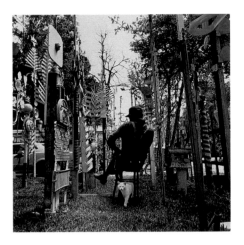

When the work became the responsibility of art museum professionals, conservation concerns became evident. The heavy, wet clay of the Beaumont area necessitated that each piece be fitted with a protective, corrosion-resistant PVC sleeve. The completed installation was stunning, but soon it became clear that the new location was detrimental to the fragile work. In Harris' yard the works had received more shelter from wind than the open space of the museum grounds afforded them. The curatorial staff found that "even minor gusts of wind [resulted in] a certain degree of damage to the sculptures." A second site was selected in the more sheltered location of a courtyard, but before the objects could be moved, the sculptures faced the threat of a category-five hurricane. Eight people worked up to ten hours a day for three days to move the sculptures from the storm's path, a task made more difficult by the care that had been taken to install them.[9]

After this crisis, a conservator worked with museum staff to develop a plan to preserve the pieces, reinforce them where necessary, and restore them through cleaning and painting. New underground mounts were devised that would enable quicker deinstallation when necessary from the new, sheltered courtyard where the objects would be displayed. The new system was tested by a second hurricane in 1989, and it proved successful.[10] Deterioration of the sculptures continued, however, and in 1995 the pieces were moved to inside storage where they remain today.

[1]Pat Carter, "'Fox' Harris: A Forest of the Spirit," *Spot* [Houston Center for Photography], Spring 1991, 12.

[2]Ibid.; "Fox" Harris, tape recorded interview, n.d., Art Museum of Southeast Texas Archives.

[3]Ibid.

[4]Carter, "Fox Harris," 12.

[5]Ibid., 12–13.

[6]John Beardsley, *Gardens of Revelation: Environments by Visionary Artists* (New York: Abbeville Press, 1995), 183.

[7]Ibid., 182, 183.

[8]Ibid., 183; Carter, "Fox Harris," 13.

[9]Lynn Castle, "A Conservation Crisis: The Work of Felix 'Fox' Harris, A Case Study," *Folk Art* (Spring 1994): 50–53.

[10]Ibid., 53.

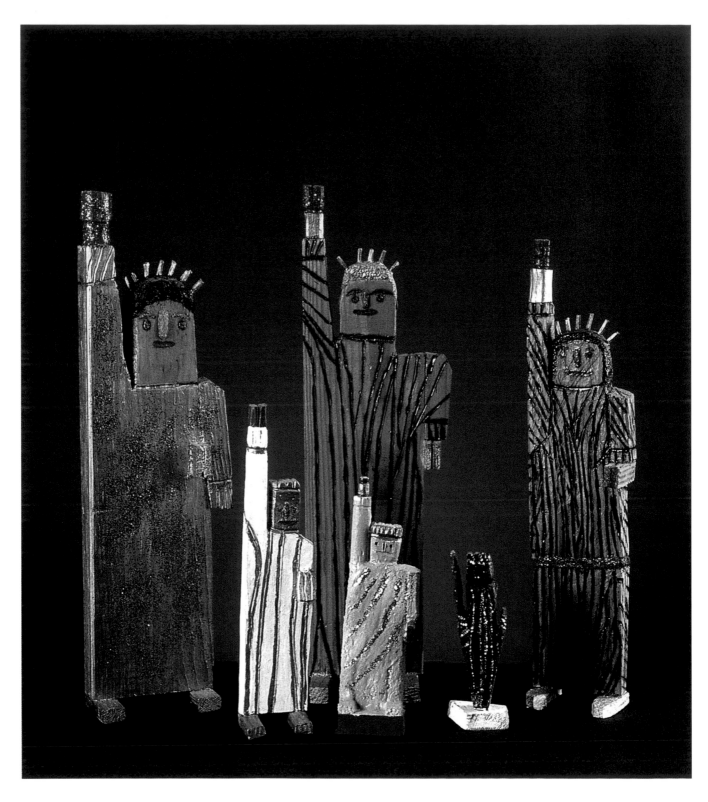

Six *Statues of Liberty*, 1985–1990

Rev. J. L. Hunter

b. 1905

John L. Hunter was born March 17, 1905 in Taylor, in Williamson County, Texas. His father died when he was a baby, and he was raised in the home of his maternal grandparents. His grandfather, a carpenter, built many of the black churches in the area surrounding Taylor. John and his mother moved to Dallas in 1918, where he attended a Catholic school. In 1928 John married Ruby Winter, and the couple had one son.[1]

Hunter worked at a number of jobs, and for fourteen years he worked for a Dallas drugstore. In the 1930s, one day while working at the drugstore Hunter read a magazine horoscope that said, "You are artistic. Put it to work!" He responded by building a wooden battleship, and he continued to pursue wood carving as an occasional hobby.[2]

In 1936 John Hunter received his religious calling and attended the Southern Bible College in Austin, and he also took some courses at Bishop College in Dallas. The Hunters moved to Texarkana, Texas, where Rev. Hunter was a pastor for thirteen years; and to Sherman, Texas where he was a pastor for eight years. The Hunters returned to Dallas in 1962, and Rev. Hunter became the senior minister at the True Light Baptist Church in south Dallas.[3]

Beginning in the late 1960s or early 1970s, in his spare time Rev. Hunter began to carve figures from natural wood forms. Occasionally he would give them to members of his congregation, and the appreciation that the recipients expressed for the objects encouraged him to continue his new leisurely pursuit. In 1988, one of these parishioners, an employee of the *Dallas Times Herald*, told a staff writer at the newspaper about Hunter's work. An article appeared in the newspaper and subsequently Hunter and his art work became known outside his circle of family and friends. Now in his nineties, Rev. Hunter preaches at his church and actively carves in his spare time.

Rev. Hunter works outside or in his workshop attached to his garage. Working with found wood, he selects pieces that suggest to him what to carve. For human figures he begins with branches that form a "Y" shape to form the legs and torso. Using a saw, a knife, and sometimes a drill he uses a minimal approach, leaving much of the original piece intact. Most of the appendages for his figures are carved separately and attached with nails and his "secret sauce" of glue and woodshavings. After the figures are assembled they are painted with house paint or enamels. Eyes may be made from screws, and he sometimes adds hu-

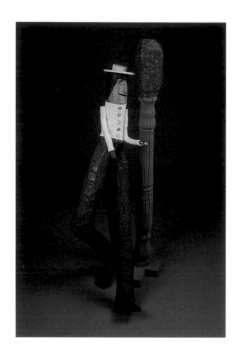

Drunk Man Leaning on Lamp Post,
c. 1992

man hair—his own or that of his wife, Ruby. Other found objects may be added for decoration. The work is signed by burning the wood with an ice pick heated on the gas stove in his kitchen. Each work takes a day or two to complete.[4]

His work consists of figures whose movements rely on the shapes of the natural forms that inspire them. They often convey a whimsical spirit, and a large number of staggering figures identified as drunk men are inspired by twisted wood forms. Occasionally the works incorporate religious themes, but more often they are couples, gunfighters, or walking men. Hunter has said of his art,

I just like making things and making them right. If I'm making something and I split the foot, I don't make a new foot, I mend that foot. . . . What I make, ain't nobody seen it before, and it's my imagination, so nobody else would see it like that either.[5]

[1]Sally M. Griffiths, "Reverend J. L. Hunter," unpublished, 1993, unpaginated.

[2]Ibid.

[3]Ibid.; Deborah Gilman Ritchey, "Rev. John L. Hunter," Gail Andrews Trechsel, ed., *Pictured in My Mind: Contemporary American Self-Taught Art from the Collection of Dr. Kurt Gitter and Alice Rae Yelen* (Birmingham, AL: Birmingham Museum of Art, 1995), 102.

[4]Deborah Gilman Ritchey, in *Pictured in My Mind*, 102.

[5]Mary Brown Malouf, "What is that, a muffler?" *Dallas Observer*, March 13-19, 1997, 30.

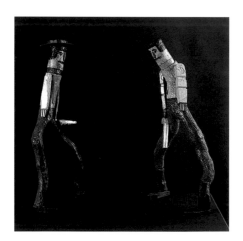

Gunfighters, n.d.

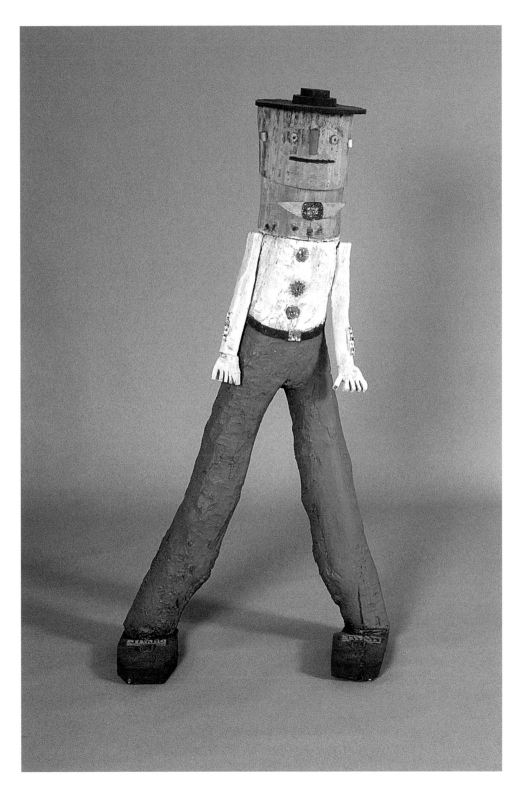

Jimbo Man, 1992

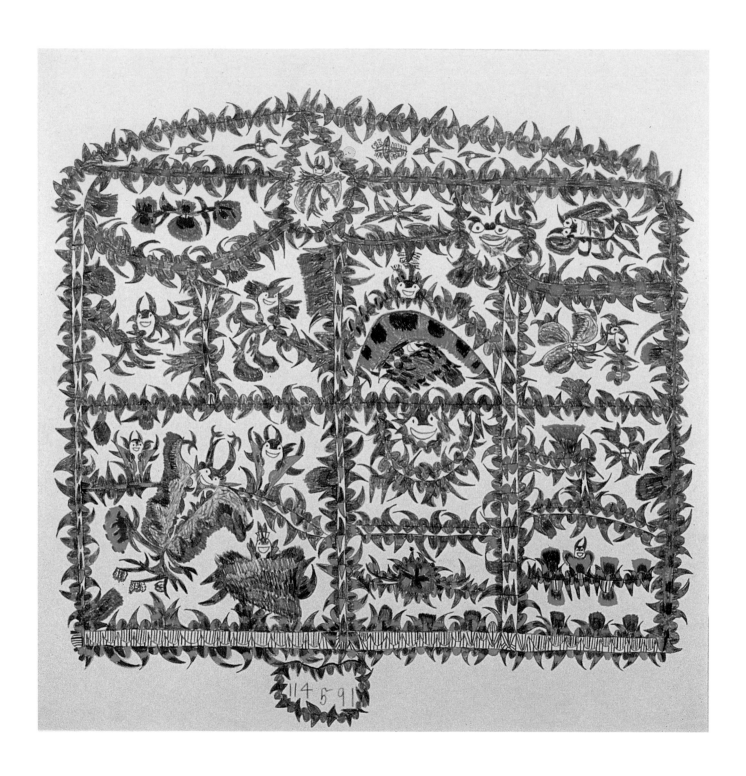

Moon Devils, 1965-66

Frank

Jones —————————————————

c. 1900–1969

F rank Albert Jones was born around the year 1900 in Clarksville, the county seat of Red River County, Texas. When Jones was a small child his mother told him that he was born with a "veil over his left eye," and that this veil would enable him to see spirits.[1] The spirit veil is a well documented and widespread African American folk belief. People born with the veil or caul (part of the fetal membrane) over their eyes were believed to have the power to see and to communicate with spirits. Such people were called "double-sighted." Beliefs regarding double-sighted individuals belong to the myriad African traditions permeating African America in which events of childbirth were connected to future powers.[2]

Jones was around nine years old at the time of his first spirit sighting. He described his double-sightedness as "looking through a hole" into the spirit world. Throughout his life he continued to see the supernatural creatures, which he called interchangeably "haints" (haunts), "devils," or "haint-devils." They appeared in various forms including male and female devils of many nationalities, animals, and inanimate objects. Jones believed the haints were everywhere but that they remained invisible to those not born with the veil.[3]

We have little information on Frank Jones's early years. Like many black Texans of his generation, he never attended school or learned to read or write. He worked as a farm laborer and as a yard man, and occasionally he traveled to nearby towns picking up odd jobs.

As the result of a series of unfortunate events that began in the year 1941, Jones spent some twenty years in and out of Texas prisons. Some time after 1960 while serving a life sentence on a murder conviction, Jones began salvaging paper and stubs of red and blue colored pencils discarded by prison bookkeepers, and he began to draw pictures of the haints he saw as the result of his veil. Jones called his drawings "devil houses." He once commented, "I draw them as I see them."[4] The drawings serve as important documents of African American aesthetic and cultural traditions, and they are a strong testament to the significance of the visionary experience as a source for black folk artists.

Jones and his unusual pictures became a source of amusement for guards and inmates alike around the prison. One prison employee remembered that Jones "used to sit out in front of the office and draw those devils and angels, and frankly, we all thought he was

Jap Devil House, 1964

a little strange." In July 1964 the Texas Department of Corrections organized its first annual inmate art exhibition, as "part of the prison's rehabilitation program designed to foster and build worthwhile interests and values among the inmates." A prison guard entered one of Jones's drawings in the show partially in jest as well as "just to make him feel good."[5] Much to everyone's surprise, the small drawing captured the interest of the judges, art faculty from Sam Houston State Teachers College in Huntsville. Jones's work was selected to win first prize.

Among the visitors to the inmate show was Murray Smither, a Huntsville native and employee of the Dallas art gallery, Atelier Chapman Kelley. Smither purchased one of Jones's drawings, *Flying Fish,* and took it back to Dallas. Gallery owner Chapman Kelley agreed that the gallery should represent Jones. Kelley began supplying Jones with art supplies and in November 1964, only three months after the inmate art show, his first solo exhibition was held at the Atelier Chapman Kelley. With the continued support of the gallery, soon his work began appearing in and receiving awards at juried exhibitions throughout the country. For the next five years Jones continued to make art, producing an estimated several hundred drawings.

Jones's devil houses contain an iconography reflecting the artist's special vision and personal experiences combined with broader, culturally based elements of his belief system. He began by drawing horizontal and vertical lines that form architectural structures viewed in cross-section. He divided the devil house structures into compartments, or rooms, bordered by sharp, claw shapes which make the houses impenetrable. Jones called these shapes "devils' horns." The devils' horns are double-edged, allowing neither entry nor escape. Within the rooms of the houses, grinning devil figures were at once both confined and sheltered.

The act of making art as symbolic protection from evil forces is an ancient African practice that persists today in African American visionary art. Jones neutralized the haints's powers and limited their activity by capturing them on paper and containing them within the devil house structures. Through his drawings, Frank Jones imposed order on a world over which he had little control. Yet even confined in the drawings, evil energy remains powerful and occasionally it threatens to emerge. The vibrating edges of Jones's devil houses leave a potential for escape, and in some drawings the barriers begin to collapse as fluttering haints break away from the houses, defying restraint.

Jones believed in haints and although in his drawings they appeared harmless, they posed a real and constant threat. He once commented, "I think about the devil quite a bit. I'm always trying to keep him away from me." Although Jones depicted the haint figures smiling, they were anything but benign. He explained that the haints smile "to get you to come closer . . . to drag you down and make you do bad things. They laugh when they do that." On another occasion, Jones said they smile because "they're happy, waiting for your soul."[6]

Jones's devil houses achieve a precarious sense of balance that is based on the tension of opposing elements. By alternating the direction of the devils' horns and the colors red and blue, Jones created the surface pattern and the internal rhythm of his drawings. At the beginning, the drawings were red and blue due to the artist's access to found materials; later

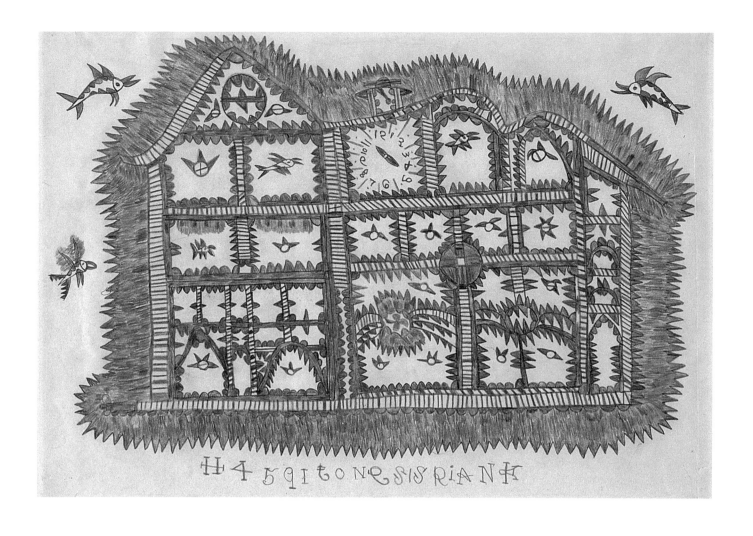

Flying Fish, 1964

Gambling Boat, 1965-66

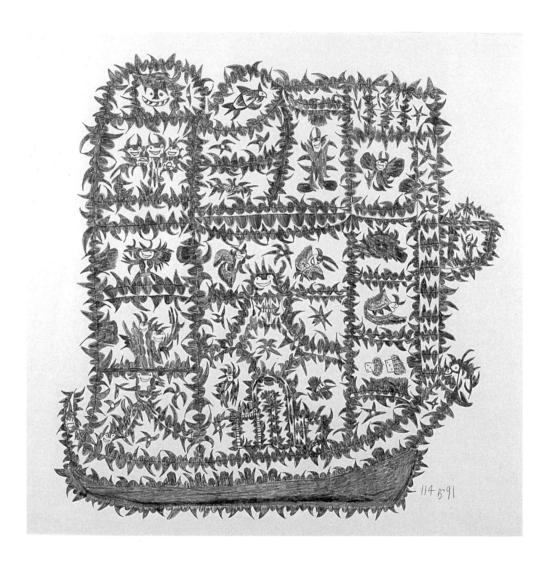

this color scheme became a conscious aesthetic decision. By late 1964 the Atelier Chapman Kelley was providing Jones with pencils and paper and he began to experiment, adding a variety of other colors to the drawings. But Jones "did not like" the other colors, and soon he returned to blue and red, which he said represented smoke and fire.[7]

The structures of the devil houses, with their multi-storied rows of compartments, were evidently inspired by the prison. Like the potentially dangerous individuals who inhabited Jones's physical world in the prison, the haints were confined in rows of small compartments to neutralize their behavior. Other iconographical elements in Jones's works are also traceable to his material environment. He included clocks in nearly half of his drawings. The clock, an icon of time and its passage, is also a symbol of imprisonment—prison slang for

incarceration is "doing time" or "serving time." The image also represents a specific clock in the prison yard which Jones believed was "hainted." In the early works containing clocks time seems to stand still, but in later works the hands of the clocks develop multiple appendages that seem to spin uncontrollably, an apparent reference to the artist's increasing awareness of his mortality as his health began to fail and his requests for parole were repeatedly denied.

Jones's earliest extant works date from the year 1964. These small-scale works were rigidly drawn, red and blue colored-pencil drawings on ordinary typing paper. They depict simple structures populated only by minimal figures. Jones often signed the work at the bottom with his prison inmate identification number, 114591.

As Jones's career rapidly developed, his style flourished along with his growing confidence, and by 1965–1966 his style was fully developed. The drawings became increasingly detailed until in the years 1966–1968, they reached a crescendo of pattern and decoration and became "catalogs" of haint types.

Untitled, c. 1968-69

During the five years of his art career, Jones captured his haints and imposed order on his world through his drawings. He also continued to dream of the day when he would be released from prison and could return to the free world. He never wavered from his claim of innocence of the crime for which he was sentenced to life in prison.

Efforts to secure Jones's release from prison were repeatedly unsuccessful. The continued denial of his requests for parole disappointed him greatly. Meanwhile his health was declining, the result of advanced liver disease. Finally, his health worsened and around the first of February, 1969, Jones was admitted to the prison hospital.

Frank Jones died February 15, 1969 in the prison hospital in Huntsville without realizing his desire for freedom. The money he earned from the sale of his drawings provided Jones with the Christian funeral he had requested. His body was returned to Clarksville for burial in the free world. During the final years of his life Frank Jones created a body of art that reflected his perception of the spiritual energies and powers of the universe, and of his own place among them.

Untitled, c.1966–68

[1] Frank Jones, interview with John Mahoney, Huntsville, November 1968.

[2] Newbell Niles Puckett, *Folk Beliefs of the Southern Negro* (Chapel Hill: University of North Carolina Press, 1926), 37, 336.

[3] Jones, interview with John Mahoney.

[4] Dee Steed, "The Devil in Contemporary Art" (unpublished paper), 1968, n.p.

[5] Billy Ware, Director of Classifications, Texas Department of Corrections, telephone conversation with the author, January 22, 1987; Richard C. Jones, Assistant Director for Treatment, Texas Department of Corrections, quoted in *Huntsville Pictorial*, July 29, 1964, 7; Steed, "The Devil," n.p.

[6] J. Cotter Hirschberg, *Frank Jones: The Art of a Troubled Man* (Topeka, Kansas: The Mulvane Art Center, 1974), 3; Steed, "The Devil," n.p.; and Jones, interview with John Mahoney.

[7] Steed, "The Devil," n.p.

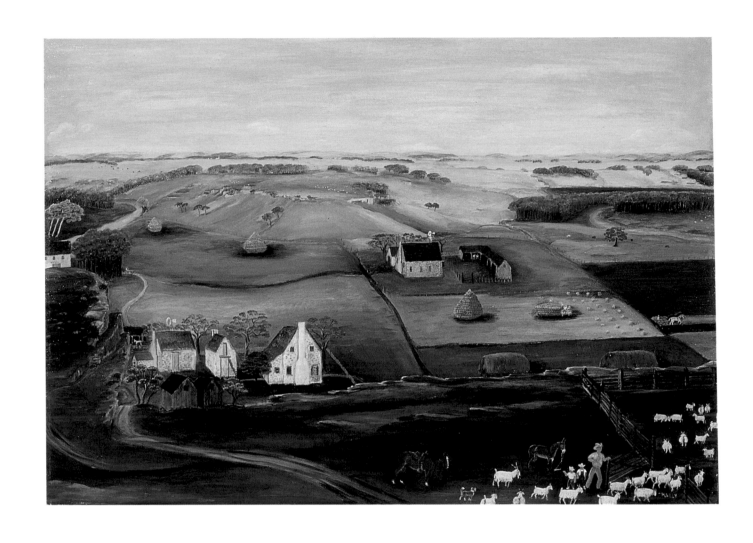

Goats in Corral, n.d.

H. O.
Kelly

Harold Osman (H. O.) Kelly[1] was born March 6, 1884 in his grandfather's home in Bucyrus, Ohio. His mother's family were German immigrants, and his grandfather Osman made his living manufacturing brick and tile and making wagons to transport people west. H. O.'s father, George Kelly, was a blacksmith for the Fremont, Elkhorn, and Missouri Valley Railroad, and as a result the family relocated often. As a young boy, H. O. was fascinated with horses and cows, and he liked to draw and paint pictures of them.

Kelly completed two years of high school before quitting at the age of sixteen to take a job as a farm hand. Although his formal education had ended, Kelly was an avid reader who continued learning throughout his life, especially enjoying history books. But his real love was for horses and travel, and he dreamed of traveling west to Nebraska, "where men still lived on horses." In his leisure time he made drawings of life in the West as he imagined it.

Kelly worked a succession of jobs for the railroad until his younger brother, Quill, became ill with tuberculosis, and H. O. was enlisted to take him to Arizona territory to recuperate. The two headed west, landing jobs in an Arizona mining camp and a large cattle ranch. From Phoenix the brothers drifted to Texas, Oklahoma, and Kansas. Eventually Quill returned East and Kelly went on to Nebraska alone and worked as a mule skinner on a wagon train. He ended up in Cheyenne, Wyoming where he worked on a ranch. The cowboy life was one of hard work and great adventure. He saved enough money to buy a half section of land near Kimball, Nebraska.

However, suffering the effects of "too much whiskey and an unwise diet," Kelly became ill and returned to New Jersey. He was lonely and unhappy there, and thought continually of the West. During his illness Kelly would often stay in his room with watercolors and paper, painting pictures of his memories of cowboy life to show to his family and friends. He framed the pictures, and presented them to family members for Christmas.

When he was feeling better and had saved enough money Kelly returned to the West, sold his land and most of his possessions, and continued on to the Ozarks. He put a down payment on an abandoned 200-acre farm, planted a crop, and did some horse trading. As usual, Kelly soon was ready to move on. He headed to Arkansas, renting land to grow cotton and sweet potatoes, and hauling timber. He worked as a cattle driver, which he stated was "one accomplishment that's always given me a lot of satisfaction." But the swampy climate

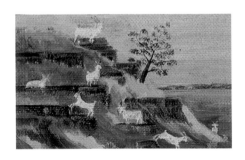

And the Goats Are the Price of the Field, n.d.

of the river bottoms caused him to suffer from malaria, so after four years away, he returned to New Jersey.

But again Kelly was unhappy in the East. In the winter of 1912 he returned to Arkansas where he met Jessie Bowers. The couple married, purchased fifty acres of land, and lived contentedly for awhile until Kelly again was stricken by the wanderlust. In 1921 the couple headed for Texas, where they made an unsuccessful attempt at farming. They went back to Arkansas where Jessie gave birth to a daughter, Martha. Two years later they returned to Texas to try again, settling in Dallam County, east of Texline, on a half section of land that had once been part of the famous XIT Ranch. For the next ten years Kelly and his family struggled to eke out a living amidst terrible drought, devastating dust storms, and the hopeless conditions of the Great Depression. His parents sent financial help when they could, and at Christmas Kelly would send them paintings.

Finally, after forty years of moving throughout thirty states[2] and a miserable decade of Dust Bowl farming, Kelly was forced to give up and the family headed east to Blanket, Texas, where they made their home in a converted chicken house. Martha married a local boy and began her own family. Kelly's health had deteriorated from years of breathing dust and he could no longer meet the physical demands of farming and ranching. Jessie suggested that he take up painting to try to earn some extra money.

Kelly bought some art supplies and began making watercolor pictures of Ohio farm scenes from his childhood, adding his own personal touches and always populating the pictures with horses. Then he moved on to his memories of the West, revisiting in his paintings the sense of adventure and freedom he had felt as a young man. The Bible also served as a source for imagery. Soon Kelly had an inventory of watercolor paintings. In 1946 he sent seven paintings to Doris Lee, a painter whose work he had seen in an old magazine given him by a friend. She wrote back, praising his work and encouraging him to try using oil paints. Included in the letter was a check for $100 from a friend of Lee's who wanted to buy the pictures. This pleased Kelly greatly, and he began working in oils immediately. He showed his paintings at a local paint and art supply store, and the work began to be collected locally. Soon he was featured in Brownwood and Fort Worth newspaper articles.[3]

A local writer brought Kelly's work to the attention of Jerry Bywaters, director of the Dallas Museum of Fine Arts, and Bywaters offered him a one-man exhibition at the museum. Thirty-seven paintings were included in the show, held in 1950. All but six of the most recent works were yet unsold, and they sold during the first hour of the exhibition. Attendance records were broken at the Dallas Museum. Soon Kelly received offers of gallery representation from New York and Boston.[4]

The success of Kelly's art career enabled him to make modest improvements in his living conditions. He and Jessie moved to a better house and he bought a horse which he rode on daily trips into town to check for mail and to socialize with friends at the gas station and drugstore. Visitors came to meet him and see his paintings. Sometimes they bought paintings, other times Kelly would give away his work. He made a number of trips to Fredericksburg, his ideal of the perfect town. He repeatedly included buildings from the town in his

paintings. He loved the Texas Hill Country, and said that "from Austin or Bryan on west to Kerrville is close to Paradise to me."[5]

The painting *Hog Killing Time* represents a favorite subject among self-taught Texas artists. In this painting Kelly captured the chill of a winter day and the familiar sky of Texas Blue Norther. He described the activities in the painting:

These folks are getting right along. Scalding, cutting up and trimming off fat. Cats and dogs are pilfering and feasting. Did you ever make pig bladder balloons? These boys are doing it. Coffee is coming for the ladies. The men will have a snort of "oh be joyful." They earn it.[6]

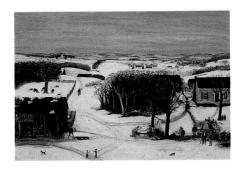

Hog Killing Time, c. 1950

The memories Kelly chose to depict in his paintings are selective, and unpleasant events are eliminated. Instead of reflecting his own difficult struggles with farming and ranching, Kelly portrayed idealized versions of agricultural perfection and his lifelong dream of achieving success doing what he loved. In *Goats in Corral* Kelly presented a bird's eye view of a sprawling, verdant landscape; dust storms and drought conditions are conspicuously absent from the work. Not only did Kelly enjoy painting, but on canvas he was able to create what he had been unable to attain in his own life.

Goats in Corral was commissioned by Stanley Marcus of Dallas. When Kelly delivered the painting, Marcus apparently expressed his displeasure that the goats were partially covered by the frame. To remedy the problem, Kelly returned home and painted a small picture of goats, which he presented to Marcus.[7] He inscribed the back of the painting, "and the goats are the price of the field," in reference to the Bible verse from the book of Proverbs:

When the grass is gone, and the new growth appears, and the herbage of the mountains is gathered, the lambs will provide your clothing, and the goats the price of the field; there will be enough goats' milk for your food, for the food of your household and maintenance for your maidens.[8]

H. O. Kelly's artistic career was brief, spanning only seven years from 1948 until his death in Blanket, Texas in 1955. In 1960 the Dallas Museum of Fine Arts held a retrospective exhibition of Kelly's work. In the exhibition catalog Jerry Bywaters wrote,

In some one hundred smallish paintings . . . there is preserved a unique record of an American rural way of life somewhat more kin to the folkish shenanigans of Currier and Ives subjects [than] to the boisterous frontier romanticism of Remington and Russell, but more full than either with universal qualities inherent in good painters everywhere.[9]

[1]William Weber Johnson, *Kelly Blue* (College Station: Texas A & M University Press, 1979), 17, 23, 133. This book served as the source of biographical information for this essay, and is the most complete resource available on Kelly's life.

[2]Cecilia Steinfeldt, *Texas Folk Art: One Hundred Fifty Years of the Southwestern Tradition* (Austin: Texas Monthly Press, 1981), 111.

[3]Ibid., 132–137, 166.

[4]Ibid., 138–139, 166.

[5]Dallas Museum of Fine Arts, *H. O. Kelly. . . . an exhibition of his paintings*, (Dallas, 1950), n.p.

[6]Steinfeldt, *Texas Folk Art*, 111.

[7]Claude Albritton, telephone conversation with the author, April 24, 1997.

[8]Book of Proverbs 27: 25–27.

[9]Jerry Bywaters, "Foreword," *H. O. Kelly: Retrospective Exhibition* (Dallas: Dallas Museum of Fine Arts, 1960), n.p.

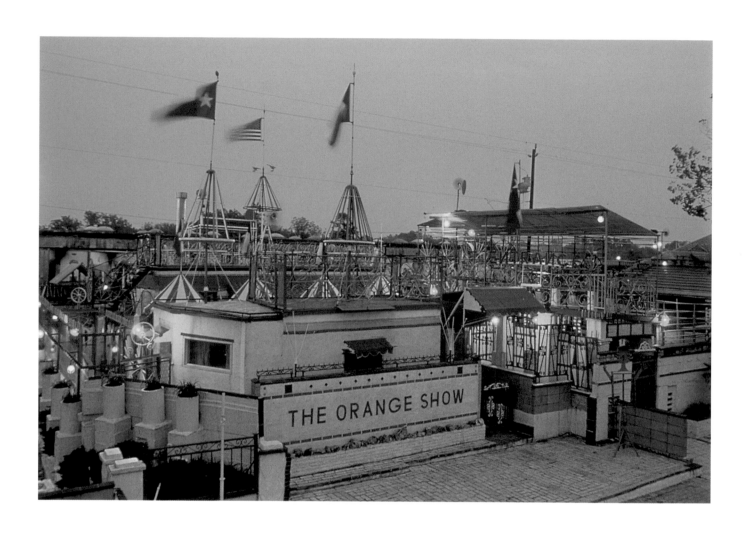

Jefferson Davis
McKissack

1902–1979

Jefferson Davis McKissack was born January 28, 1902 in Fort Gaines, Georgia. As a child he played along the banks of the Chattahoochee River on the Alabama-Georgia border, and dreamed of one day owning a steamboat. He studied commerce at Mercer University in Macon, Georgia, graduating in 1925. Relocating to New York, McKissack continued his studies at Columbia University and worked for a bank on Wall Street until losing his job during the Depression. He returned to the South and became a truck driver, delivering oranges from Florida to the Atlanta Farmers Market.

In 1942 McKissack enlisted in the Army Air Corps where he trained as a welder, and was honorably discharged less than a year later. Taking advantage of educational opportunies offered by the G.I. Bill, McKissack trained as a beautician. He relocated to Houston, and around 1950 he became a mail carrier for the U.S. Postal Service and began operating a series of businesses on the side, including a plant nursery. He built a house on Munger Street. He planned to build a beauty salon—in part because he thought it would be a good way to meet women—and he had also considered starting a worm farm. But soon McKissack "had a better idea" that was to become the driving force of his life for the next twenty years.[1]

McKissack's idea was a great construction project that was to become a monument to the orange, which he believed to be the perfect food. Each evening, McKissack returned from his job as a postman "with a car just loaded down with bricks, building blocks, anything he could get."[2] In later years he quit driving a car and hauled the materials on his bicycle, neither seeking nor accepting help from anyone. McKissack continued to work on his project, stopping only to travel to Hot Springs, Arkansas where he took the waters each year. With continued dedication McKissack worked on his project, "sweat[ing] enough over there to float a ship." When he was finished he had built a two-level structure more than 6,000 square feet in size. "Without fear or hesitation" he proudly proclaimed his accomplishment to be "the most beautiful show on earth, the most colorful show on earth, the most unique show on earth."[3] He explained,

The Orange Show is the biggest thing to hit Houston since the domed stadium. In my opinion, even though it covers only a small corner lot, it is bigger than the domed stadium, Astroworld, and Astrodomain put together because it represents the orange industry. Five hundred thousand people are employed in the orange industry. It's a billion dollar industry.

Everyone is interested in the orange from the cradle to the grave. But if it had not been for me, Jeff McKissack, the orange industry and the American people would probably have gone another two hundred years without an Orange Show.[4]

McKissack understood the uniqueness of his vision, stating, "You could take a hundred thousand architects and a hundred thousand engineers and all of them put together couldn't conceive of a show like this."[5] He believed that the Orange Show was his mission in life. "To build this show you'd have to be born in the Steam Age, and then on some river like the Chattahoochee . . . and then you would have to know about the control of steam, and only a few men have such knowledge," he explained. "They say I'm sort of a building artist. Maybe . . . maybe . . . I'm a building genius! We'll let them vote when they come."[6]

Meanwhile, McKissack was also at work writing a book, which he titled *How You Can Live 100 Years . . . and Still Be Spry*, a compilation of writings in which he warned against smoking and extolled the virtues of exercise and a high-fiber diet. The Orange Show also spread his message, with signs advising the visitor to "Love Oranges and Live," and "Rest after every meal even if your parents are dead." McKissack claimed that the Orange Show was "built like a fort. Extra strong. It's got to be. Weak construction would make the orange look weak as a nutrient."[7]

McKissack advertised The Orange Show in typewritten flyers, and was confident that eighty to ninety percent of the U.S. population would ultimately visit his monument at the rate of approximately 300,000 per year.[8] When he opened the show to the pubic on May 9, 1979, 150 visitors received a tour of the show from McKissack. But after the initial interest subsided, attendance dwindled and McKissack's disappointment was evident. His project complete, he spent an increasing amount of time inside of his house. One day he collapsed at a local bank. He had suffered a stroke and was hospitalized. Six months after the Orange Show opened, and two days before his seventy-eighth birthday, McKissack died.

Although Jefferson McKissack did not live to see the Orange Show receive the degree of success he had hoped for, it is a great example of success in the preservation of folk art environments. "One of the wonderful things is that it operates on different levels: it is about nutrition and folk art. It is one person's very unique idiosyncratic vision: the architectural embellishment of Jefferson McKissack's ideas,"[9] explained Orange Show director Susanne Theis. In keeping with McKissack's wish to create a place for education, today a variety of programs are held at the Orange Show, including performance art, music and theatrical events, films, lectures, and workshops that draw thousands of visitors to the site each year.

[1]Carol Rust, "The Orange Show," *Houston Chronicle*, November 26, 1989; John Beardsley, *Gardens of Revelation: Environments by Visionary Artists* (New York: Abbeville Press, 1995), 151–154.

[2]Rust, "The Orange Show," 6.

[3]Ibid., 9.

[4]William Martin, "What's Red, White, and Blue . . . and Orange All Over?," *Texas Monthly*, n.d., 123.

[5]Ibid., 121.

[6]Rust, "The Orange Show," 7–8.

[7]Martin, "What's Red, White, and Blue," 121-124.

[8]Rust, "The Orange Show," 12; Jefferson Davis McKissack, Orange Show Foundation Archives, n.d.

[9]Ellen Rosenbush Methner, "Visually Speaking," *Texas Star*, June 9, 1989, 5.

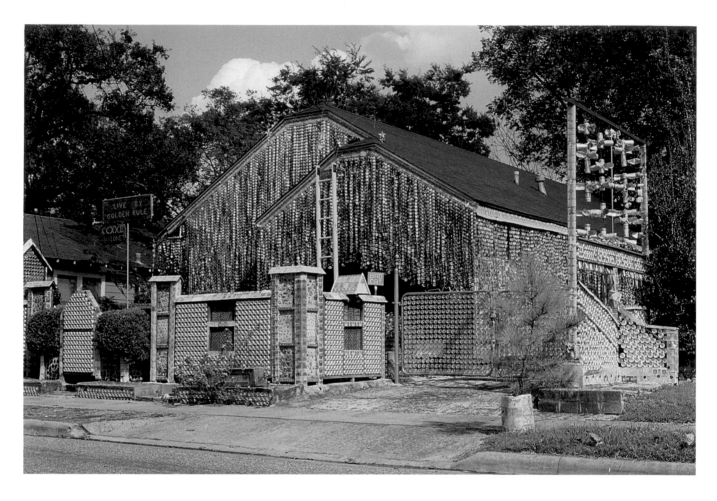

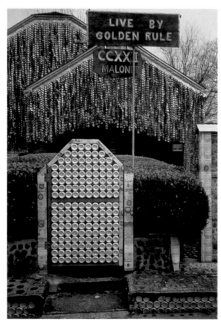

John
Milkovisch

1912–1988

John Milkovisch[1] was born in Houston December 29, 1912 to John and Marie Milkovish. He grew up in Houston's West End neighborhood, where he continued to live throughout his life. In 1940 he married Mary Hite, and the couple had a daughter and two sons. Milkovisch made his living as an upholsterer for the Southern Pacific Railroad for many years.

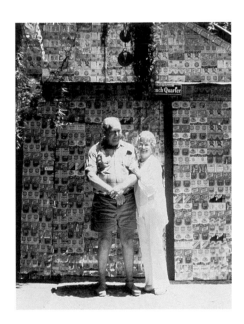

Around the year 1968 he began transforming the exterior of his home, a wood frame bungalow, into a glittering testament to his unique vision. In 1976 Milkovisch retired from his position with the Railroad, and was able to devote more time to working on the house.

Like other environmental artists, Milkovisch manifested his creative energy through one great work of monumental scale and remarkable vision, on which he worked over a long period of time. Milkovisch began his project with a concrete patio. He proceeded to the driveway and then, because he was "tired of cutting grass," he concreted his front yard. He embedded rocks and glass marbles in the concrete, and then moved on to a wooden privacy fence, drilling holes into each slat and placing marbles in the holes. This was done for the aesthetic effect created by the "sun sparkling through . . . in the morning."[2]

Milkovisch liked to drink beer, and he had been saving aluminum beer cans for seventeen years. At the outset he apparently did not know what he was going to do with the cans, but all the while he worked on the concrete and fence he was drinking beer and saving the cans. When the cans began to take up too much space in his garage, he cut off the tops and bottoms of the cans and flattened them into rectangles. Eventually he began covering the sides of his house with the rectangles, attaching them with aluminum tacks. Finally he made great chains from the tops of the cans and hung the chains from the eaves of the house. Occasionally beer was selected for the appearance of the cans in relation to the overall design, but Milkovisch stated that his decisions were usually based on which brand was "on special."[3]

Milkovisch's work is much more than an eccentric post-retirement project or a novel way to recycle an estimated 50,000 beer cans. Rising at 4:30 or 5:00 each morning,[4] he approached the task with the devoted attention of a skilled craftsman. In addition to his concern for craftsmanship and his eye for aesthetic details evident in the decorative, shifting patterns and the overall concept of the design, Milkovisch took the opportunity to express philosophical statements intended to enlighten the passerby. A green and white sign reminis-

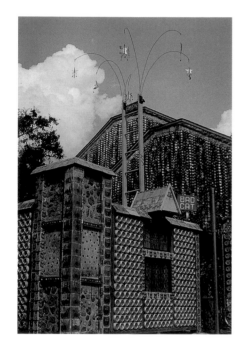

cent of freeway signs instructs the viewer to "live by golden rule." A second sign below it simply states the street address in Roman numerals, 222 Malone. Nearby a ladder, identified by Milkovisch as the "ladder of success," reaches toward the heavens. One rung is painted black to convey the artist's observation that "most people don't make it."[5] The ladder is punctuated at the top with the artist's final "Amen," while moon and star shapes suspended from it serve as heavenly symbols. The house became widely known as the "Beer Can House," and is recognized among the great examples of folk art environments in the United States.

Since Milkovisch's death in 1988 his sons, Ronald and Guy, have taken over the responsibility of maintaining the house. Since that time some changes have been incorporated, most notably in the design and construction of the fence, which reflects security concerns. Although these changes have altered the appearance somewhat, they are compatible with Milkovisch's original design.

John Milkovisch did not consider himself an artist, nor his home a work of art. He was aware that he had created a personal monument, however, when he stated, "They say every man should always leave something to be remembered by. At least I accomplished that goal."[6]

[1]Mary Milkovisch, telephone conversation with the author, June 1, 1997.

[2]Joseph F. Lomax, "Some People Call This Art," [interview with John and Mary Milkovisch], August 23, 1983, in Francis Edward Abernethy, *Folk Art in Texas* (Dallas: Southern Methodist University Press, 1985), 16-21, 17.

[3]Ibid., 18.

[4]Ibid., 19.

[5]Ibid., 21.

[6]Ibid.

Four Part Lincoln, 1996

Ike

Morgan

b. 1958

Ike Edward Morgan[1] was born October 8, 1958 in Rockdale, Texas. Around the age of ten Morgan moved to Austin where he was raised by his grandmother, Margarite Morgan, who worked as a maid. He enjoyed football and track. He said, "I did try to do art, but I didn't do no good."[2] Morgan attended Johnston High School in Austin until quitting in the eleventh grade. He worked for the City of Austin painting fire hydrants in the 1970s, until becoming disabled by schizophrenia.

On April 11, 1977 Morgan was arrested and charged with the murder of his grandmother, Margarite Morgan. Determined incompetent to stand trial, he was placed in the Austin State Hospital. He apparently remembers little about his life prior to his hospitalization.

In the hospital Morgan was introduced to art classes. But he preferred to work on his own, quietly producing paintings and drawings in a variety of media including pastel, ink, oil, and acrylic on paper, cardboard, and raw canvas. He also frequently worked on found surfaces such as cardboard, windowblinds, and bedsheets, often salvaging materials from a dumpster at the hospital.

His earliest work consisted of portraits of women. The untitled drawing from 1987 is an example of his female portraits characterized by the presence of a nervous tension. Figures often display unbalanced features, awkward poses, and the expressionistic use of color. Soon Morgan began to add to his repertoire portraits of friends, family members, and celebrities as well as religious subject matter. He often refers to magazines and books for these images. Most recently he has become obsessed with making portraits of U.S. presidents, repeating imagery over and over. George Washington appears most frequently, inspired by the portrait on dollar bills. The source for other portraits is a book on U.S. presidents.

In 1987 Jim Pirtle, an employee of the state hospital, took some of Morgan's drawings to the Leslie Muth Gallery in Houston, and subsequently Morgan's work began to gain recognition. His work has been included in a number of important exhibitions. He continues to reside at the hospital where he works prolifically.

[1]Biographical data compiled from Chuck and Jan Rosenak, *Museum of American Folk Art Encyclopedia of Twentieth-Century American Folk Art and Artists* (New York: Abbeville Press, Inc., 1996), 218–219; Jennifer Goldstein, "Artistic 'outsider' finds outlet through painting," *The Daily Texan*, July 30, 1991, 10; Leslie Muth Gallery, "Ike Morgan, Texas Black Outsider Artist, 1958–," (Santa Fe, NM, 1993), n.p.; and Webb Gallery, News Release, December 3, 1996, n.p.

[2]Chuck and Jan Rosenak, *Museum of American Folk Art*, 218.

Last Supper, n.d.

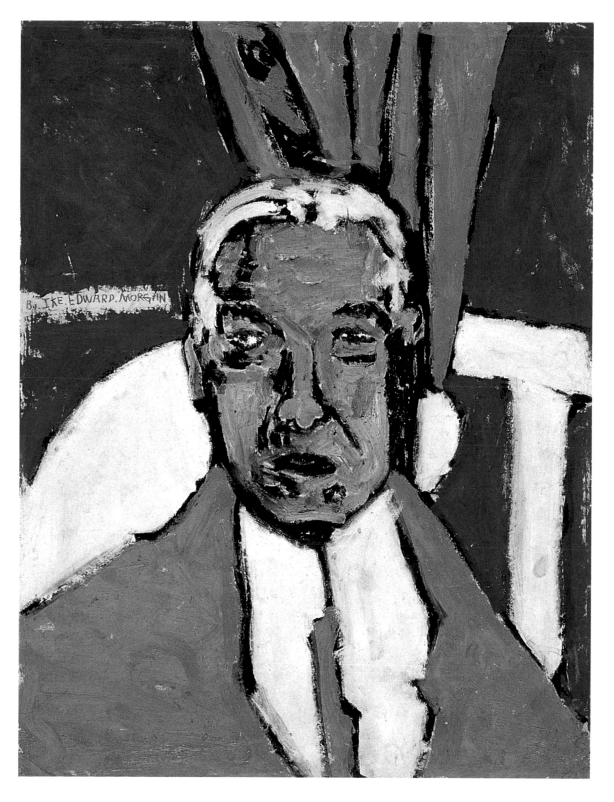

Presidential Portrait, 1996

Clouds of Widness, 1981

Emma Lee
MOSS

1916–1993

Emma Lee Dunlop was born November 3, 1916, the third of eight daughters, in St. Bethlehem, in central Tennessee. She described St. Bethlehem as "a little old place with a store and a post office and a doctor's office. It was right on the railroad track and had what you called a waitin' room for passengers. I would walk on that railroad track every day to pick up beans or corn or whatever my mother sent me for."[1]

Emma Lee enjoyed working with her hands as a child. "I always liked to be by myself, to make my little houses and doll dresses. . . . I always felt I could take from nothin' and just make it somethin.'"[2] She became skilled at crochet and embroidery, and she also expressed her creativity by drawing pictures in the dirt with a stick.

I never did have me any crayons. But I would go out and scrape me off a place and do my little drawin' in the dirt. I'd take dirt and sticks and make me a little home. I called myself building my own house, and I put the other people and things outside. But I was always in the house, never in the picture.[3]

She was not academically inclined as a youngster. She enjoyed illustrated textbooks, remembering that "As long as there was pictures, I'd always make good that day. But when it got past the place with pictures, I wasn't interested in studying."

Emma Lee Dunlop's formal education ended in the eighth grade and she went to work as a housekeeper in Clarksville, Tennessee, eventually working for the Norfleet Figuers family. When they relocated to San Angelo, Texas in 1946 Emma Lee moved with them because she "didn't want to leave little Tommy," the Figuers' son.

In the early 1950s, Emma Lee began to experiment with the nine-year old Tommy's paints and brushes while he was at school. Mrs. Figuers urged her to contact the child's art teacher, Tincy Hughs Heddins. Ms. Heddins gave Emma Lee several private lessons and then invited her to join a class she was teaching at San Angelo College (now Angelo State University), where for approximately two years Heddins introduced her to media, materials, and techniques, but never interfered with her unique style. Apparently Emma Lee was not aware that by attending these classes she had integrated the College and was making history as its first African American student. She only remembered, "Everybody was so generous, so nice to me."[4] Emma Lee sold her first paintings at a local bazaar in San Angelo in 1954, selling fourteen of the fifteen she placed for sale.

Lone Spruce Wolf, 1986

In 1956 Emma Lee Dunlop married Tucker Moss. The couple relocated to Dallas with the Figuers family in 1959. After her marriage she gave up painting until 1978 when, at the urging of a friend, she returned to it. In the early 1980s Tucker became ill, and her art helped her to cope with his illness and recover from his death in 1983.

The following year she married James Lee Horne, a long-time friend of her late husband. The couple retired and returned to San Angelo where Moss began working in earnest on her paintings, working mostly in oils on masonite or canvas. "I try to stroke a little bit every day. Then I go at it hard three days a week. I may stop and go sweep the yard or put a piece of meat on the stove, but I work at painting those days."[5]

Throughout her career, Moss experimented with materials, using watercolor, house and car paint, felt tip marker, and even shoe polish mixed with oil paint. She worked on paper, cardboard (apparently her favorite was Neiman-Marcus boxes), windowshades (which she hung on a clothesline to dry), cloth, wallpaper, and anything else she could find. She also began to make sculptures with found objects.

Subject matter included scenes from her memory, documenting African American life. She once explained, "I paints black. That's my dignity by saying this is from a black and I paints black. But it does not matter what color, I just like people."[6] Her works were always filled with color and replete with activity. She once said, "It's not mine if there's not lots going on."[7]

[1]Emma Lee Moss, quoted in Janet Kutner, "Painting, natural style," *The Dallas Morning News*, February 25, 1983, Sec. C, 2.

[2]Ibid.

[3]Ibid.

[4]"Emma Lee Moss," unpublished artist's biography, n.d., Leslie Muth Gallery, Santa Fe, NM.

[5]"Ibid.

[6]"Ibid.

[7]Moss, "Painting, natural style," 2.

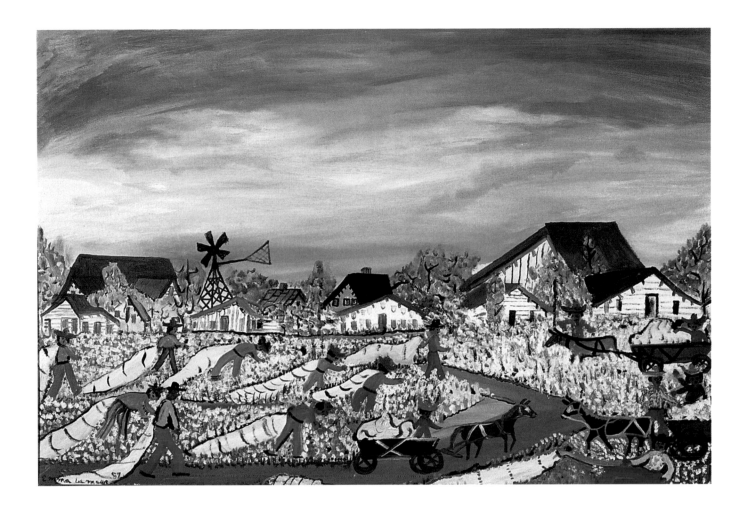

End of the Cotton Season, 1987

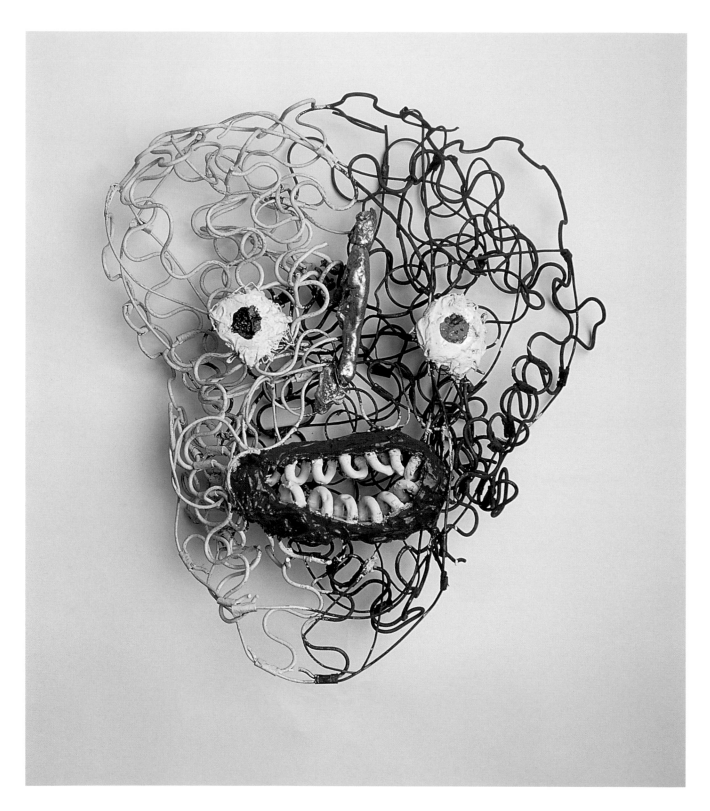

Combination of the Races, 1997

Carl Nash

b. 1951

Carl Nash[1] was born April 8, 1951 in Lubbock, Texas. He attended Lubbock's Dunbar High School, where he completed a twelfth-grade education. His first marriage produced four children. Nash married his second wife, Wanda in 1979, and the couple have eight children.

Carl Nash's art career began after he experienced what he described as a "very, very unusual vision." One night while he and his wife were in bed talking, his body was overcome suddenly with what he assumes was a spirit. He was unable to move or speak. When he began to mumble and stutter, his wife asked him what was wrong. Unable to answer her, Nash felt as though his spirit was being taken out of his body.

There were no words to describe what it was . . . but I knew that it wasn't evil. That was my first premonition . . . that God had His hand on me. I got up the next morning and I started working, as if I was being pulled into this work. And I knew then I had no control over what I was doing. And I was enjoying what I was doing, and I didn't know what I was doing. But I started just messing around . . . with these metals and stuff. Then I started putting two and two together, and I didn't get four—I got six! Then I started getting this feeling about myself— that it was art. I didn't know anything about art, I didn't know anybody to contact, I didn't know anything about anything. But this drive within me just kept pushing me and pushing me. . . . And I worked from sunup to sundown.

All of my work comes from a source that I have no control over, and I thank God for all His patience and His understanding and His teaching, because He teaches me through a source that I don't even explain. It just comes from The Man and I just start workin', I just do it as though I went to school for it, and I know it's a God gift.[2]

Nash spent most of the 1980s living with his wife and children in vacant buildings in Fort Worth, where he began to construct environments with sculptures he created from found objects. Soon he discovered, "The more I done the more I realized what I hadn't done,"[3] and he became obsessed with making art.

In 1988 a Fort Worth art critic wrote a story on Nash. Several days later he was issued citations for his "hazardous eyesore" and his family was evicted. They relocated to an abandoned warehouse, where he began working on a larger scale until he was again discovered and evicted. Much of his work was destroyed when the building was demolished. Commenting on his lack of academic training and his own perseverance through the many difficulties he has encountered in pursuing his art he has stated, "There's a big difference between wanting to be an artist and having to. You can't compare an education with God's gift."[4]

Nash's art usually begins with a vision. Sometimes he writes his visions down, but at other times he is unable even to talk about the idea although he knows what it will be. "I got

Longhorn Head, c. 1985–90

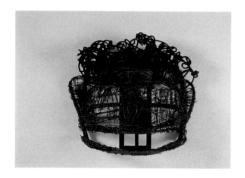

Untitled, n.d.

the mind. It just won't leave me alone," he explains. Because he works from visionary inspiration and relies on found objects, Nash's work is greatly influenced by his physical surroundings and what he has found most recently.[5] One period of time was spent creating objects with aluminum cans he collected on daily visits to a Fort Worth soup kitchen. While living in the Fort Worth warehouse, the work was made predominantly from industrial materials available in the surrounding area. Human and animal forms created during this time emerge from what seems to be miles of tightly wrapped wire.

After relocating to a Lubbock housing project, Nash began to create sculptures from objects he found in the trash there, including broken bicycle and baby stroller parts, unwanted toys, and other odds and ends of discarded items that reflect the presence of families and children. The 1996 assemblage *Anti-Christ* is from this period. The disturbing juxtaposition of objects including a child's rocking horse and a gun serve as grim reminders of the realities of life for families living on society's fringes. The presence of a torn dollar bill and losing lottery tickets, accompanied by a rusty horseshoe, are ironic symbols of fortune and materialism. A garland of artificial Christmas greenery—still decorated with bits of tinsel, and tiny stuffed toys held within a military bag challenge the viewer to make inferences about Christianity and the negative forces, embodied in the Anti-Christ, that confront us in our daily lives.

When the housing project where Nash and his family resided was converted to a juvenile detention center, they were evicted. Facing yet another uncertain housing situation, Nash broke apart his own personal belongings including lamps, furniture, and other household items, turning them into art. After moving to a house on the outskirts of Lubbock, his work has been made from discarded farm tools and wire fence material found in this rural environment. As this catalog goes to press, Nash is once again homeless. It is uncertain where his circumstances or his art will lead him.

The process of finding and recycling objects is an important part of Nash's work, as he has explained.

I like to go and just find ordinary things, and take those ordinary things and turn them into art. For me, I found out it's a relief. It takes tension off, I walk, I find different art objects that are old, they're rusty, they've been there for years, and I take it and somehow polish it up with my art work. And when I polish it up, it gives it a unique, whole new style.[6]

For Carl Nash art is life, and vice versa. Wherever he lives, Nash responds to his need to create art and to instill in others a sensitivity to their environment. Through his work he conveys a message of the beauty that surrounds us, transforming the lowliest of materials into objects of remarkable power and beauty.

[1] I am grateful to Bruce and Julie Webb for providing biographical information on the artist.

[2] Carl Nash, in Tom Denolf, *Art a la Carte*, video documentary, n.d.

[3] Julie Webb, telephone conversation with the author, May 1, 1997.

[4] Ibid.

[5] Ibid., and Bruce Webb, telephone conversation with the author, March 26, 1997.

[6] Carl Nash, *Art a la Carte*.

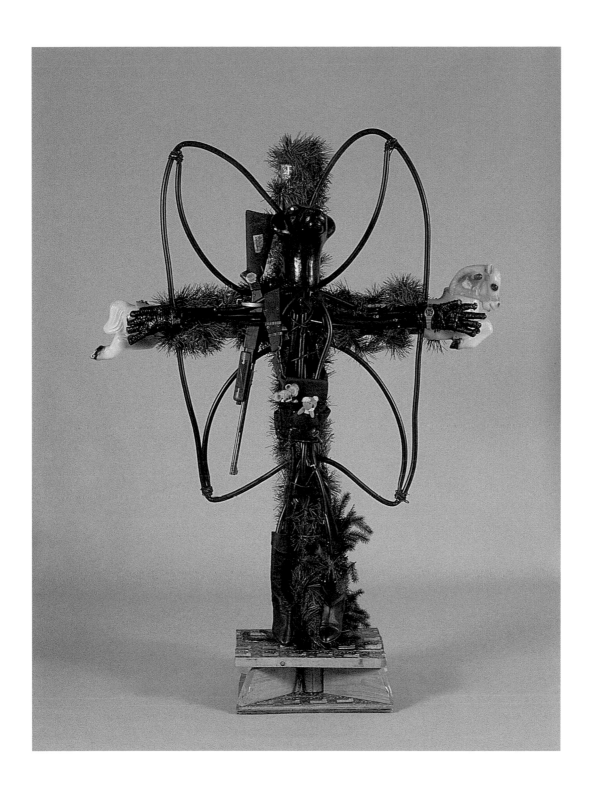

Anti-Christ, 1996

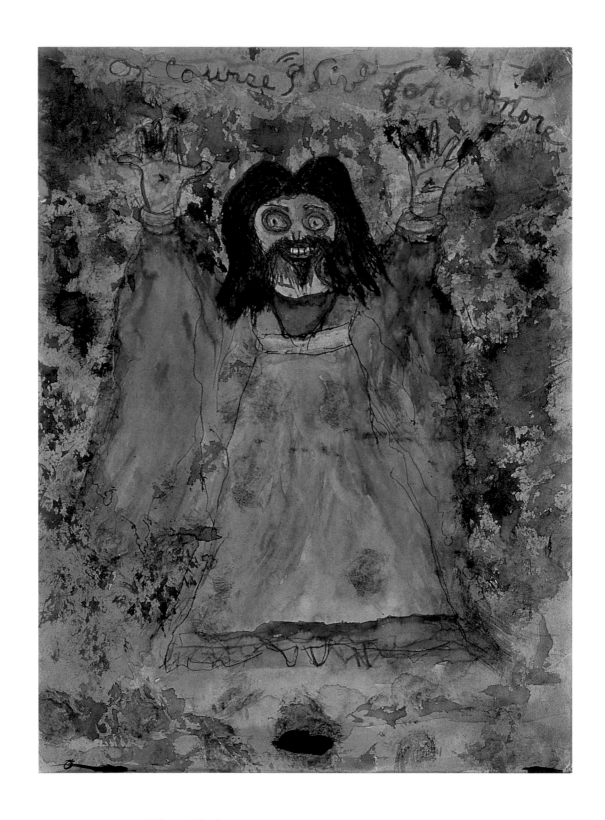

Of Course I Live Forevermore,
after 1961

Naomi

Polk

Naomi Polk was born in 1892 in Houston, the tenth child of Josephine and Woodson Howard. Her father was part Cherokee, and her maternal grandmother, Leah Walton, had been brought to this country from Africa as a slave. Leah's vivid stories of Africa apparently had a great impact on young Naomi, providing subject matter for her paintings in later years. Naomi's mother, Josephine, was the youngest of Leah Walton's nine children, all of whom were born into slavery. After slavery ended in Texas on June 19, 1865, Leah and her family, including eighteen year-old Josephine, were deeded a lot in Houston's Fourth Ward which became the family home for three generations.[1]

Josephine worked all her life as a domestic servant. Naomi was her tenth child, arriving in her mother's forty-seventh year. Naomi attended the Gregory School and briefly, the Booker T. Washington School. By the time she was in the sixth grade, Naomi was needed to help care for the children of her older sisters, and her formal education came to an end.

In the early 1920s Naomi married Bill Myers, but was soon widowed. In the mid-1920s she married Robert Polk, and the couple had three children, Samuel, Rosalie, and James. In 1933 Polk was widowed again, left to care for her children alone. She tried domestic work, but would end up quitting or being fired after a short time due to her refusal to accept the ill treatment that often accompanied being a servant.

To supplement her meager government check Polk relied on her entrepreneurial spirit, devising several unique modes of subsistence. At that time, cosmetics for black women were unavailable in Houston. She began ordering them in bulk from a northern company, selling them from her home to women in the neighborhood. She also negotiated with the nearby Phoenix Dairy for the empty cans that had held orange juice concentrate. Polk would collect the discarded cans, decorating them with painted designs of flowers and butterflies. She would fill the decorated cans with plant cuttings from her garden, load them into her children's red wagon and with their help, she would pull the wagon through the Montrose neighborhood near the Fourth Ward, selling the plants to area residents.

Polk's other cottage industry was her "secret formula" insect poisons. Her roach powder was a blend of flour, sugar, sulfur ("for color"), and a poison she bought from a neighborhood druggist. She made her "bug spray" with kerosene, turpentine, and red gasoline ("for

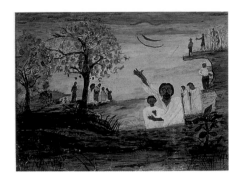

Baptism, after 1961

Lonesome Road, after 1961

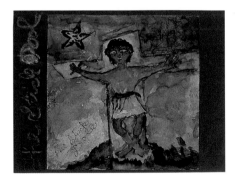

The Stick Doll, after 1961

color"). Apparently this highly flammable concoction was effective, and it became widely known and used throughout the neighborhood. "Why she didn't burn down the entire Fourth Ward with her insect spray . . . is one of the mysteries of my life," her daughter reflected.[2]

Polk considered her true life's work to be writing and making art. She wrote poetry and kept a diary of life in the Fourth Ward, chronicling the remarkable changes that occurred during her many years there. In the 1950s the Phoenix Dairy expanded, purchasing the old family homestead, and Polk relocated to Houston's first all black subdivision, Acres Homes. In 1961 a fire destroyed her home and possessions including her journals and paintings. She dedicated the rest of her life to rewriting and repainting all the work that had been lost.

Like most self-taught artists, Polk selected her media without concern for archival stability. She worked with found materials, mixing oil-based enamel paint with whatever agent was available, often kerosene or turpentine. She painted on a variety of surfaces, including old cloth windowshades, ceiling tiles, wood scraps, and cardboard. On one occasion her daughter presented her with store-bought oil paints and canvases. Although she graciously accepted the gift, she shunned these supplies in favor of her own scavenged materials.

Naomi Polk kept mostly to herself, refusing to attend senior citizen art groups and holding in disdain what she referred to as their "egg crate art." In the 1960s, then seventy-five years old, she married for the third time in a formal wedding to a neighborhood preacher. But the couple was unable to agree on who would leave his or her dog or house, and four months later they divorced.

The major influences on both Polk's art, as well as her writing, were her deep religious beliefs, her strong sense of her African American heritage, the deep sense of racial inequality she felt throughout her life, and her growing awareness of her own mortality. In a number of paintings, Polk depicted the figure of the crucified Christ which she identified as *The Stick Doll*. The paintings referred to dolls she played with as a child. Unable to afford store-bought toys, Naomi's mother fashioned handmade stick dolls for her to play with. She cherished these dolls, made by lashing together two sticks into a cross shape for the arms and body of the doll. A piece of rope became the doll's hair. By combining the image of the stick doll with that of Christ, Polk conveyed not only the repetition of forms between the two images, but the similarity between the comfort that religion provided her and that she received from the treasured toys of her childhood.

Polk viewed her life as a long and narrow journey on which she was a lonely traveler. She expressed that view poignantly in her *Lonesome Road* series of paintings completed toward the end of her life. Based on a favorite gospel song, the series of winding roads, devoid of figures, reveal Polk's view of the loneliness of the human voyage. Sometimes the presence of a house along the road suggests the shelter found by the faithful at the end of the journey. Naomi Polk died on May 1, 1984 at the age of ninety-two without experiencing recognition as an artist. Her work was not shown in public until after her death, and it has remained relatively unknown outside the state of Texas.

[1] All biographical information, Rosalie Taylor, interview with the author, Houston, October 8, 1988.

[2] Rosalie Taylor, "Family Honors Mother with an Exhibit of Her Art," *Magazine of the Houston Post*, December 8, 1985, 20.

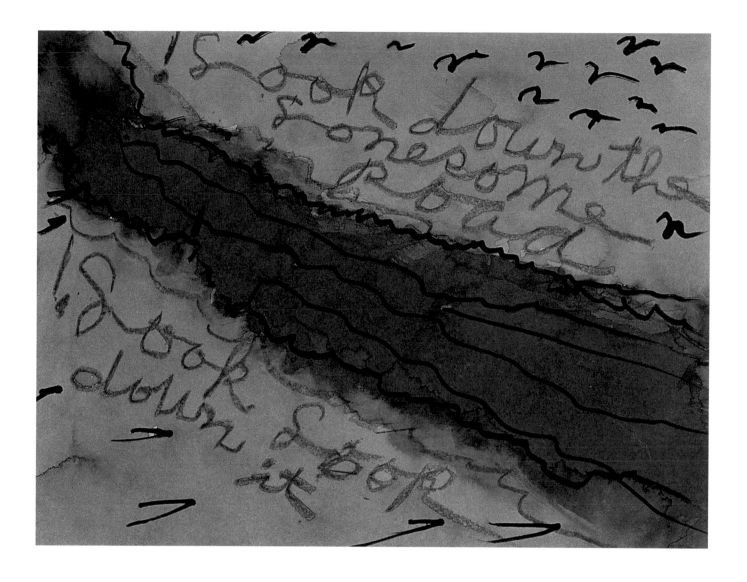

Lonesome Road, after 1961

Angry Angels, 1996

Xmeah

ShaEla'ReEl

b. 1943

Xmeah ShaEla'ReEl was born David Jones in Latania, in Rapides Parish, Louisiana October 29, 1943, one in a family of seventeen children. When David was a child, he moved with his family to East Texas. After graduating from high school he served in the United States Air Force, where he was trained in electronics. Following his military service he began working for a telephone company in Santa Barbara, California.

Around the year 1976 Jones received a vision in which a figure who looked like himself appeared before him. The figure walked toward him and said, "I am Xmeah ShaEla'ReEl, Warrior, Divine Angel of God." After his vision, he quit his job and began hitchhiking throughout the country. Eventually he was led to Houston where he met his wife Cherry also an artist. The same year, 1980, he had a second vision in which the figure returned, commanding him to change his name. The figure said, "Your name is no more David Jones. Your name is Xmeah ShaEla'ReEl."[1]

After receiving the visions in which he was commanded by the Lord to spread the message of salvation, Xmeah and Cherry ShaEla'ReEl moved to Beaumont, where Xmeah formed his own church, The Children of Christ of America. As "the messenger and scribe of Jesus Christ," he also publishes a newsletter, *The Carrium*, in which he conveys his message of faith and repentance. He explains that

"The Carrium" is the newspaper that the Lord Jesus Christ has given me to write. All of the messages come from Him! The name "Carrium" was given to me by Him! The word is pronounced like Carry-um. This word will not be found in any dictionary. It is a new word. The word means, "A Message From God!"[2]

Each newsletter represents a tract which has a corresponding tape-recorded message. At certain points within the tract the reader is instructed either to listen to a tape or read a Bible passage. Xmeah distributes his newsletter and cassette tapes of his sermons free of charge. When one is completed the reader is instructed to request the next tract in the series.

A religious visionary, Xmeah considers himself the "messenger of prophesy spoken of by Malachi the Prophet."[3] He often receives messages from God through dreams. Xmeah's art is an outward manifestation of his religious visions, as are his writings and sermons. He has stated,

Drinking the Wine
of Wrath, n.d.

It's hard to really explain how the inspiration comes, except that I'm told what to do. I can't do nothing by myself. If the inspiration and the directions are not there, I cannot do anything. I know I have a desire to do something, but if I'm not shown anything, I cannot do it. . . . Each color has to be told to me. . . . Often times I don't even know what it's turning out to be or the purpose of it. What I was told is that like an executive secretary, I take dictations. . . . I take the message down and I write it and sent [sic] it out.[4]

The earliest work was intended for his congregation, and consisted of messages that were finely painted and decorated with glitter and designs. Later he began adding more images until his work developed into powerful compositions illustrating his religious visions. The paintings incorporate images and text blending Bible verses with his own messages about contemporary issues. ShaEla'ReEl uses his art as a way to show his concern for people. "Getting the message out is not a problem. The problem is getting the response, getting people to respond to the message," he has explained.[5]

Part of ShaEla'ReEl's message is the belief that "there is distinct light and distinct darkness. There is distinct evil and distinct good." He wants people to take responsibility for their actions in order to secure salvation. "You might have to sit down with a man on the side of the road some place, or jump into a ditch and pull somebody out, or change somebody's tire. The good works you do will glorify Him."[6]

The paintings *Angry Angels* and *Drinking the Wine of Wrath* illustrate ShaEla'ReEl's visions of God's displeasure over man's behavior and treatment of his fellow man. This message also appears on his van, which allows him to make his statement visible to more people. He explained,

People talk a lot about "Jesus is love," "God is love," but they never talk about God's anger. The Lord told me to put that on the side of the van. He's angry. I don't see a smile on His face when He sees what He sees. His word is kindled against the wicked every day. So when I see wickedness I know the truth of the words He's saying, and He's angry."[7]

ShaEla'ReEl creates his paintings on a variety of surfaces including board and canvas, and also transforms such objects as ordinary furniture into devotional objects. Each Sunday he presides over services at his home. The living room, where services are held, is filled with works of art that function as illustrations for his sermons, including a communion table decorated with Bible and *Carrium* verses.[8]

Xmeah has become increasingly concerned that recent public interest in his work has somewhat overshadowed the message, and it is the message that is of utmost importance to him. For Xmeah ShaEla'ReEl, artmaking represents a direct communion between himself and God, and recently he indicated that God instructed him to stop painting. The couple had their telephone disconnected, and have stated that the Lord wants people to start praying and to contact them through the Holy Angels.[9] As this catalog goes to press, he has been instructed to resume painting and is once again at work sharing his religious message through his art.

Light of the World, n.d

[1] Artists' Alliance, Lafayette, Louisiana, *It'll Come True: Eleven Artists First and Last*, 1992, 68; and telephone conversation with Bruce Webb, May 13, 1997. In *The Carrium*, (No. 1, n.d.), 2 ShaEla'ReEl explains that "The name is interpreted to mean, 'Warrior: Divine Angel of God!'"

[2] Xmeah ShaEla'ReEl, *The Carrium*, (No. 1, n.d.), 2.

[3] Ibid.

[4] *It'll Come True*, 68-69.

[5] Ibid., 69.

[6] Xmeah ShaEla'ReEl, videotaped interview with Bruce and Julie Webb, Beaumont, June 29, 1993.

[7] Ibid.

[8] Xmeah ShaEla'ReEl, conversation with the author, Beaumont, Texas, December 19, 1996.

[9] Julie Webb, telephone conversation with the author, March 13, 1997; Cherry ShaEla'ReEl, private communication with Bruce and Julie Webb, May 16, 1997.

Michael Fight, 1995

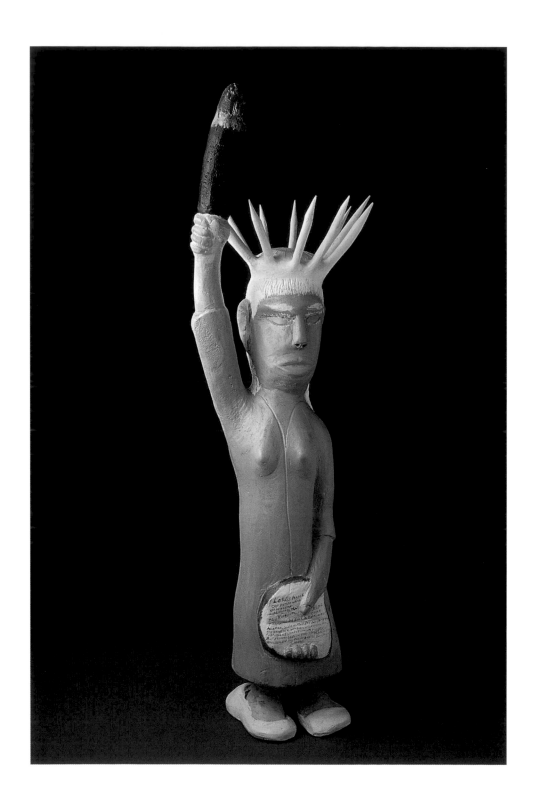

Statue of Liberty, c. 1994

Isaac
Smith

Isaac Smith was born April 27, 1944 in Winnsboro, Louisiana, approximately forty miles south of Monroe, the third in a family of eleven children. Smith's father made his living as a farmer and nightclub owner. As a child Isaac enjoyed fishing and exploring the Louisiana bayous, where he developed a love for wildlife. He recalled,

When I was a kid, the animals I saw were so great. . . . I followed them around in the woods and studied them, studied how they were made. . . . I guess I just had that instinct for animals. . . . I just loved the woods. I think it's a gift from God almighty.[1]

On one of these outings, he picked up a snake and was bitten, an encounter that taught him respect for the power of nature. Smith preferred spending time in nature to academic pursuits, remembering, "I spent too much time in the woods, really—the school officers had to come and get me sometimes."[2]

Smith did his first woodcarving at the age of ten after watching a man carve a chain of unbroken links from a broomstick. Seeing how it was done, he carved his own chain.[3] After quitting school in the eighth grade, Smith went to work for a pipeline company in Mississippi. In 1961, the seventeen-year-old Smith relocated to Dallas and went to work for LTV, an aerospace contractor.

Around the year 1975, Smith began carving in his spare time. He had been laid off from LTV, and spent more time pursuing his art. Eventually he returned to work, but his passion was carving. He recalled, "On every break, I'd sketch, then I'd go home and carve. . . . I'd go to the libraries and study books about wood. And when I had time off, I'd spend every day in the woods." After being laid off from LTV again in 1978, Smith began making art full time as a way to make a living "without depending on someone else." Sawing, chipping, shaving, and carving wood that he picks up along the roadside, he creates animals of many species. His ideas come from his youth in Louisiana, from studying *National Geographic* nature videos, and above all, from divine inspiration: "I work from God. . . . Why make something based on another man's idea?"[4]

Smith finds logs and branches in the woods or along the roadside, his favorites being willow, oak, cypress, cedar, ash, and sycamore,[5] which he then cures by soaking in gasoline and sealing them in a closed tank for several days. When it is time to carve a figure, he roughs out the shape with a chain saw and refines it with a hatchet and chisel. Occasionally

Tiger, n.d.

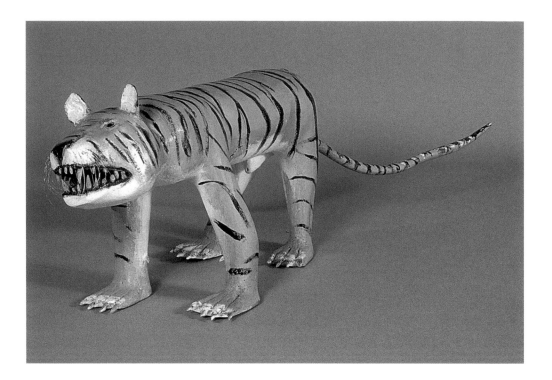

he uses a knife or file, and finally, uses sandpaper to finish the piece. Legs, feet, ears, and other appendages are carved separately and secured with a mixture of glue and wood shavings. Wood splinters form teeth and claws. Finally, he paints the figure with acrylic paint.[6] Smith says, "My animals come alive in my dreams,"[7] and in the event that they should come alive at any time in the future, he provides all of his figures with the ability to breathe and hear by drilling holes in their ears and nostrils.

Smith's animals assume charming personalities, and his carvings of jungle cats seem more friendly than fierce. In *Monkey Mother and Child* Smith portrays the mother enveloping her baby. In the sculpture the two become one, revealing the special bond connecting mother and child. In Smith's rendition of the *Statue of Liberty* the cultural icon wears house shoes, holds a great torch, and carries the Lord's Prayer, which Smith felt was appropriate in light of the fact that she represents a religious country.

Isaac Smith lives in the Dallas suburb of Oak Cliff, where he spends his time gardening, raising chickens, and creating his sculptures.

[1]Joy Dickinson, "Animal instincts: Folk artist turns memories into masterpieces," *Richardson News Weekender*, February 14–16, 1992, 3.

[2]Ibid.

[3]Deborah Gilman Ritchey, "Isaac Smith," Gail Andrews Trechsel, ed., *Pictured in My Mind: Contemporary Self-Taught Art from the Collection of Dr. Kurt Gitter and Alice Rae Yelen* (Birmingham: Birmingham Museum of Art, 1995), 188.

[4]Dickinson, "Animal instincts"; Dallas Museum of Art, wall label, *Animals with Attitude: Sculpture by Isaac Smith*, 1997.

[5]Dickinson, "Animal instincts."

[6]Ritchey, "Isaac Smith," 188.

[7]Chuck and Jan Rosenak, *Contemporary American Folk Art: A Collector's Guide* (New York: Abbeville Press, 1996), 257.

Monkey Mother and Child, n.d.

The Quilting Bee, 1966

Fannie Lou

Spelce _____

b. 1908

Fannie Lou Bennett[1] was born June 19, 1908 in Dyer, Arkansas to Hillary Arter Bennett and Florence Loomis Bennett. Fannie Lou was the first of the couple's five children. Florence's father, an early settler in the area, had come to Dyer, a town of approximately 300 in the foothills of the Ozarks, from New York City. He was an architect and builder who designed and built a number of the churches, schools, and homes in the area. Fannie Lou's father was a farmer. Her life centered around work, school, religion, and family activities. The Bennett home was a gathering place for family and friends, and the outgoing Fannie Lou delighted in the constant visitors.

After completing her public school education in Dyer, Fannie Lou left for Fort Smith, Arkansas where she enrolled in nurses training at Sparks Memorial Hospital. She became a registered nurse in 1929, and practiced her profession for more than forty years. In 1934 Fannie Lou Bennett married Neal L. Spelce, and the couple had two sons, Neal Jr., born in 1936, and Bennett, born in 1937.

Following her divorce Fannie Lou Spelce raised her sons in Clarksville, Arkansas, where she worked at the Catholic hospital. In 1954 Fannie Lou relocated to Austin, where she resided for two years. In 1956 she moved to Houston, but returned permanently to Austin in 1959 to be nearer her sons, then both students at The University of Texas at Austin. She took a position as the school nurse at St. Stephen's School, where she worked for eleven years until retiring in 1971.

In the summer of 1966 Fannie Lou Spelce and a friend enrolled in a painting course at Austin's Laguna Gloria Art Museum. Spelce's main reason for attending was to accompany her friend. But her own interest was sparked by the desire to paint a portrait of her sons based on a photograph she had of them as children. When she arrived at the class, the first assignment was to paint a still life. Spelce began her painting but was not pleased with the results, so she took her paints home and completed the still life from memory. When she returned to class with the picture the following week her instructor, Owen Koppelman, was delighted with what he saw. Recognizing her unique talent, he explained to Spelce that she was a "true primitive," to which she retorted, "I may be old, but I'm not primitive!"[2]

Koppelman suggested that Spelce remove herself from the class, which was held on

Uncle Floyd, 1968

the second floor of the museum, and paint instead by herself downstairs. He supplied her with such information as how to stretch her own canvases and prepare them for painting, and introduced her to oil paints and sable brushes. Only three years later, Koppelman entered her work in a juried exhibition at the Dallas Museum of Art, where it was accepted.[3]

Dyer and Clarksville, Arkansas provided the settings for Spelce's paintings. From the outset her interest in painting was to record her memories. She explained,

I paint because I have such happy memories of everything. I try not to remember ugly scenes or ugly things. . . . I like to share those memories and those thoughts with other people. To me, there's a lot of love in my paintings. I like to paint those things because I love to remember them and think about them.[4]

Spelce approached her work earnestly, often having several canvases underway at a time. She described her working method as follows:

When I start painting, I know how it's going to look before I ever put it down, but I sketch it out. And then I start from the top down to keep my hands from getting dirty and messy, and start with the clouds, and if it's an inside scene I start from the ceiling. And I usually do all that and then go back and put the people in afterwards. And maybe while I'm doing one painting I'll get an idea and remember something else, and so I'll stop and go start another one, and so on. Sometimes I'll have one, two, and even six at a time.[5]

Working very deliberately and only occasionally using a magnifying glass, she executed her work in great detail with tiny 000 brushes from which she would often pluck some of the hairs until only a single hair remained. She preferred using large canvases, because as she worked she would often get ideas that she wanted to incorporate into her paintings, and the larger scale allowed room for expansion.

The painstaking effort she employed to create her work is evident in the painting, *The Quilting Bee*, from 1968. In this work, which took her a year to complete, she carefully included portraits of her parents, her aunt Lucy, and two of her sisters, as well as other friends and family members who complete the circle of women joining together in the communal effort of quiltmaking. Each woman wears a thimble, and each holds a threaded needle. On the wall are portraits of her maternal grandparents, and on the piano are photographs of each of the five children of Hillary and Florence Bennett. She carefully included the lace curtains and crocheted doilies made by her mother, and captured the flowered wallpaper and the plush texture of the carpet. Her great attention to detail resulted in the painting's reproduction in Patsy and Myron Orlofsky, *Quilts in America*, as an example of how quilting frames were mounted to the ceiling in drawing rooms and then lowered for quilting bees. Spelce described the scene depicted in the painting.

The ladies in the town would all bring a covered dish . . . not only at our home but each home, you see, they'd take turns and go spend the day and quilt all day. . . . They'd play the piano, and sing, and eat, and quilt. . . . They would come and quilt all day, and if they weren't able to finish the quilt, the way the frames were, they'd roll it up . . . to the ceiling. Maybe they'd lack just a little bit, or they'd come back at a later date and finish the quilt.[6]

Other works also serve as important historical documents. *Camp Meeting at Maple Shade* portrays an outdoor tent revival—an event once common throughout the South as

*Camp Meeting at
Maple Shade*, 1968

large groups would congregate for periods of up to a week of round-the-clock preaching to renew their faith. Spelce struggled to get the tent right in her painting,[7] and ultimately she succeeded in her effort as evidenced by the graceful structure at the center of the painting.

In *Arkansas Peach Season* Spelce employed a continuous narration, combining in a single painting various events that took place over a period of years. Each scene within the painting represents a "snapshot" of a memorable moment in her sons' childhood years. Grouped together on canvas, the scenes comprise a personal scrapbook of their early lives. Though based on personal experiences, the painting represents a collective memory and a strong sense of Americana that gives the work its wide appeal.

In other works Spelce painted portraits of family members based on photographs and on her own memory. *Uncle Floyd* represents the artist's uncle as a child. The child has apparently interrupted his play briefly to pose obligingly for a picture. The bulge in his jacket pocket created by a baseball adds both humor and the sense that a fleeting moment has been captured; in the next moment he will return to his game. The awkward perspective and the artist's difficulty with the shoes give the work its charmingly naïve appearance.

In 1970 Spelce's son Bennett took her work to New York, and the Kennedy Galleries agreed to represent her. She began to receive recognition for her art as well as numerous awards for her painting. The interest in her work came as a surprise, as she has stated.

Of course, I like them. Yes, I like them very much because I have happy memories about them, and I just love doing them, and I don't know why other people like them, because they're all so personal and seem like [they] just belong to me and my memories.

For twenty years she continued to paint, producing between 300 and 400 paintings until failing eyesight due to macular degeneration forced her to quit painting. Driven by her desire to revisit cherished memories and to share them with others, Fannie Lou Spelce created an important body of work in which she recalled her experiences, celebrated her love for her family, and documented her observations of small town American life.

[1]Biographical information courtesy of Neal and Bennett Spelce, sons of the artist, Austin, Texas.

[2]Fannie Lou Spelce, interviewed in Sandra Mintz and Larry Cormier, *Fannie Lou Spelce, Folk Artist,* Austin Community Television and The University of Texas Institute of Texan Cultures, c. 1970s.

[3]Neal and Bennett Spelce, interview with the author, Austin, December 3, 1996.

[4]Fannie Lou Spelce, interviewed in Sandra Mintz and Larry Cormier, *Fannie Lou Spelce, Folk Artist.*

[5]Ibid.

[6]Ibid.

[7]Bennett Spelce, interview with the author, April 2, 1997.

Arkansas Peach Season, 1968

Scarecrow, 1997

David
Strickland

b. 1955

David Strickland[1] was born August 26, 1955 in Dallas, Texas. His parents separated when he was a child, and he and his sister lived with their father, a postal employee. Strickland grew up in Oak Cliff, a south Dallas neighborhood. Summers were spent on his grandparents' farm in Clifton, Texas. In high school David was exposed to working with metal and wood in shop classes. After graduating from Carter High School in Dallas he moved to Clifton, Texas, where he began working for the local telephone company.

In 1975 Strickland was arrested for driving while intoxicated. He received six months probation and was ordered to attend a meeting directed by the Texas Rehabilitation Commission where he was offered state-funded trade schooling. Because the heating and air-conditioning repair course was filled, he enrolled in a welding course, and afterward he worked as a freelance welder for several years. Strickland then worked as a construction laborer for the Veterans Administration. In 1979 he met and married his wife, Nancy. The couple have two children, Myra and Brian.

After being laid off his job in 1988 Strickland resumed welding, working for the Glen Rose Nuclear Power Plant. After being laid off from the power station, Strickland began an add-on construction project at his home. To make additional money he repaired farm equipment and sold scrap metal.

As he repaired the farm machinery, Strickland began to notice that some of the machine parts resembled the parts of animals. Working with these found materials he created his first welded metal sculpture, a bird figure standing more than three feet high. He completed his first work in 1990 and went on to create an additional seven sculptures that year. He gave one of these early works to a friend who owned an auto body shop located next to Interstate Highway 35, where it was displayed. There they were discovered by Bruce and Julie Webb, owners of the Webb Gallery in nearby Waxahachie.

Strickland often conveys humor, play, and wit through his choice of subject matter and the combination of materials he uses to create the pieces, and this lightheartedness is often reiterated in the titles of the works. The creatures he concocts have personalities—some friendly, others more intimidating. The works are powerful, reflecting the tough, heavy materials and the scale that give the pieces their physicality. Tractor parts form *Case Alien,* named for the make of tractor emblazoned across the radiator that forms the imposing creature's

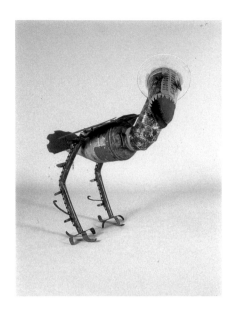

Big Bird, 1996

chest. Inside, red lights form "organs." Antennae atop the alien's head are punctuated with lightbulbs wired for electricity, and the creature has a "seat" that is a play on words.

Strickland's *Big Bird* is not a metaphor for flight, but a decidedly earthbound creature possessing an awkward charm. The cumbersome proportions and ponderous weight of its body, balanced on lanky waterbird legs, suggest that this bird is incapable of achieving flight. In all its clumsiness the bird nonetheless boldly displays a dazzling crown, and the presence of sharp teeth lend a predatory aspect to its appearance.

Strickland's *Scarecrow*, with its ability to change position so that it can face two directions and the added element of sound through an alarm bell on the figure's torso, is transformed into a powerful guardian figure. Two pair of arms and hands increase its ability as a protector. Scarecrows are designed to frighten—but not harm—birds from invading crops. In the event that Strickland's *Scarecrow* should fail to scare off potential intruders with its imposing appearance, it will certainly send them running for cover once the alarm is sounded.

David Strickland is the focus of increasing attention, and in the brief seven years of his art career his work has been included in several major exhibitions. Positive public and critical reception of his work will undoubtedly generate continued interest as he responds to his materials and environment in new and innovative ways.

[1]Primary biographical information from Deborah Gilman Ritchey, "David Strickland," in *Pictured in My Mind: Contemporary American Self-Taught Art from the Collection of Dr. Kurt Gitter and Alice Rae Yelen* (Birmingham: Birmingham Museum of Art, 1995), 198–201; Bruce and Julie Webb, interview with author, Waxahachie.

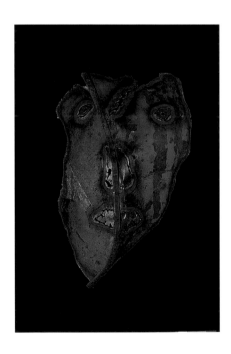

Untitled , 1996

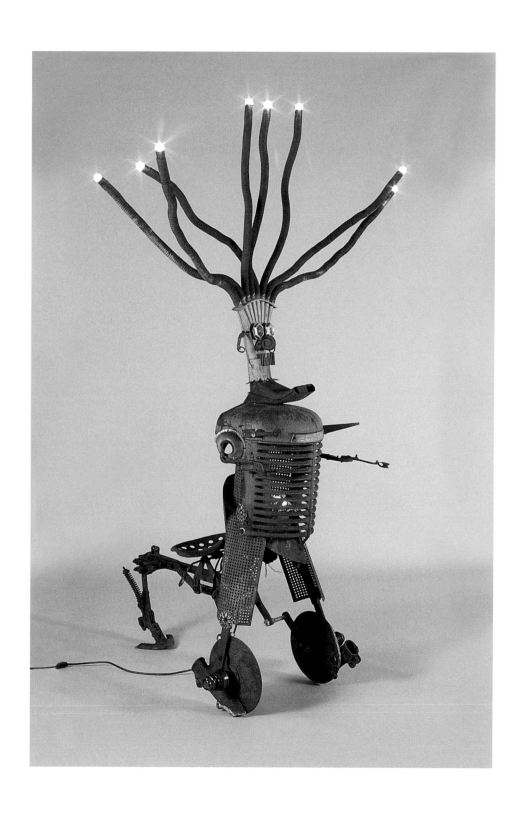

Case Alien, 1991

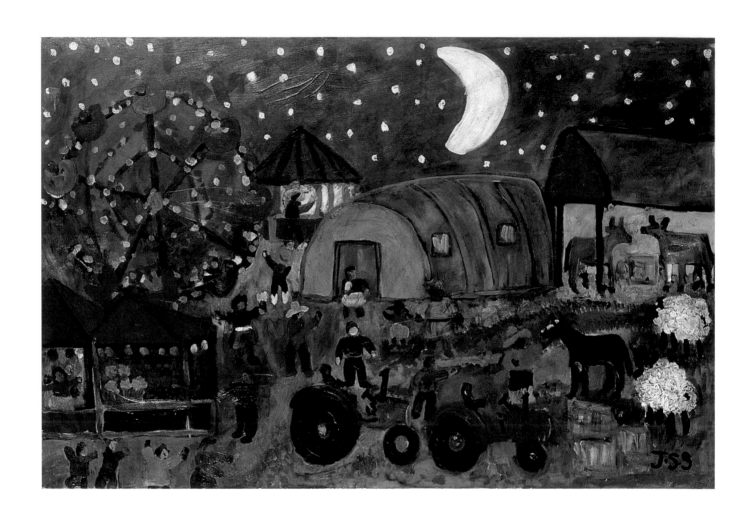

Untitled (Washington County Fair
at Night), c. 1982

Rev. Johnnie
Swearingen

Johnnie Swearingen was born August 27, 1908 in the black community of Campground Church near Chappell Hill in Washington County, Texas. His parents, Lemuel and Eula Swearingen, were sharecroppers. Swearingen claimed to have been called to preach at the tender age of four, and delivered his first sermon standing on a box between his parents. First he joined an A.M.E. church, and later transferred his membership to a Missionary Baptist church in Chappell Hill. Although Johnnie attended school sporadically, he completed the eighth grade in Petersville. He claimed to have begun painting around the age of twelve, often using the walls of his home as his canvas. When he could not afford better materials he relied on whatever was available, including shoe polish and house paint on cardboard.[1]

As a young man Swearingen began to "turn away" from his parents, rebelling and getting into trouble. He stopped attending church and he lied to his father. After seeking the aid of various healers his parents finally enlisted the help of a fortune teller in Waco, with whom Swearingen stayed for a period of two weeks. During this visit, the fortune teller prayed for him and gave him special medicine to rid him of the devil. He had a powerful religious vision in which he saw his own death and was commanded to preach God's word. But his behavior improved only temporarily. Suffering another setback, he got into fights and began to carry a pistol. Within a short period of time his mother and several other friends and relatives died, and Swearingen believed his disobedience to God brought about their untimely deaths.[2]

Around 1926 Swearingen married Lora Ann Williams, and fathered a child who did not survive. The couple divorced and Swearingen traveled west, working his way first to Arizona and then on to California by chopping cotton, picking grapes, and doing construction and railroad work. He worked as a longshoreman in San Pedro, California.

In 1948 Swearingen received word that his father had taken ill, and he returned to Texas. But by the time he reached Chappell Hill, his father had died. Swearingen decided to stay in Texas. He settled in Brenham, the county seat of Washington County, and resumed farming. In 1949 he married Murray Lee Williams. His new family included her two sons and two daughters.[3]

The Devil's Got the Church on Wheels, n.d.

In 1962 Swearingen received his final religious calling. He completed a correspondence course from the Lone Star Bible School in 1965 and was ordained in Huntsville.[4] After returning to Texas Swearingen had begun to devote more time to his art, and many of his paintings reflected his religious beliefs. He often spent his days painting and preaching outside the Washington County Courthouse.

Swearingen sold his paintings from his truck, and he also set up a roadside stand in front of his house. His rural scenes were popular with locals and with travelers who passed through Brenham on their way between Houston and Austin, and soon collectors began to discover it. Swearingen was featured on the television series, *The Eyes of Texas*. Among those who saw this program was Gaye Hall, who subsequently began selling his work in her Houston store. His work was first exhibited in the 1980 exhibition, *Eyes of Texas: An Exhibition of Living Texas Folk Artists*, co-curated by Hall and David Hickman at the University of Houston. He had business cards made, announcing himself as

> One of the best and oldest true
> primitive FOLK ARTISTS around
> today.
> All My paintings are subjects or
> scenes from everyday life and are
> treated realistically.

Swearingen's paintings are important documents of rural East Texas life in the early twentieth century. His work chronicled daily events, farm work, church services, baseball games, rodeos, and other activities familiar to himself and those around him. His paintings told the story of African American life through his own perspective and experiences. He explained, "Painting's just part of my life. I paint to make people happy. I love it. It's a gift from God."[5]

Satan appears frequently throughout his work. Often humor and biting social commentary are evident in works in which Swearingen depicted the Devil disrupting church services, greeting parishioners at the door, and even preaching from the pulpit. He explained, "Every time the preacher opens up the church, there stands the Devil with his hand on the Bible, waiting to put words in the preacher's mouth."[6] In *The Devil's Got the Church on Wheels*, the Devil brazenly claims the souls of worshippers at church. Not content to claim them one by one, he has placed the entire church on wheels, attached it to a motorcycle, and is depicted in the act of towing the church straight into Hell where the damned wait to be counted.

Swearingen's serious side was reflected in works with such subject matter as the Passion of Christ, scenes of slavery, and views of the nursing home in which his wife was confined toward the end of her life. Swearingen also painted works that were manifestations of his visionary experiences. He believed that God was with him throughout his creation of certain inspired works. In some of these he included written text which narrated the scenes, alluded to Bible verses, and sometimes represented dialogues between the figures. Swearingen sometimes used these works to illustrate his own lengthy sermons which he often delivered to his visitors.

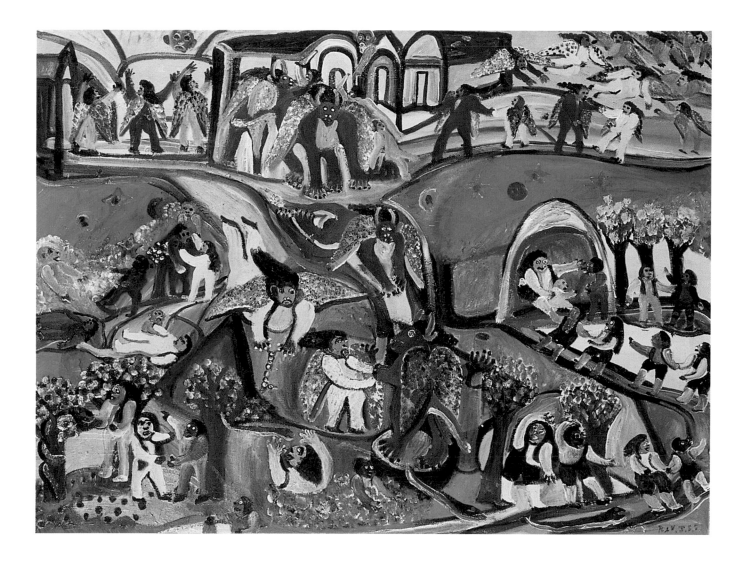

Going to Hell, 1990

Swearingen's innate sense of composition, color, and form were at once naïve and sophisticated. He developed a form of continuous narration that he frequently incorporated in his larger, more complex works. In these paintings multiple scenes tell a story that unfolds from one scene to the next. Swearingen composed his works to guide the viewer through the story, often using a winding road or hilly terrain as a device to move the eye through the intended action.

The Creation of the World, from the 1970s, is a magnificent example of his visionary work as well as one that incorporates continuous narration. The subject was one he repeated, and has its sources in both the old and new testaments of the Bible. In this work the simultaneous representation of multiple scenes tell the stories of Satan, the fallen angel; Adam and Eve; and Cain and Abel.

Although his figures were not executed with great detail they expressed emotion, and even animals assumed personalities. Joyous figures with outstretched arms in his painting of the Washington County Fair express the glee of excited children. Swearingen often said that a picture was not complete unless it had a dog or a child in it.

Early in his career Swearingen mixed all combinations of media, including oil paint, house paint, and even shoe polish, and his preferred surface was masonite. Toward the end of his career he was supplied with stretched canvases. His palette was determined by the age of his brushes, as he never cleaned them. The result is colors that range from very fresh in some paintings, to very muddy in others. Occasionally he painted on found materials such as the lunette-shaped board he used for *Cotton Picking*, which may have been a remnant salvaged from a construction project. Nowhere is Swearingen's depiction of a landscape more successful than in this picture, in which he exploited the shape of the board to capture the roundness of the Washington County terrain that so inspired him throughout his career.

Swearingen's wife of more than forty years, Murray, died in 1990. He continued to make art, creating some fine religious paintings as well as a picture of his wife's funeral, before his own health began to decline. A series of strokes affected his vision and the use of his hands, and eventually left him unable to make art. Johnnie Swearingen died in a Brenham nursing home on January 14, 1993 at the age of eighty-four. He left a body of work that established him as one of Texas' most recognized, and certainly one of its finest, self-taught artists.

[1] Johnnie Swearingen, interview with the author, Brenham, Texas, September 13, 1988; Bruce Webb, "Rev. Johnnie Swearingen," unpublished, 1995.

[2] Swearingen, interview with the author.

[3] Ibid.; Chuck and Jan Rosenak, *Museum of American Folk Art Encyclopedia of Twentieth-Century American Folk Art and Artists* (New York: Abbeville Press, 1990), 298–299. Although his wives shared the same last name, it should be noted that they were not related.

[4] Bruce Webb, "Rev. Johnnie Swearingen."

[5] Swearingen, interview with the author.

[6] Johnnie Swearingen, quoted in *Houston Home & Garden*, 1976.

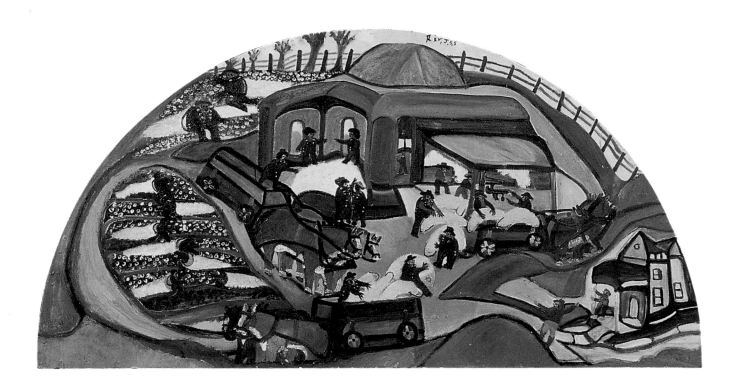

Cotton Picking, n.d.

*Adoration of the Magi, "Filippo
Lippy,"* 1973

Tom
Tarrer

b. 1927

Will Tom Tarrer[1] was born December 3, 1927 to Turner and Lila Tarrer in Chatfield, Texas, a "quaint nineteenth-century village" northeast of Corsicana. Tom was the elder of the Tarrer's two sons. His father was a livestock and feed farmer who also worked in the Malakoff coal mine for many years. When Tom was fourteen the family moved to Corsicana.

As a young man Tom Tarrer moved to Dallas to attend printing school, but ended up working in a hospital for a number of years. In the 1950s, inspired by carved chalk cows he had seen for sale on the side of the road, Tarrer got a piece of limestone and, working with a pocket knife, carved an Indian on a horse. When he was finished he took the carving to the hospital, seeking the critical advice of a co-worker who had studied art for two years in college. His friend suggested he work on the piece some more, and Tarrer followed his advice. When he brought the piece in a second time it met with his friend's approval, although he suggested that Tarrer paint the carved piece. Tarrer took the piece home and painted it and again showed it to his friend. After praising the work his friend suggested that Tarrer try carving wood. Acting on this advice, Tarrer completed his first carved wood scene, a symphony orchestra, in 1961. During the next twenty years he carved hundreds of scenes and figurines.

Carving for the amusement of himself and others, he enjoyed giving his work as gifts to friends, relatives, and neighbors. He explained, "I just enjoy it. If others enjoy it, well, that's what it's all about."[2] Tarrer taught himself to draw and began the practice of making drawings which served as sketches for the carved pieces. He has also made between 200 and 300 acrylic paintings on posterboard.

In 1963 Tom Tarrer married his wife, Maurine, his "greatest critic and helper." She gets paint for him when he needs it, gives her opinions on colors, and offers encouragement and support. Following his marriage he continued to pursue his interest in carving, storing the pieces in boxes in his garage. In the 1970s he went into the real estate business, which was experiencing a boom, and by the year 1976 he no longer had time for carving. Then the real estate market went bad, and one summer he decided to take the carved figurines out of the boxes and paint them. Using one color at a time, he lined up the pieces—estimated at more than 300 figures—and painted them until his hand "just gave out."

*Washington Crossing the
Delaware*, n.d.

During the years he was actively carving, Tarrer twice took his work to exhibit in the Texas State Fair, but found it to be "too much trouble." Around the year 1990 his nephew began to take the works to flea markets and galleries, including the American Gallery on Elm Street. The gallery began to carry his work, where it became popular with customers.

Tarrer enjoys reading, and often a title, or even just a sentence, will give him an idea for a scene. A self-described history buff, historical scenes are among his favorite subjects, especially those depicting significant events and figures in American and Texas history. He has also created a large collection of British and French soldiers. *Washington Crossing the Delaware* is one of many historical events he has depicted in his work. This work is typical in that it includes a construction of small carved figures positioned on a base before a painted backdrop that provides a setting in which the action takes place.

He also completed a "whole set" of Biblical scenes, reflecting his spiritual devotion. The idea for his carving based on Fra Fillippo Lippi's *Adoration of the Magi* was found in an old art book. The figures are delicately carved and carefully painted, with Tarrer's choice of colors based on those of the original he wished to imitate in his three-dimensional tableau.

Other favorite subjects are drawn from the Old West, with Indians, cowboys, buffalo, gunfights, and bar scenes being particular favorites. Tarrer considers himself a "big fan" of Charles Russell and Frederic Remington. His *Midnight Around the Campfire* displays an extraordinarily successful solution to the challenge of depicting figures illuminated only by moonlight and the glow of a campfire in this romantic western scene.

In 1996, twenty years after he had ceased carving, Tarrer decided to try again, uncertain that he would be able to carve after all the years. He found that he still had the ability, and has carved well over a hundred new figurines and scenes. He continues "because it entertains people and they enjoy it." As to the source of his creative energy, Tarrer explains,

I don't have any talent. My talent came from the Lord Himself. I didn't have any training or any experience. I found out I could do it. It just came to me out of nowhere and I've been doing it ever since. The talent's not mine. It came from above.[3]

[1] All biographical information, Tom Tarrer, telephone interview with the author, May 13, 1997.
[2] Ibid.
[3] Ibid.

Midnight Around the Campfire, n.d.

Clyde Barrow, Pretty Boy Floyd,
Bonnie Parker, and Fred Douglas, n.d.

Rev. L. T.
Thomas

1904–1995

Lilion T. Thomas[1] was born October 9, 1904 in Calvert, Texas, east of the Brazos River in Robertson County. Lilion (L. T.) was one of Rev. Andrew and Annie Thomas' thirteen children. In addition to being a preacher, Andrew Thomas was a farmer and architect-carpenter who built churches. L. T. received a fourth grade education, then became a cotton farmer. He said he received "a PhD on his knees" and became a preacher, serving as pastor at a succession of country churches in the area around Calvert. He was married twice.

L. T. Thomas had the ability to see spirits and devils, and to "cast them out." Throughout the 1940s and 1950s, he exercised this gift by working with Annie Buck Hanna, who apparently was a well-known fortune teller in Corsicana. Among L. T. Thomas' special powers were the ability to make it rain (or to stop raining when necessary) and to stop bleeding by praying and reciting certain Bible scriptures known as "conjures" which, when read at certain times or repeated a certain number of times, apparently had powerful effects.

In the 1940s while a pastor at Mt. B Zion Baptist Church in Kerens, Texas he began drawing in his spare time "to keep his mind busy." He explained, "All the folks is out gambling, drinking beer, chasing women, and cussing, and so I drawed to keep myself company."[2]

The subjects of his drawings were the outlaws Clyde Barrow, Pretty Boy Floyd, and Bonnie Parker, whom he claimed to have known. Using pencils, ballpoint pens, and occasionally crayons, Thomas repeated their portraits over and over again in an obsessive manner. His earliest drawings were frontal portraits, and later he drew the figures in profile. He depicted the charming figures dressed in uniforms of the First World War era, and occasionally they appeared riding horses or flying primitive airplanes. When asked where he got the ideas for his pictures, Thomas answered, "My mind just gives it to me, and the old man upstairs gives it to my mind." He displayed row upon row of the repetitive drawings in his church, and he often gave them to members of the congregation.

For a time Thomas preached on a radio show from Corsicana, Texas. In the 1960s he moved to Abilene, where he became the pastor at Mt. Pleasant Baptist Church and continued to draw in his spare time. Thomas received the nickname "Thunderbolt" Thomas

because, he explained, "I don't play in the pulpit. . . . I don't run no women, I don't drink no whiskey. You live what you preach."[3] After decades of preaching, eventually Thomas was confined to a nursing home in Abilene, where he died in 1995.

[1] I am grateful to Bruce and Julie Webb, Waxahachie, for providing biographical information on Rev. L. T. Thomas which formed the basis of this essay.

[2] Chuck and Jan Rosenak, *Contemporary American Folk Art: A Collector's Guide*, p. 259.

[3] James Salzer, "Minister puts in request for rain," *Abilene Reporter News*, June 4, 1985, 1A.

Clyde Barrow, Pretty Boy Floyd,
Bonnie Parker, and Fred Douglas, n.d.

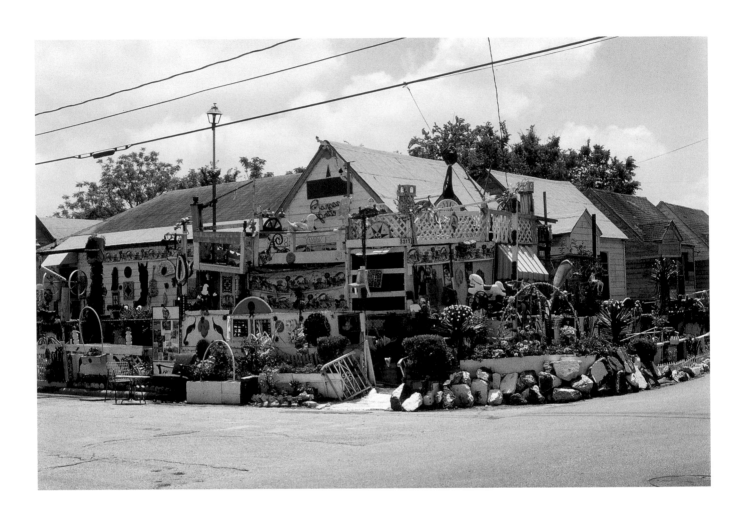

Cleveland

Turner

b. 1943

Cleveland Turner[1] was born near Jackson, Mississippi in 1943, where his parents were farmers. His mother and his aunt were gifted gardeners, and as a child Turner dreamed of living in a house surrounded by flowers. Unlike other children who often trampled flowers in their play, Cleveland respected them. His mother and aunt rewarded this behavior by sharing their knowledge of gardening with him.

As a young man Turner left rural Mississippi and headed west toward California. When he stopped in Houston, he was "dazzled by the city and the temptations that were present on every corner," and decided to stay. He found work as a sheet metal worker, a job he held for the next seven years. However, he also became addicted to alcohol and eventually "went down on skid row." Finally, in 1982 he was twice hospitalized with severe alcohol poisoning. During the second hospitalization he recalled his boyhood dream of living in a house surrounded by flowers, and he made a pact with God: if God would help him stay sober, he would create a place of beauty in His honor.

Turner began participating in Alcoholics Anonymous and took a part time job as a gardener. He also began the construction of a most unusual garden as a spiritual offering for his continued sobriety. With planted flower beds and brightly painted found objects he transformed his shotgun house on Sauer Steet in Houston's Third Ward into a neighborhood landmark. He built an observation tower and a shade porch, and he covered the walkways with red carpet. Paintings and drawings of figures including Martin Luther King, Jr., the Pepsi Girl circa 1955, Mickey Mouse, and Mahalia Jackson were part of the garden design. Turner's home became known throughout the neighborhood and beyond as the "Flower House."

In the 1980s the neighborhood was undergoing serious crime problems, and in 1988 Turner's home fell victim to a malicious act of arson. The home sustained serious damage in the blaze. In his rage, Turner destroyed what was left of the garden. He moved into a house a mile and a half away. Soon the spirit of survival in which he had begun the original garden prevailed, and Turner began to decorate his new home.

Within a year Cleveland Turner had created a new place of beauty on a corner lot on Sampson Street near the University of Houston. Turner's house stands in colorful contrast to the monochromatic rhythm created by the weathered wood of shotgun houses that share the street. The house and garden are embellished with objects he had collected since childhood including a mule harness from his parents' farm in Mississippi now attached to the side

of the house. A faux well includes an authentic winch. As a child Turner had fallen into a well and the winch is the one his father used to rescue him. Other objects are those Turner collects on his bicycle travels throughout Houston.

Prominently displayed in Cleveland Turner's yard is a concrete sign that contains memorabilia including his certificate from AA given in honor of five years of sobriety. The gardener's reward for his efforts is a place where beauty flourishes, a gift to all who encounter it.

[1]Biographical information from The Orange Show Foundation, "The Flower Man," *The Orange Show Newsletter*, Winter 1996-97, n.p.; David Theis, "Flowering Environments," *Houston Press* Vol. 6 No. 22 (June 2-8, 1994), 11; Susanne Theis, telephone conversation with the author, June 13, 1997.

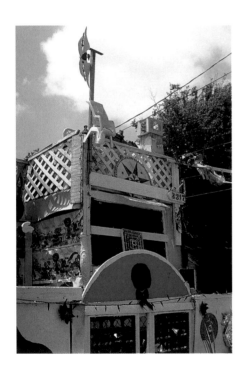

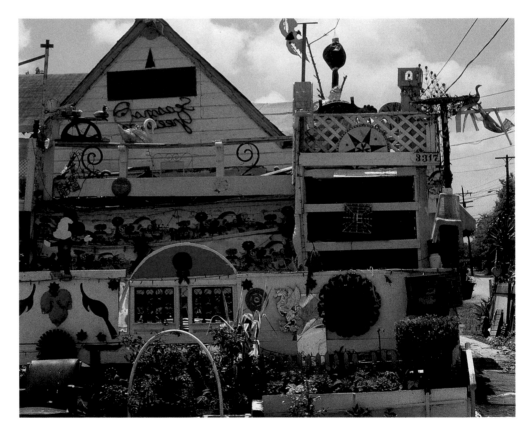

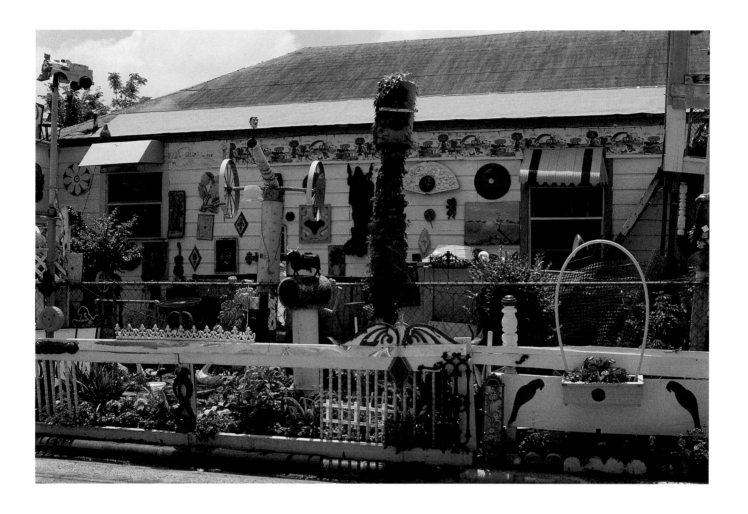

Mama Blows the Horn, 1967

Velox

Ward

Velox Ward was born in 1901 near Winfield in Franklin County, Texas where his father, Frederick Bowers Ward, was a farmer. Velox was named after his mother's German-made sewing machine. On the machine, beneath the brand name of Velox, the words "Speed and Accuracy" were emblazoned. Apparently this was a source of great pleasure to Velox, who enjoyed pointing to the slogan and exclaiming, "That's me!" His childhood was marked by such typical early twentieth-century rural Texas activities as attending school in a one-room schoolhouse, brush arbor revivals, and large family gatherings, and engaging in various youthful outdoor adventures.[1]

In 1910 Velox's father gave up farming and moved the family from East Texas to Foard City in West Texas, where he opend a general mercantile store, a lumber yard, and a grocery store. After two years of severe drought Frederick Ward's business went broke and the family returned to East Texas, where he opened a sawmill. This venture also soon failed, and in 1914 the family moved back to West Texas. In 1917 they moved to Everton, Arkansas where Ward again tried farming. It was to be his last business venture. He died after contracting influenza during the deadly 1918 flu epidemic.

Velox, in the seventh grade at the time of his father's death, was forced to give up his formal education and he began a colorful series of vocations to support himself. His first business was catching and killing wild animals and selling the skins. When he had saved enough money, Velox and his mother moved back to Mt. Pleasant, where he planted a crop of cotton and also worked at a machine-shop and foundry. From there he worked a succession of jobs including car painting, ministry, and professional wrestling (where he was known as "Bullet Head" Ward).[2]

In 1925, after seven years of courtship, Velox Ward married Jessie Baines Howell. The couple had three children, Velox Jr., Anita, and Fred. Ward repaired shoes and restored and repaired furniture to support the family and pay for his children's college educations.[3]

Velox Ward's art career began in 1960 when his adult children asked him to paint each of them a picture for a Christmas present. Ward explained,

I figured that was a good deal, so I went out and bought three brushes, five tubes of paint—red, yellow, blue, black, and white—and four 10" x 12" canvases. I knew neither of them would want my first attempt and I was right. However, I found I really enjoyed painting and after completing theirs, I got two more canvases.[4]

He developed a practice of painting at night and hanging his canvases in his shoe repair shop, where he would study them throughout the day. He would then take them home and correct them at night. One day a leather salesman came into the shop and saw his work, and asked him if he could paint a picture from a photograph. He agreed to try, and a woman who saw the painting asked him to paint a picture of her grandparents' old home. When the leather salesman returned for his painting, he was very pleased with the result, and paid Velox $35.

Ward's painting business continued by word of mouth, until finally he stopped repairing shoes and devoted himself to painting full time. Soon his work came to the attention of Donald and Margaret Vogel, owners of Valley House Gallery in Dallas, and they began to represent him. In 1972 a solo exhibition of the work of Velox Ward was organized by the Amon Carter Museum in Fort Worth. The exhibition was shown in six additional Texas museums.

Velox and Jessie Ward built a home in Longview, Texas with a small studio behind the house where Ward continued to work in the evenings. Jessie was the model for many female figures in the paintings and Ward's beloved dog, Muggs, modeled for the canine figures. Painting was to become Ward's final occupation, the one he enjoyed the most, and which he found continually challenging. In 1970 he wrote,

I have been painting for ten years. . . . That is the longest time I have ever spent in any voca-tion. Since I have started painting, I have found something I can't seem to master. I won't be satisfied until I can paint a house so real that someone will try to open the door, or paint a mule or horse that anyone might say "getty-up" to. . . . I will be striving the rest of my days to attain what I want on canvas.[5]

I get a lot of pleasure from watching people admire my paintings as they remember the "good ole days." The rural life of my boyhood has influenced most of my work. Some people see things they've never seen before and might not see again . . . country churches, the old cotton gin, sorghum making, scenes around the farmyard and even the outhouse with the Sears and Roebuck catalogue inside. . . . I always try to have some humor and pleasant things in my paintings. It is a pleasure to see people smile as they view them. . . .[6]

Mama Blows the Horn, from 1967, reflects Ward's desire to portray life as he experi-enced it in "the good ole days." All elements in the painting focus our attention on the central figure. The horizon line and the diagonal created by the fence converge at the figure, who occupies the center of the picture. The bright red of her dress contrasts with the cool colors of the landscape and the drabness of the house and earth; the red color is repeated in the chicken which runs toward her, and in livestock grazing on the hills leading toward the tiny figures of men who are being summoned to their mid-day meal. On the table inside the house Ward created a miniature still life rendered in great detail.

Ward referred to his work as "buildups," because they were developed from various sources including photographs, memories, and his own imagination. He frequently created paper cutouts, which he called " dollies," arranging them until he achieved the proper per-spective, and tracing them onto the canvas.

The enigmatic painting *The Life of a Tree*, dated 1961, in which the image of a log house is embedded in that of a great tree, looks like the work of a surrealist. Like the central figure in *Mama Blows the Horn*, all activity in this painting leads our attention toward the tree

at the center of the painting. A road leads the viewer into the picture from the left; a fence leads the eye toward the tree from the right. Both lines continue outside the frame and come to an abrupt conclusion behind the tree, and the landscape to the left of the tree does not correspond with that on its right. The painting's title leads the viewer to thoughts of the tree as a natural resource; the tree as a home to birds and other animals; the tree as a silent witness to changes in the environment both natural and man-made. In reality, the work was inspired by a photographic image —in this case, a double-exposure.

Velox Ward continued painting until 1989, when he was forced to stop due to poor health. He died in December 1994. In the three decades that comprised his art career he completed an estimated 200 paintings that document his memories of rural Texas life.[7]

[1]Donald and Margaret Vogel, *Velox Ward* (Fort Worth: Amon Carter Museum, 1972), 15–16.

[2]Ibid., 20–26.

[3]Ibid., 25–26.

[4]Ibid., 26.

[5]Ibid., 29.

[6]Ibid.

[7]Velox Ward, Jr., telephone conversation with the author, June 6, 1997; Chuck and Jan Rosenak, *Museum of American Folk Art Encyclopedia of Twentieth-Century American Folk Art and Artists* (New York: Abbeville Press, 1990), 317.

Boar's Head, 1988

Willard

Watson "The Texas Kid"

1921–1995

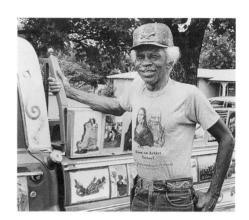

Willard Watson was born June 17, 1921 on a plantation near Powhatten in Caddo Parish, Louisiana, the seventh of L.T. and Mary Liza Frazier Watson's eleven children. His father's parents were freed slaves from Louisiana, and his mother's family relocated from Virginia first to Mississippi and then to Louisiana following emancipation. Watson claimed a combined ancestry of African, Choctaw, French, and Cajun.[1]

L.T. Watson did not accept Willard as his biological son, and as a result Willard suffered abuse and neglect throughout his childhood. As a young child Willard frequently accompanied his mother on fishing excursions. He was given the responsibility to watch for snakes and to frighten them away while his mother fished. Willard enjoyed looking for animal forms in tree limbs and roots he found in the woods. He began to collect these objects and to finish carving the figures that the natural forms suggested. Among the many figures he carved throughout his life, he especially enjoyed the snakes that were inspired by his early childhood experiences.

In 1928 the Watson family left Louisiana and relocated to Dallas in search of a better life than sharecropping offered them. The train trip made a great impression on seven year-old Willard, and he was thrilled at the sight of the towering Magnolia building (the tallest in Dallas at the time) with its spectacular flying red horse, the logo of the Mobil oil company. The family settled in north Dallas, where they enjoyed a "four room house with a kitchen, lights, gas, water, running bathwater and everything. That was all in the house. Hadn't had that, you know."[2] Willard attended the B.F. Derrell School where his fondness for drawing was encouraged by his beloved art teacher, Mrs. Thrash, whom he remembered years later as the person who had the greatest impact on his life.[3]

Watson left school and home at the age of fourteen during the height of the Great Depression. He began frequenting the east end of Elm Street known as "Deep Ellum," the hub of life for Dallas' African American population at the time, where he led a dissolute lifestyle that included drinking, gambling, fighting, and pimping. When World War II began, he was drafted into the U.S. Army and was stationed in the South Pacific. After receiving a medical discharge he returned to Dallas, and worked at a variety of jobs throughout his life. He was married seven times and fathered a daughter.

In the early 1960s Watson finally settled down, marrying Elnora Kitchen, his seventh

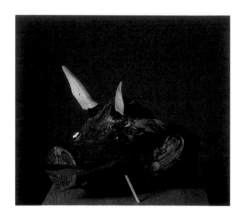

Boogie Woogie Bull, c. 1980

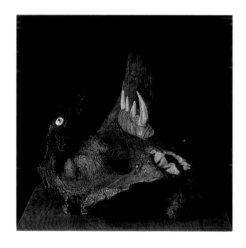

Two Headed Thing, 1985

and final wife. Around the year 1968, Elnora's relatives in Marietta, Oklahoma gave Watson the nickname "the kid from Texas." When the citizens band radio craze hit the U.S. Watson took the "handle," "The Texas Kid," the name by which he became widely known.

Miss Elnora, as she was called, was a religious woman—and proved to be a stabilizing influence in Watson's life. In 1973 while vacationing with Elnora, Watson was baptized at the Pleasant Hill Baptist Church in Shreveport, Louisiana. The couple bought a home on Kenwell street near Dallas' Love Field. Enjoying both the sense of permanence and the creative freedom that home ownership afforded him, Watson began to decorate his front yard. Eventually he transformed it into an environment that became a well known and important example of African American yard decoration.

He also decorated his red 1967 Ford pickup, and one day in 1976 while driving it he was noticed by Claire Frost, artist Bob Wade's agent. Wade was working on his *Bicentennial Map of the United States* project, a football-field size installation near the intersection of the LBJ Freeway and the Dallas North Tollway. Wade invited Watson to contribute to the project. He built a lighthouse to represent the state of Maine, and his own decorated Cadillac represented Detroit, Michigan. Wade found him to be "one of the most inventive guys around,"[4] and the two established a lasting friendship. When it was time to dismantle the *Map*, Watson selected objects from it to add to his yard show.

Among outdoor environments certain yard decoration traditions represent a distinctly African American form of expression. According to Robert Farris Thompson, who has undertaken extensive study into the African antecedents in African American environments, formal principles are followed and distinctive elements are repeated to convey certain universal meanings that reflect the "artistic and philosophic values of classical Kongo culture." Far from being casual or accidental in their design, decorated yards serve as "go-betweens intended to summon a world of benevolent spirits and banish hostile ones." Willard Watson's yard stood as an archetypal example of this type of environment, in which "the house guards the spirit of the owner, and the icons in the yard guard or enhance that spirit with gestures of protection and enrichment."[5]

The overall appearance of Watson's yard was one of balance and symmetry. Certain figures and elements were arranged in pairs, while others were arranged asymetrically within the yard. At the front of Watson's yard sixteen white-washed cement pylons visually established territory and discouraged intruders and evil forces from entering. Inside the yard a Texas-shaped mirror in the front door and a rectangular one beneath the bedroom window reinforced the protection of the pylons by reflecting evil back upon itself. Watson explained, "I can tell what you are doing by mirror reflection."[6]

Figuration is another of the classic African American yard show elements identified by Thompson. Among the figures that inhabited Watson's yard were a pair of plastic Venus de Milo figures, spray-painted gold, which flanked the sidewalk leading toward the house.

The "motion emblem" is frequently articulated in yard shows through the circular forms of wheels, hubcaps, and tires. Motion emblems, according to Thompson, are related to the Kongo view of the spirit journey as circular and may also "mystically 'wheel' anti-social spirits

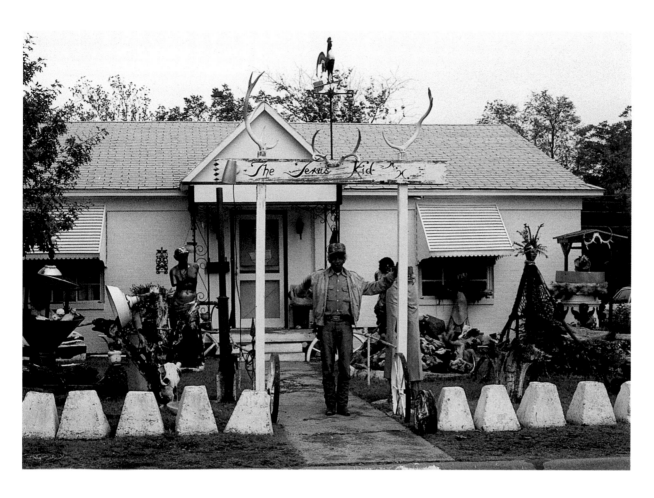

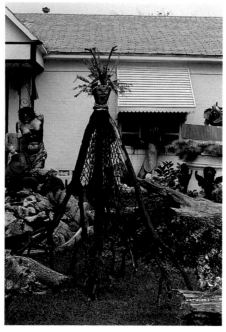

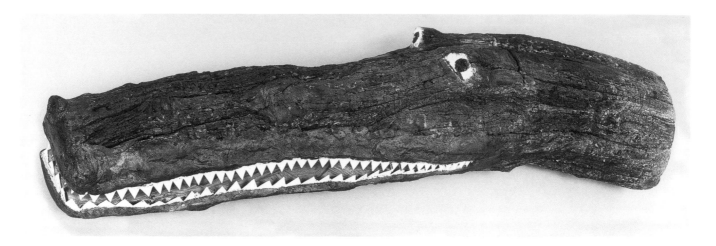

Texas Kid Crocodile, 1980

off the premises."[7] Watson incorporated motion through balanced wagon wheels that edged the sidewalk and porch of his home.

In African American yard decoration, graveyard allusions symbolically link the yard to the spirit. Graveyards are frequently represented by rockpiles. Watson incorporated a rockpile in his yard that formed a volcano activated when he ignited a mixture of water and gasoline to produce smoke and sound effects. But he also made a more literal reference to the graveyard by incorporating a mock grave, at once both ominous and humorous.

Yet another Kongo tradition that predominates throughout African America is the use of unusual wood forms from the forest and driftwood from the water. The ability to see anthropomorphic forms in roots, limbs, and driftwood—materials held sacred by African artists for their great spiritual powers—is not uncommon among African American visionary artists. Watson was one of many artists who have created sculpture from natural, found materials. These artists echo the belief that their role is to give physical form to a spiritual presence already inherent within the natural materials, or as Watson explained, to "finish where nature left off." One way the spirit can be activated is by turning it upside down to reflect the vantage point of the other world. Watson included such objects in his yard, including a dead tree which he inverted and for which he fashioned a magnificent head adorned with feathers, glitter, beads, and paint. Dressed in a cape of fish net, this commanding figure seemed to keep a watchful eye over the yard.

Although Watson's yard show is now understood as a New World manifestation of ancient African traditions, its significance was not always appreciated. In 1982 a neighbor complained to local authorities about the yard and traffic congestion created by its visitors. When Watson received a citation for "illegal open storage" other neighbors came to his aid, signing a petition in favor of allowing the yard show to remain. Considerable attention was given the

case in the Dallas press. When a hearing was held in July 1983 Watson's friend Bob Wade was among those who spoke on Watson's behalf, and Watson was allowed to keep the yard.

While he was working on his yard show Watson also continued to make sculptures from found natural forms, and he began to draw colorful pictures in which he documented his life experiences. Beginning with the Louisiana river bottoms of his childhood and continuing with Dallas street scenes, he revisited the everyday activities and poignant events of his life. Watson believed that he was born with the gift of artistic talent, and that he had a "photo-static mind" which enabled him to remember everything he saw in order to later paint or sculpt the image.

As the years passed, Watson's celebrity status grew. He dined with movie stars and politicians. He became a popular member of the Dallas art scene and appeared at Democratic party functions as well as society parties, always attired in the elaborate costumes he designed and sewed for himself. He was featured on various television programs and in the print media. David Byrne used his yard as well as the interior of his home as the setting for a pivotal scene in the 1986 film *True Stories*, bringing national attention to the environment. The same year Watson was given a cameo role in Jonathan Demme's film, *Something Wild*. He enjoyed the attention and more importantly, the acceptance he finally received from his family.

During the final years of Willard Watson's life, he suffered increasingly from emphysema. His declining health curtailed his art activities, but he continued to draw on the days when he felt well enough to do so. In 1994 Elnora, his wife of thirty years, died. On March 28, 1995 Texas' most celebrated self-taught artist was hospitalized at Dallas' St. Paul Hospital, where he died June 12, 1995, five days before his seventy-fourth birthday.

After Watson's death, his yard environment was dismantled, and objects were sold at an auction in September 1995. Unfortunately, accurate records were not kept from this sale and the locations of many of the pieces are unknown. Although it was ultimately destroyed—a fate that befalls a great number of such works after the death of their makers—Willard Watson's yard will be remembered among the most significant examples of African American yard decoration in the United States.

[1] All biographical information, Willard Watson, interview with the author, Dallas, August 20, 1988, except where otherwise noted.

[2] "The Texas Kid Comes Home," *Shreveport Journal*, April 6, 1990, Sec. B, 1–9.

[3] Colleen O'Connor, "Willard Watson," *The Dallas Morning News*, December 3, 1989, Sec. E, 2.

[4] Bill Marvel, "An artwork in Himself: The Texas Kid Draws on a Colorful Past," *Dallas Life Magazine, The Dallas Morning News*, August 29, 1993, 8.

[5] Robert Farris Thompson, "The Song that Named the Land: The Visionary Presence of African-American Art," Alvia J. Wardlaw, ed., *Black Art/Ancestral Legacy* (Dallas: Dallas Museum of Art, 1989), 97–141, traces African elements within African American yard show traditions that form the basis for understanding them in Watson's work. See also, John Beardsley, *Gardens of Revelation: Environments by Visionary Artists* (New York: Abbeville Press, 1995), 178.

[6] Thompson, "The Song that Named the Land," 130.

[7] Robert Farris Thompson, "The Circle and the Branch: Renascent Kongo-American Art," *Another Face of the Diamond: Pathways Through the Black Atlantic South* (New York: INTAR Latin American Gallery, 1988), 29–30.

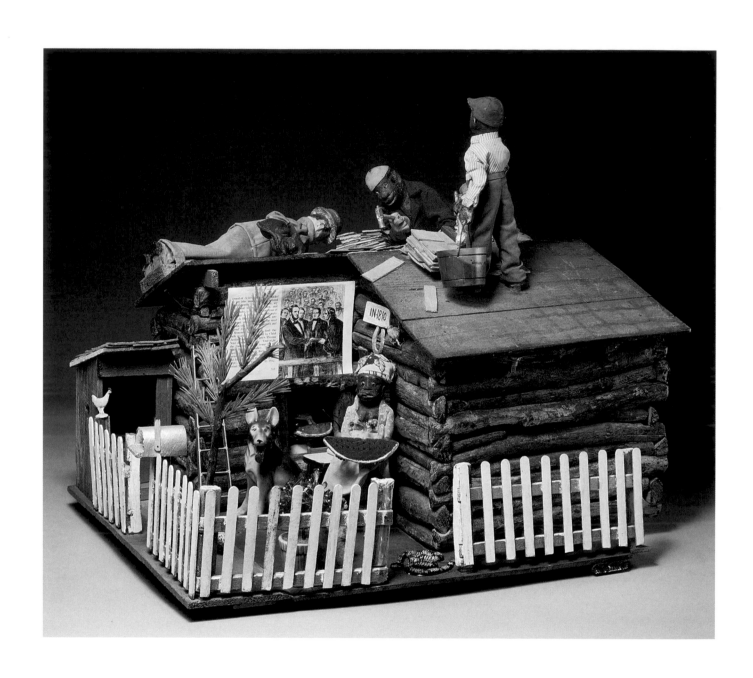

Emancipation House, 1964

George W.
White, Jr.

George W. White, Jr. was born September 8, 1903 in
Cedar Creek, in Bastrop County, Texas to George White
and Lilly Hodge.[1] His ancestry was a mixture of Afri-
can American, Native American, and Mexican American. He
attended Evo Elementary School in Cedar Creek until the age of
ten. At the age of seventeen, White left home to work in the
oil fields, and in 1925 he got a job as a cowboy on the Dou-
glas Ranch in Vernon, Texas. There he learned the craft of
leather working. In 1929 he went to work assisting a veteri-
narian in Post City, Texas. In 1932 White enlisted in the
Army, was stationed in Virginia, and traveled to Africa where
he saw and learned about wood carving. After being discharged
from the Army in 1936 he returned to Vernon, Texas, where he
became a well known bronco rider. In 1940 White went to
Petersburg, Virginia, where he took a job as a barber and
eventually became a deputy sheriff. Three years later he moved
to Washington, D.C., where he worked for the FBI and taught
leather crafting.

White's father died in 1944, leaving his mother, a brother, and his sister to run the farm
in Cedar Creek. The following year George White invented his secret formula, White's New
Discovery Liniment, which was "guaranteed to cure all." In 1956 White joined his family in
Cedar Creek, but a year later he moved to Dallas, living with a cousin. In the bathtub of his
east Dallas home, he began to produce his liniment, selling it on street corners. He aug-
mented this income by running a small barbecue stand.

In 1957 White met Lucille Williams while selling his liniment door to door. "He didn't
look all that good, but he seemed sincere," so Lucille bought a bottle of liniment.[2] The couple
married later that year and settled into a house on Clyde Street in Dallas, near the old Hall
Street Cemetery. The same year White had a dream about being a great artist. The following
morning he informed his wife, "When you come home from work, I'll have a surprise for you."
That day he created his first picture. The subject was a rodeo scene, and he had carved the
figures in low relief on wood and painted them.[3] The following year he began to work full time
at carving and painting.

The Old Hills of Kentucky, 1966

In 1967 master guitar maker and craftsman Richard Wilkinson met White and saw some of his woodcarvings, and he took his friend Murray Smither to meet White. Smither described their first meeting:

The day Richard took me down that narrow little road by the cemetery, George was sitting on his porch with a gun across his lap whittling out a figure with a big pocket knife. . . . [H]e had on his handmade boots and a Stetson hat; he wore a full white beard and not a very friendly look on his face.

When Smither was finally invited in, he found that

The inside of the Whites' small house was completely collaged in paintings and filled with carved mechanical figures. The effect was overwhelming. I knew I was seeing a rare collection of folk art and the intimate life of a unique man. Some of his constructions were outfitted with coin-operated motors that would be animated by inserting a quarter in a slot.

White called his home his "museum," and he dreamed of one day opening a real museum. His plan was to buy a bus and start a road show, selling his liniment for admission.[5]

During the twelve years of his art career, George White, Jr. created some twenty-eight painted low relief carvings and fifty three-dimensional mechanical tableaux that featured scenes from the Old West and depicted everyday activities of African American life. His wife, Lucille, created costumes for the figures, designed and sewn according to White's specifications and often fashioned from his shirts. When the pieces were completed White would often act out the voices of the figures, tape recording a narrative that was to accompany his art in his traveling museum roadshow. In addition to these works, White also created carved and decorated walking sticks and fine tooled leather pieces.

The Old Hills of Kentucky, from 1966, depicts a group of panting dogs who have been chasing a fox all night. In the typed description included on the picture, White described the moment he captured: "Now it is nine o'clock in the morning and A[u]nt Ann said, I hope they will cat[c]h him because he has eaten all of my chickens but two."

Emancipation House, dated 1964, includes both typical and stereotypical references to African American life. As is often the case in White's work, humor and serious social commentary are combined in the work. Beneath its toylike appearance lie symbolic references to the united effort necessary to achieve freedom, as figures work together to build the "emancipation house." A collaged image of Abraham Lincoln provides information as to the serious nature of the piece.

In *Butchering the Pig*, from 1968, White included a magazine clipping to complete the setting—in this case a slaughterhouse. A bloodsplattered figure has just completed the grisly task of eviscerating the carcass of a pig. White exploited the opportunity to graphically depict the event, including a vivid red gash down the center of the animal that reveals a still-intact kidney, and a bucket containing bloody entrails. His concern for detail is evident in the tiny beaded moccasins worn by the butcher. Hog butchering was an important event in rural life, comparable in significance to the harvesting of crops. It also provided sensational subject

Fishing Out on the Island, 1965

matter for art, and consequently it is a theme we find repeated in the work of a number of self-taught Texas artists.

Hunting and fishing, two of White's favorite activities, provided subject matter for a number of his works. The remarkable *Fishing Out on the Island*, 1965, combines painting, collage, and the ingenious addition of a three-dimensional carved fish linked to the two-dimensional picture by an actual fishing line. White has chosen to depict the dramatic moment in which the big fish has taken the bait and is about to be reeled in by an excited fisherman. Collaged figures in boats, their scale out of sync with the rest of the picture, paddle through waters in which giant fish wait to be caught.

In 1969 White made a certificate, typed and decorated with colored ribbons. The certificate, which he hung on the wall of his home, proclaimed that

G W White Jr has reached his destination in arts. . . . He is a great genius because he possessed high, mental powers or faculties of intellect, inventions, talent, taste, nature and character. . . . There are more historical inventions to be made by G W White Jr right at the standpoint he has more that his brains can hold now.[6]

He went on to list his accomplishments: "leather craft, wood carver, sculpture, artist, cabinet maker, mounting, brick mason, plumber, electrician, physiologist, farming, interior decorator, train horses and dogs, building contractor and barber."[7]

Although his dream of a traveling museum was never to materialize, White continued to document his experiences through his art until his death in Dallas on January 1, 1970 from blood poisoning caused by a minor foot infection. His body was returned to Cedar Creek for burial.

In 1975, through the efforts of Murray Smither the Waco Creative Art Center presented the first public exhibition of White's work; twenty-eight paintings and fifty constructions were included in the show. He was included in the landmark exhibition, *Black Folk Art in America 1930–1980*, organized by the Corcoran Gallery of Art in 1982—the only Texas artist in the show. Since his work became known to the public, White has become recognized as a self-taught artist of major importance.

[1]Biographical information is based on a chronology compiled by Murray Smither in *The World of George W. White, Jr.* (Waco: Waco Creative Art Center, 1975), 14.

[2]Bill Porterfield, "The Genius," *The Texas Observer*, November 1, 1974, 15.

[3]Smither, *The World of George W. White, Jr.*, 6.

[4]Ibid.

[5]Cecilia Steinfeldt, *Texas Folk Art: One Hundred Fifty Years of the Southwestern Tradition* (Austin: Texas Monthly Press, 1981), 147.

[6]George White, quoted in Smither, *The World of George W. White, Jr.*, 9.

[7]Ibid.

Pig Butchering, 1968

Chicken for Dinner, 1945

Clara McDonald
Williamson "Aunt Clara" ———————

1875–1976

Clara Irene McDonald[1] was born November 20, 1875 in Iredell, in Bosque County, Texas, the second of Thomas McDonald and Mary Lasswell McDonald's six children. Thomas, a carpenter by trade, and Mary were early pioneers in the area, arriving from Limestone County near Mexia by wagon train only a couple of years before Clara's birth. The family first settled in an abandoned log cabin, where Clara was born and lived for several years until the family relocated to a large frame house built by her father.

Iredell, located in a valley on the north side of the Bosque River, was newly settled at the time of Clara's birth. During her childhood the town grew into a typical rural community with a population of around 800, and it served as a stopover on the Old Chisholm Trail from the south to Kansas City.

Mary McDonald was a religious woman, and she made certain that Clara and her siblings attended the Methodist church as often as possible. Unfortunately, Clara was not able to attend school regularly. As the oldest daughter she was needed at home to help care for her younger sister and assist with household chores, and her responsibilities there took precedence over her formal education. Clara missed more days of school than she attended but she was an avid reader and a bright and eager student, and she pursued her studies as best she could. Throughout her childhood and teen years Clara's routine of hard work continued, leaving her no time for leisurely interests.[2]

Clara's opportunity to leave Iredell came when her uncle, Allen Lasswell, became the County Clerk of Ellis County in Waxahachie. He offered her a position working for him, which she eagerly accepted. She learned to type and became a dedicated and well liked employee. She was proud to learn the new skills and took great pride in her work. She greatly enjoyed her new life in the "big city" of Waxahachie.[3]

After seven years in Waxahachie, there was an upset in local politics, and Clara returned home to her parents in Iredell where she reluctantly resumed her household duties. Soon she was courted by John Pierce Williamson, a local businessman and widower with two young children. The couple married in 1903, and two years later Clara gave birth to a son, Pierce McDonald Williamson. In addition to the housework and child rearing, Clara also worked at her husband's dry goods store. Eventually her parents left Iredell, and the children grew up and began their own lives.

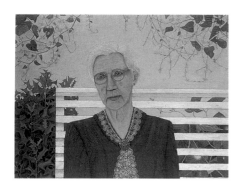

Self-Portrait, 1948

Around 1920 Clara and John moved from Iredell to Dallas, buying a home in the Oak Cliff neighborhood. For a time they operated a successful store. Eventually they sold the store and built a new home in University Park near Southern Methodist University. Clara planted bluebonnets in the yard, and took up painting. But her husband disapproved of spending money on painting, an activity which he considered a waste of time.

John's health was deteriorating and finally, after years of illness, he died in 1943. For the first time in her life, Clara "was left alone, with nothing especially to do."[4] Clara McDonald Williamson, now in her late sixties, responded to her new freedom and solitude by sketching in pencil, charcoal, and watercolor. She audited a drawing class at Southern Methodist University in the fall of 1943 but attended sporadically, finding it difficult to climb the stairs to the classroom. That winter she began sitting in on evening painting classes at the Dallas Museum School, where she felt more comfortable among the more mature student population.[5]

It was at the Dallas Museum School that she painted her first memory picture, *Chicken for Dinner*. The painting includes Clara's self-portrait, the child in the pink dress who takes the role of observer in the scene. It was Williamson's practice to portray herself dressed in pink in her paintings. In this painting we see Williamson's Uncle Joe plowing with his horse, Prince, and the home built by her father. The small V-shaped structure at the center of the painting is the school Clara attended as a child.[6]

At the Dallas Museum School Williamson met Donald Vogel, then a young artist who later became a gallery owner, and the two developed a lasting friendship. By spring 1945, with Vogel's support, her work was winning awards and purchase prizes in artistic competitions. Williamson responded to this recognition by pursuing her art even more seriously. She was given the title "Aunt Clara" at a dinner party for artists in a group exhibition, and the name stuck.

In the late 1940s, Vogel took a number of her canvases to New York, and received the offer of gallery representation for her work. But Williamson was adamant in her refusal, not wanting a "yankee" to handle her work.[7]

From the outset it was Clara's goal to depict "the good, the true, and the beautiful" in her work. She wrote in 1952,

There is nothing unusual or especially interesting in my efforts in the art of painting. I try to paint because of the love of the art. . . . I try to accomplish realism, truth, beauty, and some amusement in my pictures. . . . I often try to record my memories in my paintings I have never yet made a painting that measured up to my mental picture of the subject; yet it is always a challenge to try.[8]

One of Williamson's favorite themes was the cattle drive, the subject of her painting *Get Along Little Dogies* from 1945. As a child she had observed such scenes many times when herds of Longhorn cattle were driven across the Bosque River at Iredell on their way up the Old Chisholm Trail. The river played a central role in the life of the town, and it is equally important in many of Williamson's paintings. In *Get Along Little Dogies* the viewer is looking upstream from a high vantage point. The river and the trees that line its banks form a gentle curve as the river bends out of sight in the distance. This curve is contrasted by the

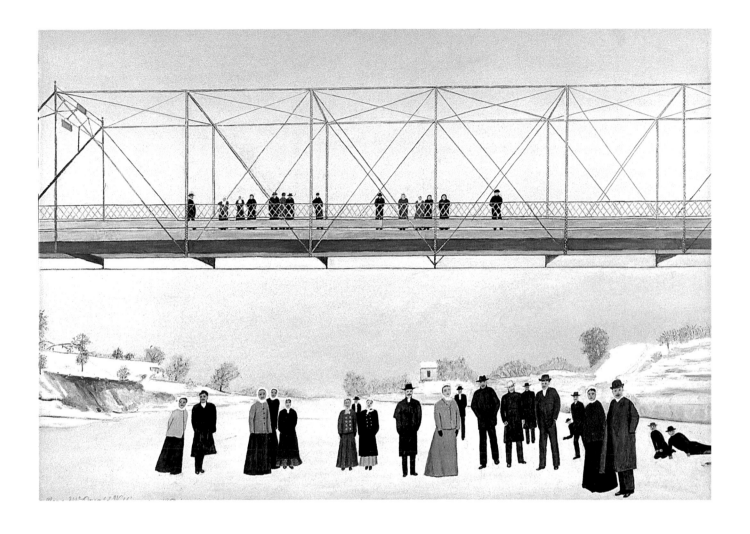

The Day the Bosque Froze Over,
1953

strong horizontal movement from right to left created by the line of cattle crossing the picture frame. One animal pauses to drink; another has wandered from the herd and is being chased by a cowboy. The artist depicted herself as a child standing under a tree in the foreground, observing the event from a safe distance. Farther upstream two boys have left their fishing poles in the water and climbed a tree to enjoy an elevated view of the scene, giving the impression that the interruption was sudden and unexpected. Williamson was critical of this early work, saying, "I wish I'd made them right while I was at it. When I look at some of my old pictures—well, I can find mistake after mistake in the one the Dallas Museum has *(Git 'Long Little Dogies)*."[9]

The Day the Bosque Froze Over, from 1953, is one of several paintings in which Clara McDonald Williamson depicted the "new" bridge built when she was a teenager. In this painting, Williamson portrayed a specific incident, "the only time that anyone could remember that . . . [the Bosque River] was frozen solid enough to 'drive a team of horses across.' Even the most timid walked daringly across the river on the ice this day, and told the unbelievers about it later."[10] Williamson, inspired by a photograph, chose to represent the moment when townspeople have gathered on the river's frozen surface to witness the extraordinary occurrence and to pose for a photograph documenting the event. The scene is viewed from the vantage point of the photographer. With a limited palette she captured the subtle nuances of a cloudless winter sunset. Because she composed the painting so that the ends of the bridge are outside the picture frame, the bridge appears as a strong horizontal seemingly suspended in space. The starkness of the scene in which dark figures appear silhouetted against the light colors of the landscape, the linearity of the bridge, and the frontal composition all contribute to the strongly geometric character of the work. It is at once both a nostalgic memory painting and a modern composition.

Clara McDonald Williamson spent the last seven years of her life in a Dallas nursing home where she made her last painting, a picture of her home in University Park. She died February 12, 1976 shortly after her one hundredth birthday, leaving more than 150 paintings in which she fulfilled her goal to "make some beauty."[11]

[1] Donald and Margaret Vogel, *Aunt Clara: The Paintings of Clara McDonald Williamson* (Austin: University of Texas Press, 1966), the most complete resource available on the artist, is the source of biographical information for this essay.

[2] Donald and Margaret Vogel, *Aunt Clara.* 37–39.

[3] Ibid., 79–82.

[4] Ibid., 95–101.

[5] Ibid., 100–102.

[6] Donald Vogel, interview with the author, Dallas, March 28, 1997.

[7] Ibid.

[8] Donald and Margaret Vogel, *Aunt Clara.* 102-106.

[9] Ibid., 50–51.

[10] Ibid., 57–63.

[11] Vogel, interview with the author.

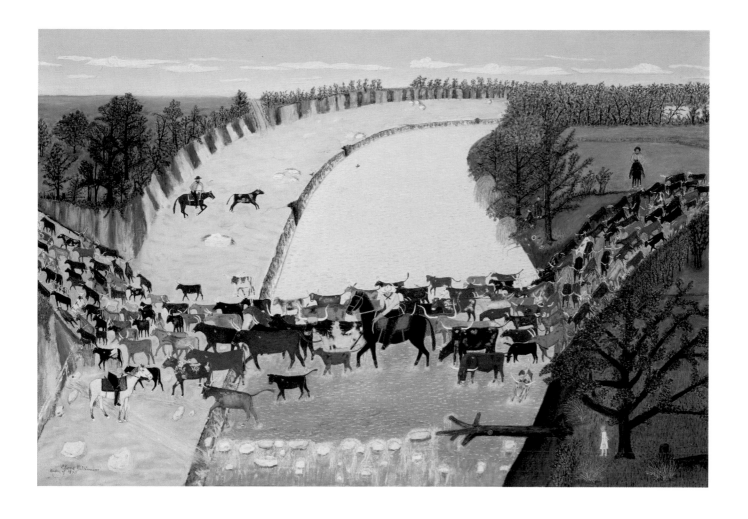

Get Along Little Dogies, 1945

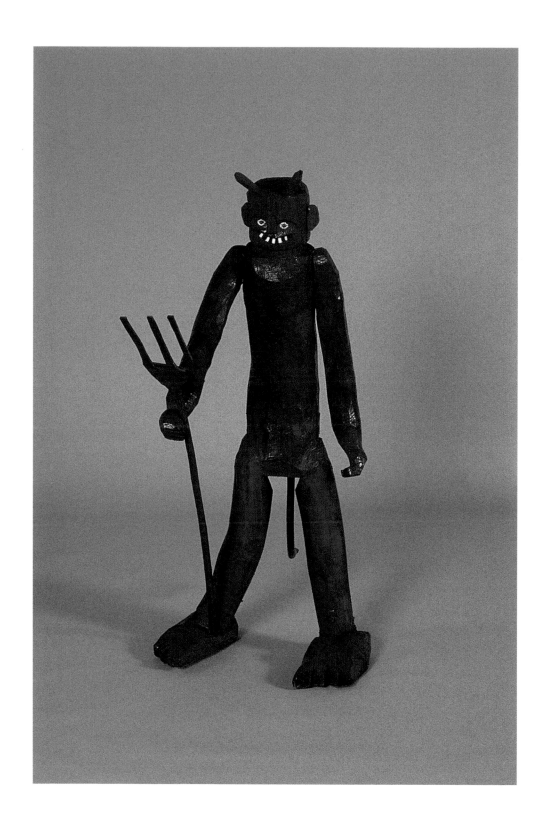

Red Devil, 1997

Onis

Woodard

b. 1926

Onis Woodard[1] was born September 25, 1926 in Elkhart, thirteen miles from Palestine in Anderson County, Texas to Isaac and Gaudrie Woodard. The family, which included Onis and his brother and a sister, moved to Palestine when Onis was a child. He attended school in Palestine until the eighth grade.

As a child Woodard was inspired by his grandfather's wood carving. "We called him a whittler. He'd sit under a shade tree and do that. I watched him all the time, doing that." Woodard took up carving as a teenager, but remembers, "It was nothing like it is now—there wasn't a market for it or anything."

When he was eighteen Woodard was inducted into the Air Force and was stationed at the flying school of the Black Academy in Alabama. After the service he returned to his family in Palestine. He attended automobile mechanic training and worked for a time at a produce warehouse. Woodard continued to carve small objects in his spare time, giving them as gifts to friends and family members. "Relatives came and asked for it, so I'd carve another one," he recalls.

In 1959 Onis Woodard moved to Dallas, married, and the couple had a daughter, Altheia. Woodard worked for the City of Dallas Public Works Department doing street maintenance for nineteen years. In 1968 he married Lula Hart Smith. The couple lives in Pleasant Grove.

Since 1978 Woodard has been a member of the True Light Baptist Church, where he is a deacon and is active in church activities. Rev. John Hunter, pastor of the Church, discovered that like himself Onis was a woodcarver. With Hunter's encouragement Woodard began to devote more time to his art. Woodard stated, "Rev. Hunter, he really encouraged me—so I give a lot of credit to him." In 1991 he sold his first piece, a Santa Claus figure, to Bruce and Julie Webb. They now sell his work at their gallery in Waxahachie.

Woodard's favorite wood for carving is catalpa, commonly called the "bean tree," that grows throughout the southern U.S. and is best known for its profusion of long seed pods. He prefers this wood because it is easy to work with and does not split when nailed. Using a "good, sharp pocket knife," he carves figures, adding a "sauce" of glue and sawdust for special textures such as the mane of a lion, and rolled wood putty for eyes. The figures are painted with enamel paint. He occasionally uses other materials to complete the figures,

Lion, 1992

such as a red devil figure which has a tail made from a garden hose. His favorite subjects are religious—especially the Crucifixion, and animals—particularly lions and tigers. Woodard says of his work, "I put a lot of effort in it to make people like it. And if they love it, I like it more better, too."

[1]Biographical information compiled from Sally M. Griffiths, "Onis Woodard," unpublished, 1993; Onis Woodard, telephone conversation with the author, June 16, 1997.

Exhibition Checklist

EDDIE ARNING
(1898–1993)

Untitled (Boy and Girl with Banjo), 1973
Oil pastel on paper, 19 x 25 1/4 in.
Archer M. Huntington Art Gallery,
The University of Texas at Austin,
Gift of Dr. Alexander and Ivria
Sackton, 1986

Untitled (Four Cows and Hay), 1967
Wax crayon on paper, 20 x 26 in.
Archer M. Huntington Art Gallery,
The University of Texas at Austin,
Gift of Dr. Alexander and Ivria
Sackton, 1986

Untitled (Texas Windmill), n.d.,
1960s
Wax crayon on paper, 30 x 23 in.
Archer M. Huntington Art Gallery,
The University of Texas at Austin,
Gift of Thomas Cranfill, 1980

Untitled (Three Men with Harnessed Dogs), 1971
Oil pastel on paper, 22 x 32 1/4 in.
Archer M. Huntington Art Gallery,
The University of Texas at Austin,
Gift of Dr. Alexander and Ivria
Sackton, 1986

Untitled (Woman Seated with Dog),
1972
Oil pastel on paper, 20 x 26 in.
Archer M. Huntington Art Gallery,
The University of Texas at Austin,
Gift of Dr. Alexander and Ivria
Sackton, 1986

JOHN BANKS
(1912–1988)

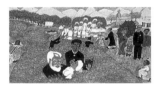

The African Life on the Safaria, 1982
Felt tip marker, crayon, and
ballpoint pen on posterboard,
14 3/16 x 22 1/8 in.
Collection of Dr. and Mrs. Joseph
A. Pierce, Jr., San Antonio

Baptism, n.d.
Ballpoint pen, felt tip marker,
colored pencil, and crayon on
posterboard, 15 1/16 x 28 1/8 in.
Collection of Dr. and Mrs. Joseph
A. Pierce, Jr., San Antonio

Juneteenth Celebration, 1983
Ballpoint, watercolor, felt tip
marker, and crayon on poster-
board, 22 1/8 x 28 1/16 in.
Collection of Dr. and Mrs. Joseph
A. Pierce, Jr., San Antonio

Old Time Funeral, n.d.
Ball point pen, felt tip marker, and
crayon on posterboard,
15 1/8 x 28 1/8 in.
Collection of Dr. and Mrs. Joseph
A. Pierce, Jr., San Antonio

*Picking Cotton in South Texas Year
1923*, 1986
Mixed media on paper,
18 x 28 1/8 in.
Collection of Jehan Mitchell,
Austin

HECTOR ALONZO BENAVIDES
(b. 1952)

Untitled, n.d.
Mixed media on wood,
28 1/4 x 99 in.
Collection of Stephanie and John
Smither, Houston

Untitled, 1996
Mixed media on posterboard,
32 x 40 in.
Webb Gallery, Waxahachie

Untitled, 1996
Mixed media on posterboard,
32 x 40 in.
Webb Gallery, Waxahachie

Untitled, 1996
Mixed media on posterboard,
32 x 40 in.
Webb Gallery, Waxahachie

HENRY RAY CLARK
(b. 1936)

*The Black-Board Jungle The Home
of the Red Eye—The Only Thing
That Can Predict the Future of
Mankind*, 1996
Ballpoint pen on manila
envelope, 11 1/8 x 15 3/8 in.
Collection of the artist

*I Am Azer, The Eyes of a Planet
Called Klar*, 1996
Ballpoint pen on manila
envelope, 10 7/8 x 15 1/4 in.
Collection of the artist

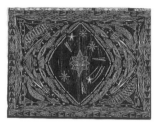

*I Am King of the Planet Star They
Call Me Forever—Because I Am
Always*, 1996
Ballpoint pen on manila
envelope, 12 x 15 1/4 in.
Collection of the artist

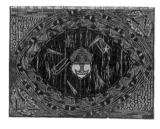

*I Am King Hutu from the Planet with
the Black & Silver Eye—Name—
Zoton*, 1996
Ballpoint pen on manila
envelope, 12 x 15 5/8 in.
Collection of the artist

*I Am Time the Keeper of the Wheel
of Life—Where Will It Stop for You*,
1996
Ballpoint pen on manila
envelope, 10 7/8 x 15 1/2 in.
Collection of the artist

*I Am Michael J. I Bought My Own
Planet, I Name It After Me—
The Greatest*, 1996
Ballpoint pen on manila
envelope, 12 x 15 1/4 in.
Collection of the artist

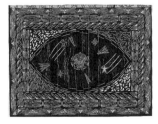

*I Am A Warrior from the Planet Star
My Name is Star—I Come in Peace
This Time*, 1996
Ballpoint pen on manila
envelope, 12 x 15 1/4 in.
Collection of the artist

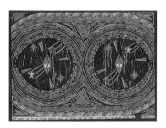

My Name is Go My Twin Brother is Getem We Are from the Planet Called Catch Me, 1996
 Ballpoint pen on manila envelope, 11 1/8 x 14 3/4 in. Collection of William Steen, Houston

Stop Look and Listen, Drug Will Kill You Fool, 1995
 Ballpoint pen on manila envelope, 12 x 15 1/4 in. Collection of William Steen, Houston

WALTER F. COTTON
(1895–1978)

Reading the Emancipation Proclamation on the Governeur Stroud Plantation, June 19, 1865, n.d.
 Oil on board, 48 x 96 in. Webb Gallery, Waxahachie Courtesy of Thomas Beall Chatham, Jr., Corsicana

C.A.A. DELLSCHAU
(1830–1923)

Aero Babymyn, 1912
 Watercolor, graphite pencil, and black ink on paper, 15 1/4 x 19 in. The Witte Museum, San Antonio

Aerocita, Broad Center, 1911
 Watercolor, gouache, graphite pencil, and black ink with cut printed color reproductions on paper, 16 1/2 x 19 in. The Menil Collection, Houston

Aero Doobely, Deck View, 1911
 Watercolor, gouache, graphite pencil, and black ink with cut printed color reproductions and German newspaper on paper, 16 5/8 x 19 in. The Menil Collection, Houston

Aero Doobey, Frontal View, 1911
 Watercolor, gouache, graphite pencil, and black ink with cut printed color reproductions and German newspaper on paper, 19 1/8 x 15 1/4 in. The Menil Collection, Houston

Aero Dora, Center Front or Rear, 1911
 Watercolor, gouache, graphite pencil, and black ink on paper, 16 1/2 x 19 in. The Menil Collection, Houston

Aero Hunter, 1910
 Watercolor, graphite pencil, and black ink on paper, 15 1/4 x 19 in. The Witte Museum, San Antonio

Aero Hunter from Above, 1910
 Watercolor, graphite pencil, and black ink on paper, 19 x 16 in. The Witte Museum, San Antonio

Aero Hunter, Front Rear, 1910
 Watercolor, graphite pencil, and black ink on paper, 15 1/4 x 19 in. The Witte Museum, San Antonio

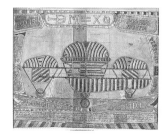

Aero Mio, Flank Down, 1910
 Watercolor, graphite pencil, and black ink on paper, 15 1/4 x 19 in. The Witte Museum, San Antonio

Aero Mio from Above and Below, 1910
 Watercolor, graphite pencil, and black ink on paper, 15 1/4 x 19 in. The Witte Museum, San Antonio

Baby Myn, Long Center Cut, 1912
 Watercolor, pencil, and collage on paper, 16 5/8 x 20 in. Collection of Stephanie and John Smither, Houston

Babymyn, 1912
 Watercolor, graphite pencil, and black ink on paper, 16 x 19 in. The Witte Museum, San Antonio

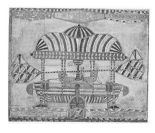

Long Distance Aero Immer, 1910
 Watercolor, graphite pencil, and black ink on paper, 15 3/4 x 19 1/4 in. The Witte Museum, San Antonio

WILLIAM HUNTER DILLARD
(b. 1905)

American Realism . . . Females, 1975
 Ink and pencil on paper, 11 1/2 x 9 in. Courtesy of Murray Smither, Dallas

Civilization & Smogization, 1969
 Ink and pencil on paper, 12 x 9 in. Courtesy of Murray Smither, Dallas

Five Boxey Skyscrapers in Metropolitan Smog (Houston, Texas), 1970
 Ink and pencil on paper, 9 x 12 in. Courtesy of Murray Smither, Dallas

King Rhythm—I, 1981
 Wood construction, 11 x 9 x 8 in. Courtesy of Murray Smither, Dallas

Old and New Styles, 1983
 Paper and wood construction, 12 3/4 x 4 x 5 1/4 in. Courtesy of Murray Smither, Dallas

Rhythmns (& Stains). . . Smoggenheimer Nat. Ind. Corp, 1970
 Ink and pencil on paper, 8 7/8 x 11 7/8 in. Courtesy of Murray Smither, Dallas

Some Minimal Reforms. . ., 1970
 Ink and pencil on paper, 12 x 9 in. Courtesy of Murray Smither, Dallas

Success; Step by Step, Ambition, Action!, 1983
Marker ink on paper, wood construction, 11 x 6 x 10 in.
Courtesy of Murray Smither, Dallas

The Wilted Flower: The Shapely but Ineffectual Woman, 1970
Ink and pencil on paper, 9 x 12 in.
Courtesy of Murray Smither, Dallas

CARL DIXON
(b. 1960)

The Crucifixion of Jesus Christ, 1996
Polychromed wood, 17 3/4 x 24 in.
Collection of Stephanie and John Smither, Houston

Martin Luther King, n.d.
Polychromed wood, 14 x 12 in.
Collection of Chuck and Jan Rosenak, Tesuque, NM

Woman with the Issue of Blood, St. Luke 8:43-48, n.d.
Polychromed wood, 24 x 36 in.
Collection of Chuck and Jan Rosenak, Tesuque, NM

PETER PAUL DRGAC
(1883–1976)

Untitled, 1972
Enamel on paper, 16 x 12 in.
Leslie Muth Gallery, Santa Fe, NM

Untitled, 1976
Enamel on paper, 22 x 14 in.
Leslie Muth Gallery, Santa Fe, NM

Untitled, 1976
Enamel on paper, 22 x 14 in.
Leslie Muth Gallery, Santa Fe, NM

Untitled, 1976
Enamel on paper, 22 x 14 in.
Leslie Muth Gallery, Santa Fe, NM

VANZANT DRIVER
(b. 1956)

Igloo Church, 1985
Broken glass and mirror on wood base, 9 3/4 x 24 x 19 3/4 in.
Collection of Murray Smither, Dallas

Untitled, n.d.
Broken glass and mirror on wood base, 15 x 13 1/4 x 9 1/2 in.
The Menil Collection, Houston

EZEKIEL GIBBS
(1889–1992)

Untitled, n.d.
Watercolor and pencil on paper, 17 3/4 x 11 3/4 in.
Collection of Stephanie and John Smither, Houston

Untitled, n.d.
Wax crayon on paper, 11 7/8 x 17 5/8 in.
Collection of Stephanie and John Smither, Houston

Untitled, n.d.
Oil pastel, watercolor, pencil, and crayon on paper, 18 x 12 in.
Collection of Bernard and Wanda Williamson, Magnolia

Untitled, 1986
Oil pastel, watercolor, pencil, and crayon on paper, 18 x 24 in.
Collection of Bernard and Wanda Williamson, Magnolia

Untitled, c. 1990-1992
Tempera, watercolor, and crayon on drywall, 44 1/2 x 37 1/2 in.
Collection of Rebecca and Gary Cohen, Austin

CONSUELO GONZÁLEZ AMÉZCUA
(1903–1975)

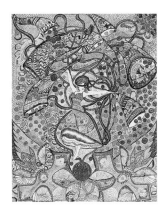

Abundance, 1966
Pencil and pen on paper, 26 1/2 x 20 1/4 in.
Cavin-Morris, Inc., New York, NY

America's Relic, n.d.
Carved stone, 1 3/8 x 11 3/8 x 4 7/8 in.
Collection of Livia Fernández, Austin

Art Relics, n.d.
Carved stone, 19 1/2 x 15 1/4 x 2 3/8 in.
Whitehead Memorial Museum, Del Rio

Creative Hands, c. 1970
Pencil and ballpoint pen on paper, 28 x 22 in.
Cavin-Morris, Inc., New York, NY

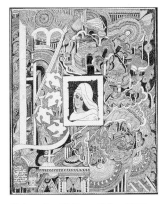

Deba—the Girl from Fulbe, 1968
Blue and black ballpoint pen on posterboard, 28 x 22 in.
Cavin-Morris, Inc., New York, NY

Maya, n.d.
Carved stone, 1 3/4 x 9 1/2 x 10 1/8 in.
Collection of Marina García, Austin

Primaveral (Spring), c. 1970
Black and colored ballpoint pen on posterboard, 32 x 19 in.
Cavin-Morris, Inc., New York, NY

The Smile of a Texan Girl, n.d.
Ballpoint pen on paper, 29 x 23 in.
Collection of Stephanie and John Smither, Houston

MARK COLE GREENE
(b. 1955)

Lighthouses, 1996
Felt tip marker on posterboard,
26 1/8 x 40 1/16 in.
Webb Gallery, Waxahachie

The Mine, 1996
Felt tip marker on posterboard,
26 1/8 x 40 1/16 in.
Webb Gallery, Waxahachie

South Fork Ranch, 1996
Felt tip marker on posterboard,
24 x 44 in.
Webb Gallery, Waxahachie

MICHAEL GREGORY
(1951–1995)

Crucifix, n.d.
Ceramic, 14 x 14 x 3 1/2 in.
Collection of Stephanie and
John Smither, Houston

Untitled, n.d.
Ceramic, 20 x 17 x 14 in.
Collection of Stephanie and
John Smither, Houston

ALMA P. GUNTER
(1909–1983)

Mama's Day Out, 1979
Acrylic on canvas, 16 x 20 in.
Collection of Sally M. Griffiths,
Dallas

Pretty Mama, 1981
Acrylic on canvas, 18 x 24 in.
Collection of Mary Sanger,
Austin

Saturday Afternoon, n.d.
Acrylic on canvas, 24 x 36 in.
Collection of Sally M. Griffiths,
Dallas

Winter Cry, 1979
Acrylic on canvas, 16 x 20 in.
Collection of Sally M. Griffiths,
Dallas

FELIX "FOX" HARRIS
(1905–1984)

Five Untitled Totems, n.d.
Metal and found objects,
Fig. 1: 110 x 50 x 18 in.
Fig. 2: 116 x 60 x 11 in.
Fig. 3: 145 x 22 x 9 in.
Fig. 4: 158 x 42 x 12 in.
Fig. 5: 188 x 40 x 13 in.
Art Museum of Southeast Texas,
Beaumont

REV. J. L. HUNTER
(b. 1905)

Drunk Man Leaning on Lamp Post,
c. 1992
figure: Carved wood with paint,
screws, buttons,
41 x 10 1/2 x 18 1/2 in.
lamp post: wood with glitter,
46 x 7 1/2 x 11 3/4 in.
Collection of Sally M. Griffiths,
Dallas

Gunfighters, n.d.
Wood and house paint,
Fig. 1: 29 x 14 1/2 x 7 1/2 in.
Fig. 2: 30 x 17 x 8 in.
Collection of Stephanie and John
Smither, Houston

Jimbo Man, 1992
Paint and found objects on wood,
62 x 31 1/2 x 16 in.
Webb Gallery, Waxahachie

Six *Statues of Liberty,* 1985–1990
Carved, stained, and burned
wood with paint, glitter,
rhinestones, and varnish,
Fig. 1: 7 3/4 x 2 1/2 x 2 in.
Fig. 2: 10 3/4 x 2 7/8 x 1 3/4 in.
Fig. 3: 13 3/4 x 3 1/4 x 2 1/4 in.
Fig. 4: 20 3/8 x 4 1/4 x 2 7/8 in.
Fig. 5: 22 1/8 x 6 1/4 x 2 3/4 in.
Fig. 6: 22 1/2 x 6 5/8 x 2 5/8 in.
Collection of Sally M. Griffiths,
Dallas

FRANK JONES
(c. 1900–1969)

Flying Fish, 1964
Colored pencil on paper,
12 x 17 in.
Collection of Murray Smither,
Dallas

Gambling Boat, 1965-66
Colored pencil on paper,
22 1/4 x 22 1/4 in.
Collection of Chapman Kelley,
Chicago, IL

Jap Devil House, 1964
Colored pencil on paper,
12 1/16 x 18 1/2 in.
Collection of Chapman Kelley,
Chicago, IL

Moon Devils, 1965-66
Colored pencil on paper,
22 1/4 x 22 1/4 in.
Collection of Chapman Kelley,
Chicago, IL

Untitled, c. 1968-69
Colored pencil on paper,
27 x 30 1/2 in.
Collection of Stephanie and
John Smither, Houston

Untitled, c. 1966-68
Color pencil on paper,
25 1/2 x 30 1/2 in.
The Harmon and Harriet Kelley
Collection of African
American Art, San Antonio

H. O. KELLY
(1884–1955)

*And the Goats Are the Price of the
Field,* n.d.
Oil on canvas, 3 x 4 3/4 in.
Collection of Claude Albritton,
Dallas

Goats in Corral, n.d.
Oil on canvas, 14 x 20 in.
Collection of Claude Albritton,
Dallas

Hog Killing Time, c. 1950
Oil on canvas covered board,
14 x 20 in.
Dallas Museum of Art, Art
Association Purchase

IKE MORGAN
(b. 1958)

Four Part Lincoln, 1996
Acrylic and ink on paper,
4 sheets 24 x 18 3/4 in. each
Webb Gallery, Waxahachie

Last Supper, n.d.
Mixed media on paper,
24 x 36 in.
Collection of Sally M. Griffiths,
Dallas

Presidential Portrait, 1996
Oil and ink on paper, 24 x 18 in.
Webb Gallery, Waxahachie

Presidential Portrait, 1996
Oil and ink on paper, 24 x 18 in.
Webb Gallery, Waxahachie

Presidential Portrait, 1996
Oil and ink on paper, 24 x 18 in.
Webb Gallery, Waxahachie

Presidential Portrait, 1996
Oil and ink on paper, 24 x 18 in.
Webb Gallery, Waxahachie

Untitled, n.d.
Oil pastel on bamboo window
shade, 70 x 38 in.
Collection of Chuck and Jan
Rosenak, Tesuque, NM

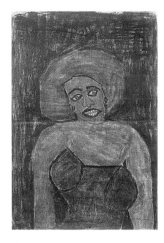

Untitled, 1987
Oil pastel on linen paper,
36 x 24 in.
Leslie Muth Gallery,
Santa Fe, NM

EMMA LEE MOSS
(1916–c. 1993)

Clouds of Widness, 1981
Mixed media on paper,
21 1/2 x 15 1/2 in.
Collection of Sally M. Griffiths,
Dallas

End of the Cotton Season, 1987
Oil on canvas, 23 1/4 x 35 1/2 in.
The Harmon and Harriet Kelley
Collection of African
American Art, San Antonio

Lone Spruce Wolf, 1986
Oil on canvas, 16 x 20 in.
Collection of Sally M. Griffiths,
Dallas

CARL NASH
(b. 1951)

Anti-Christ, 1996
Mixed media, 83 x 60 x 23 in.
Webb Gallery, Waxahachie

Combination of the Races, 1997
Found wire construction,
22 1/2 x 21 x 6 1/2 in.
Private Collection, Courtesy of
Webb Gallery, Waxahachie

Longhorn Head, c. 1985-90
Galvanized and ungalvanized
wire, 40 1/2 x 118 x 7 1/2 in.
Collection of Lisa and Marshall
Twinam, Courtesy of Webb
Gallery, Waxahachie

Untitled, n.d.
Wire, 24 x 24 x 12 in.
Collection of Tom De Nolf,
Dallas

NAOMI POLK
(1892–1984)

Baptism, after 1961
Enamel, crayon, watercolor, and
felt tip marker on paper,
22 1/8 x 28 1/8 in.
Collection of Chuck and Jan
Rosenak, Tesuque, NM

Lonesome Road, after 1961
Watercolor, crayon, and felt tip
marker on paper, 8 1/2 x 11 in.
Collection of Chuck and Jan
Rosenak, Tesuque, NM

Lonesome Road, after 1961
Watercolor, crayon, and felt tip
marker on paper, 8 1/2 x 11 in.
Collection of Chuck and Jan
Rosenak, Tesuque, NM

Of Course I Live Forevermore,
after 1961
Watercolor on paper,
14 5/8 x 10 7/8 in.
Collection of Chuck and Jan
Rosenak, Tesuque, NM

The Stick Doll, after 1961
Watercolor on paper, 9 x 12 in.
Collection of Chuck and Jan
Rosenak, Tesuque, NM

XMEAH SHAELA'REEL
(b. 1943)

Angry Angels, 1996
Acrylic, glitter, and varnish on
plywood, 49 x 49 in.
Webb Gallery, Waxahachie

Drinking the Wine of Wrath, n.d.
Enamel, glitter, and varnish on
board, 18 x 24 in.
Collection of Bernard and
Wanda Williamson, Magnolia

Light of the World, n.d.
Lamp and paper lampshade
with acrylic paint,
glitter, and varnish,
31 x 18 x 18 in.
Collection of Sally M. Griffiths,
Dallas

Michael Fight, 1995
Wood chair with vinyl
upholstery, enamel, glitter, and
varnish, 38 1/4 x 17 1/2 x 21 in.
Collection of Lynn P. Castle,
Beaumont

Revelation 17:16, n.d.
Acrylic paint, glitter, and varnish
on board, 41 x 30 1/2 in.
Collection of Chuck and Jan
Rosenak, Tesuque, NM

ISAAC SMITH
(b. 1944)

Monkey Mother and Child, n.d.
Carved and painted wood,
27 x 10 x 12 1/2 in.
Collection of Sally M. Griffiths,
Dallas

Statue of Liberty, c. 1994
Carved and painted wood,
34 x 10 1/2 x 4 1/2 in.
Collection of Sally M. Griffiths,
Dallas

Tiger, n.d.
Carved and painted wood,
24 1/2 x 84 1/2 x 16 1/2 in.
Collection of Sally M. Griffiths,
Dallas

FANNIE LOU SPELCE
(b. 1908)

Camp Meeting at Maple Shade, 1968
Oil on canvas, 24 x 36 in.
Collection of the Spelce family, Austin

Arkansas Peach Season, 1968
Oil on canvas, 24 x 30 in.
Collection of the Spelce family, Austin

The Quilting Bee, 1966
Oil on canvas, 28 x 38 in.
Collection of the Spelce family, Austin

Uncle Floyd, 1968
Oil on canvas, 24 x 12 in.
Collection of the Spelce family, Austin

DAVID STRICKLAND
(b. 1955)

Big Bird, 1996
Metal and glass, 58 x 55 x 52 in.
Collection of Bruce and Julie Webb, Waxahachie

Case Alien, 1991
Metal machinery parts and glass, 104 x 46 x 63 in.
Collection of Sally M. Griffiths, Dallas

Scarecrow, 1997
Found metal assemblage, 79 x 39 x 33 in.
Private Collection, Courtesy of Webb Gallery, Waxahachie

Untitled , 1996
Barrel with paint, 21 x 13 x 7 in.
Webb Gallery, Waxahachie

REV. JOHNNIE SWEARINGEN
(1908–1993)

Cotton Picking, n.d.
Oil on board, 36 x 71 in.
Collection of Stephanie and John Smither, Houston

The Creation of the World, 1970s
Oil on masonite, 30 x 96 in.
Collection of Gaye Hall, Houston

The Devil's Got the Church on Wheels, n.d.
Oil on masonite, 15 1/2 x 24 3/4 in.
Collection of Dr. and Mrs. Joseph A. Pierce, Jr., San Antonio

Going to Hell, 1990
Oil on canvas, 36 x 48 in.
Collection of Stephanie and John Smither, Houston

Untitled (Washington County Fair at Night), c. 1982
Oil on masonite, 27 3/4 x 42 in.
Collection of Jehan Mitchell, Austin

TOM TARRER
(b. 1927)

Adoration of the Magi, "Filippo Lippy," 1973
Carved and painted wood, 17 x 15 3/4 x 16 in.
Collection of Sally M. Griffiths, Dallas

Midnight Around the Campfire, n.d.
Carved and painted wood, 11 3/4 x 18 3/4 x 15 1/8 in.
Collection of Sally M. Griffiths, Dallas

Washington Crossing the Delaware, n.d.
Carved and painted wood, 9 1/4 x 14 1/2 x 7 1/4 in.
Collection of Sally M. Griffiths, Dallas

REV. L. T. THOMAS
(1902–1996)

Clyde Barrow, Pretty Boy Floyd, Bonnie Parker, and Fred Douglas, Nine frontal views, n.d.
Ballpoint pen, pencil, and crayon on paper, varying sizes
Webb Gallery, Waxahachie

Clyde Barrow, Pretty Boy Floyd, Bonnie Parker, and Fred Douglas, Nine profile views, n.d.
Ballpoint pen, pencil, and crayon on paper, varying sizes
Webb Gallery, Waxahachie

VELOX WARD (1901–1994)

The Life of a Tree, 1961
Oil on panel, 16 x 20 in.
Collection of Eric S. Vogel, Dallas

Mama Blows the Horn, 1967
Oil on wood, 20 x 24 in.
Valley House Gallery, Dallas

WILLARD WATSON "THE TEXAS KID"
(1921–1995)

Boar's Head, 1988
Wood with hair, animal teeth, marbles, and paint, 13 1/2 x 22 x 15 in.
Collection of Chuck and Jan Rosenak, Tesuque, NM

Boogie Woogie Bull, c. 1980
Wood with horn, paint, and taxidermist's eyes, 12 x 24 x 12 in.
Collection of George and Beverly Palmer, Dallas

Texas Kid Crocodile, 1980
Wood with paint and metal, 10 1/4 x 44 x 8 1/2 in.
The Menil Collection, Houston

Two Headed Thing, 1985
Wood with deer antler, pig toes, bones, and rhinestones, 11 x 21 x 8 in.
Collection of Bernard and Wanda Williamson, Magnolia

GEORGE W. WHITE, JR.
(1903–1970)

Emancipation House, 1964
Painted wood and mixed media construction, 19 1/2 x 23 1/2 x 18 1/2 in.
National Museum of American Art, Smithsonian Institution, Washington, DC

Fishing Out on the Island, 1965
Oil on wood panel, collage, and carved pine, 13 1/2 x 17 1/2 in.
Witte Museum, San Antonio

The Old Hills of Kentucky, 1966
Oil paint on carved wood relief, 30 x 44 in.
Collection of Stephanie and John Smither, Houston

Pig Butchering, 1968
Painted wood and mixed media construction, 13 1/2 x 13 1/2 x 6 1/2 in.
Collection of Butler Hancock and Lisa Nuñez-Hancock, Los Angeles, CA

CLARA MCDONALD WILLIAMSON
(1875–1976)

Chicken for Dinner, 1945
Oil on canvas, 22 1/2 x 30 1/4 in.
Collection of Eric S. Vogel, Dallas

The Day the Bosque Froze Over, 1953
Oil on composition board, 20 x 28 in.
The Museum of Modern Art, NY

Get Along Little Dogies, 1945
Oil on canvas, 26 3/4 x 39 3/4 in.
Dallas Museum of Art, Ted Dealey Purchase Prize, Seventeenth Annual Dallas Allied Arts Exhibition, 1946

Self-Portrait, 1948
 Oil on panel, 24 x 30 in.
 Valley House Gallery, Dallas

ONIS WOODARD (b. 1926)

Lion, 1992
 Wood with paint, 11 x 11 $\frac{1}{2}$ x
 30 $\frac{1}{2}$ in.
 Collection of Murray Smither,
 Dallas

Red Devil, 1997
 Wood and garden hose with
 paint, 50 x 38 x 22 in.
 Webb Gallery, Waxahachie

Statue of Liberty, c. 1994
 Wood with paint, 29 $\frac{1}{2}$ x 10 $\frac{1}{2}$
 x 5 $\frac{1}{2}$ in.
 Collection of Sally M. Griffiths,
 Dallas

*Not all works of art will be shown
in all locations

List of Selected Exhibitions, Museum Collections, and Publications, by Artist

EDDIE ARNING

EXHIBITIONS
Eddie Arning: Selected Drawings 1964-1973, The Abby Aldrich Rockefeller Folk Art Center, Williamsburg, VA, 1985; *Eddie Arning Drawings,* Archer M. Huntington Art Gallery, The University of Texas at Austin, 1986; *Treasures of American Folk Art from the Abby Aldrich Rockefeller Folk Art Center,* Abby Aldrich Rockefeller Folk Art Center, 1989; *Made with Passion: The Hemphill Folk Art Collection,* National Museum of American Art, Smithsonian Institution, Washington, DC, 1990; *Outside/In: Contemporary and Outsider Art in Texas,* Laguna Gloria Art Museum, 1992; *Contemporary American Folk Art: The Balsley Collection,* Patrick and Beatrice Haggerty Museum of Art, Marquette University, Milwaukee, W I, 1992; *Passionate Visions of the American South,* New Orleans Museum of Art, 1993; *Driven to Create: The Anthony Petullo Collection of Self-Taught & Outsider Art,* Milwaukee Art Museum, 1993; *Tree of Life,* American Visionary Art Museum, Baltimore, MD, 1996.

MUSEUM COLLECTIONS
The Abby Aldrich Rockefeller Folk Art Center, Williamsburg, VA; Archer M. Huntington Art Gallery, The University of Texas at Austin; Austin Museum of Art at Laguna Gloria, Austin; Cincinnati Art Museum, Cincinnati, OH; Herbert F. Johnson Museum of Art, Cornell University, Ithaca, NY; The High Museum of Art, Atlanta, Georgia; Milwaukee Art Museum, Milwaukee, WI; The Museum of American Folk Art, New York, NY; Museum of Fine Arts, Boston, MA; The Museum of International Folk Art, Santa Fe, NM; National Museum of American Art, Smithsonian Institution, Washington, DC; New Orleans Museum of Art, New Orleans, LA; New York State Historical Association, Cooperstown, NY; San Antonio Museum of Art, San Antonio; Smith College Museum of Art, Northampton, MA; The University of Michigan Museum of Art, Ann Arbor, MI; The University of South Carolina McKissick Museum, Columbia, SC.

PUBLICATIONS
The Abby Aldrich Rockefeller Folk Art Center, *Eddie Arning: Selected Drawings 1964–1973,* Williamsburg, VA, 1985; Francis Edward Abernethy, ed., *Folk Art in Texas,* Dallas: Southern Methodist University Press, 1985; Beatrix T. Rumford and Carolyn J. Weekley, *Treasures of American Folk Art from the Abby Aldrich Rockefeller Folk Art Center,* Boston: Little, Brown and Company, 1989; Lynda Roscoe Hartigan, *Made with Passion: The Hemphill Folk Art Collection,* Washington, DC: National Museum of American Art, Smithsonian Institution, 1990; Chuck and Jan Rosenak, *Museum of American Folk Art Encyclopedia of Twentieth-Century American Folk Art and Artists,* New York: Abbeville Press, 1990; *Outside/In: Contemporary and Outsider Art in Texas,* Austin: Laguna Gloria Art Museum, 1992; *Contemporary American Folk Art: The Balsley Collection,* Milwaukee: Patrick and Beatrice Haggerty Museum of Art, Marquette University, 1992; *Passionate Visions of the American South,* New Orleans: New Orleans Museum of Art, 1993; *Driven to Create: The Anthony Petullo Collection of Self-Taught & Outsider Art,* Milwaukee: Milwaukee Art Museum, 1993; *Tree of Life,* Baltimore: American Visionary Art Museum, 1996; Chuck and Jan Rosenak, *Contemporary American Folk Art: A Collector's Guide,* New York: Abbeville Press, 1996.

JOHN BANKS

EXHIBITIONS
Handmade and Heartfelt: Folk Art in Texas, Laguna Gloria Art Museum, Austin, 1986; *Black History/Black Vision: The Visionary Image in Texas,* Archer M. Huntington Art Gallery, The University of Texas at Austin, 1989; *Twentieth-Century Texas Folk Art,* Sewall Art Gallery, Rice University, Houston, 1992; *The Wind in My Hair,* American Visionary Art Museum, Baltimore, MD, 1996.

MUSEUM COLLECTIONS
African American Museum, Dallas; National Museum of American Art, Smithsonian Institution, Washington, DC; San Antonio Museum of Art.

PUBLICATIONS
Francis Edward Abernethy, ed., *Folk Art in Texas,* Dallas: Southern Methodist University Press, 1985; Lynne Adele, *Black History/Black Vision: The Visionary Image in Texas,* Austin: Archer M. Huntington Art Gallery, The University of Texas at Austin, 1989; Chuck and Jan Rosenak, *Museum of American Folk Art Encyclopedia of Twentieth-Century American Folk Art and Artists,* New York: Abbeville Press, 1990.

HENRY RAY CLARK

EXHIBITIONS
Texas Selections from the Menil Collection, Galveston Art Center, Galveston, 1991; *It'll Come True: Eleven Artists First and Last,* Artists' Alliance, Lafayette, LA, 1992; *Avenues of Departure,* Contemporary Arts Center, New Orleans, 1992; *Texas Folk Art,* Sewall Art Gallery, Rice University, Houston, 1992; *Fresh Visions/ New Voices: Emerging African-American Artists in Texas,* Glassell School of Art, Museum of Fine Arts, Houston, 1992; *Houston Area Exhibition,* Sarah Campbell Blaffer Gallery, University of Houston, 1992; *Passionate Visions of the American South: Self-taught Artists from 1940 to the Present,* New Orleans Museum of Art, 1993; *Contemporary American Folk Art,* Museums of Abilene, 1993.

MUSEUM COLLECTION
The Menil Collection, Houston

PUBLICATIONS
Chuck and Jan Rosenak, *Museum of American Folk Art Encyclopedia of Twentieth-Century American Folk Art and Artists,* New York: Abbeville Press, 1990; Artists' Alliance, Lafayette, LA, *It'll Come True: Eleven Artists First and Last,* 1992; Alice Rae Yelen, ed., *Passionate Visions of the American South: Self-taught Artists from 1940 to the Present,* New Orleans Museum of Art, 1993;

Chuck and Jan Rosenak, *Contemporary American Folk Art: A Collector's Guide*, New York: Abbeville Press, 1996.

CHARLES DELLSCHAU

EXHIBITIONS
The Sky Is the Limit, University of St. Thomas, Houston, 1969; *The I at Play*, Institute for the Arts, Rice University, Houston, 1977; *A Survey of Texas Naïve Artists*, The Museum of Fine Arts, Houston, 1979; *C.A.A. Dellschau*, San Antonio Museum of Art, 1984; *Texas Seen/Texas Made*, San Antonio Museum of Art, 1986; *Texas Selections from the Menil Collection*, Galveston Arts Center, 1991; *Twentieth-Century Texas Folk Art*, Sewall Art Gallery, Rice University, Houston, 1992; *The Wind In My Hair*, American Visionary Art Museum, Baltimore, MD, 1996.

MUSEUM COLLECTIONS
The Menil Collection, Houston; San Antonio Museum of Art; Witte Museum, San Antonio.

PUBLICATIONS
Cecilia Steinfeldt, *Texas Folk Art: One Hundred Fifty Years of the Southwestern Tradition*, Austin: Texas Monthly Press, 1981; Cecilia Steinfeldt, *Art for History's Sake: The Texas Collection of the Witte Museum*, San Antonio: Witte Museum, 1993; Jimmy Ward and P.G. Navarro, "C.A.A. Dellschau and the Sonora Aero Club Mystery," *Visions*, vol. 2, American Visionary Art Museum, 1996.

CARL DIXON

EXHIBITIONS
Black Folk Art of East Texas, Museum of East Texas, Lufkin, 1986; *Rambling on My Mind: Black Folk Art of the Southwest*, Museum of African American Life and Culture, Dallas, 1987; *Texas Folk Art of the Twentieth Century*, Sewall Art Gallery, Rice University, Houston, 1992; *Works of Art . . . Worlds Apart*, New York State Historical Association, Cooperstown, NY, 1993.

MUSEUM COLLECTIONS
African American Museum, Dallas; Museum of East Texas, Lufkin; New York State Historical Association, Cooperstown, NY.

PUBLICATIONS
Works of Art . . . Worlds Apart, Cooperstown: New York State Historical Association, 1993; Chuck and Jan Rosenak, *Contemporary American Folk Art: A Collector's Guide*, New York: Abbeville Press, 1996

PETER PAUL DRGAC

EXHIBITIONS
Twentieth-Century Texas Folk Art, Sewall Art Gallery, Rice University, Houston, 1992; *Deep in the Heart: Personal Passions of Contemporary American Folk Artists*, Texas Tech Art Gallery, Lubbock, 1992; *Contemporary American Folk Art*, Museums of Abilene, Abilene, Texas, 1993; *Tree of Life*, American Visionary Art Museum, Baltimore, MD, 1996.

PUBLICATIONS
Clinton Machann, "'Uncle Pete' Drgac, Czech-American Folk Artist," Francis Edward Abernethy, ed., *Folk Art in Texas*, Dallas: Southern Methodist University Press, 1985; Chuck and Jan Rosenak, *Museum of American Folk Art Encyclopedia of Twentieth-Century American Folk Art and Artists*, New York: Abbeville Press, 1990; Rebecca Hoffberger, Roger Manley, and Colin Wilson, *Tree of Life*, Baltimore: American Visionary Art Museum, 1996.

VANZANT DRIVER

EXHIBITION
Twentieth-Century Texas Folk Art, Sewall Art Gallery, Rice University, Houston, 1992.

MUSEUM COLLECTION
The Menil Collection, Houston

EZEKIEL GIBBS

EXHIBITIONS
The Eyes of Texas: An Exhibition of Living Texas Folk Artists, University of Houston, 1980; *Black History/Black Vision: The Visionary Image in Texas*, Archer M.

Huntington Art Gallery, The University of Texas at Austin, 1989; *Ezekiel Gibbs*, Midtown Art Center, Houston, 1992; *Twentieth-Century Texas Folk Art*, Sewall Art Gallery, Rice University, Houston, 1992; *Passionate Visions of the American South: Self-Taught Artists from 1940 to the Present*, New Orleans Museum of Art, 1993; *Outside/In: Outsider and Contemporary Artists in Texas*, Laguna Gloria Art Museum, Austin, 1994.

PUBLICATIONS
Gaye Hall and David Hicks, *The Eyes of Texas: An Exhibition of Living Texas Folk Artists*, Houston: University of Houston, 1980; Lynne Adele, *Black History/Black Vision: The Visionary Image in Texas*, Austin: Archer M. Huntington Art Gallery, 1989; Chuck and Jan Rosenak, *Museum of American Folk Art Encyclopedia of Twentieth-Century American Folk Art and Artists*, New York: Abbeville Press, 1990; Alice Rae Yelen, ed., *Passionate Visions of the American South: Self-Taught Artists from 1940 to the Present*, New Orleans: New Orleans Museum of Art, 1993; *Outside/In: Outsider and Contemporary Artists in Texas*, Austin: Texas Fine Arts Association, 1994.

CONSUELO GONZÁLEZ AMÉZCUA

EXHIBITIONS
Texas Folk Art: One Hundred Fifty Years of the Southwest Tradition, San Antonio Museum Association, San Antonio, 1981; *The Latin American Spirit: Art and Artists in the United States, 1920-1970*, Bronx Museum of Art, New York, NY, 1988; *Driven to Create: The Anthony Petullo Collection of Self-Taught and Outsider Art*, Milwaukee Art Museum, Milwaukee, WI, 1993; *Every Picture Tells a Story: Word and Image in American Folk Art*, Museum of American Folk Art, New York, NY, 1994; *Tree of Life*, American Visionary Art Museum, Baltimore, MD, 1995; *A Labor of Love*, The New Museum, New York, NY, 1996.

MUSEUM COLLECTIONS
Marion Koogler McNay Art Institute, San Antonio; Museum of American Folk Art, New York, NY; The Smithsonian Institution, Washington, DC; Whitehead Memorial Museum, Del Rio.

PUBLICATIONS
Jacinto Quirarte, *Mexican American Artists*, Austin: University of Texas Press, 1973; Cecilia Steinfeldt, *Texas Folk Art: One Hundred Fifty Years of the Southwest Tradition*, Austin: Texas Monthly Press, 1981; *The Latin American Spirit: Art and Artists in the United States, 1920-1970*, New York: Abrams, 1988; Milwaukee Art Museum, *Driven to Create: The Anthony Petullo Collection of Self-Taught & Outsider Art*, 1993; Jacinto Quirarte and Rolando Hinojosa-Smith, *Mystical Elements/Lyrical Imagery: Consuelo González Amézcua 1903-1975*, Del Rio Council for the Arts, 1993; Diane Telgen and Jim Kamp, eds., *Notable Hispanic American Women*, Detroit: Gale Research, 1993; Rebecca Hoffberger, Roger Manley, and Colin Wilson, *Tree of Life*, Baltimore: American Visionary Art Museum, 1995; Chuck and Jan Rosenak, *Contemporary American Folk Art: A Collector's Guide*, New York: Abbeville Press, 1996.

ALMA PENNELL GUNTER

EXHIBITIONS
East Texas Heritage, Lufkin Historial and Creative Arts Center, 1980, with additions by the Victoria Regional Museum Association, 1981; *Texas Women: A Celebration of History*, Institute of Texan Cultures, 1981; *Folk Art of Alma Gunter*, George Washington Carver Museum, 1982.

PUBLICATIONS
Rudolph Pharis and Karen Wittliff, "I Remember When . . . : Alma Gunter, Ruby Yount," *Southwest Art*, September, 1980; Rose Sharp, "A Portfolio of Naïve Painters: Alma Pennell Gunter," *Art Voices/South*. November/December, 1980; George Washington Carver Museum, *Folk Art of Alma Gunter*, Austin: Austin Public Library, 1982.

FELIX "FOX" HARRIS

EXHIBITIONS
Handmade and Heartfelt, Laguna Gloria Art Museum, Austin, 1986; *Felix "Fox" Harris*, Art Museum of Southeast Texas, Beaumont, 1987.

MUSEUM COLLECTION
Art Museum of Southeast Texas, Beaumont

PUBLICATIONS
Pat Carter, "'Fox' Harris: A Forest of the Spirit," *Spot*, Houston Center for Photography, Spring 1991; Lynn P. Castle, "A Conservation Crisis: The Work of Felix 'Fox' Harris, A Case Study, *Folk Art*, Spring 1994; John Beardsley, *Gardens of Revelation: Environments by Visionary Artists*, New York: Abbeville Press, 1995.

REV. J. L. HUNTER

EXHIBITIONS
Texas Folk Art, Sewall Art Gallery, Rice University, Houston, 1992; *Passionate Visions of the American South: Self-Taught Artists from 1940 to the Present*, New Orleans Museum of Art, 1993; *Folk Art from the Collection of Sally M. Griffiths*, Art Museum of Southeast Texas, Beaumont, 1994; *Outside/In: Outsider and Contemporary Artists in Texas*, Laguna Gloria Art Museum, Austin, 1994; *Pictured in My Mind: Contemporary American Self-Taught Art from the Collection of Dr. Kurt Gitter and Alice Rae Yelen*, Birmingham Museum of Art, 1995.

MUSEUM COLLECTION
African American Museum, Dallas

PUBLICATIONS
Alice Rae Yelen, ed., *Passionate Visions of the American South: Self-Taught Artists from 1940 to the Present*, New Orleans: New Orleans Museum of Art, 1993; Gail Andrews Trechsel, ed., *Pictured in My Mind: Contemporary American Self-Taught Art from the Collection of Dr. Kurt Gitter and Alice Rae

Yelen, Birmingham: Birmingham Museum of Art, 1995; Chuck and Jan Rosenak, *Contemporary American Folk Art: A Collector's Guide*, New York: Abbeville Press, 1996.

FRANK JONES

EXHIBITIONS
Art on Paper 1965 and *Art on Paper 1966*, Weatherspoon Gallery, University of North Carolina; *17th Exhibition of Southwestern Prints and Drawings*, Dallas Museum of Fine Arts, 1967; *Third Annual Missouri Valley Drawing Competition*, Mulvane Art Center, Topeka, Kansas, 1967; *American Drawing 1968* Moore College of Art, Philadelphia, 1968; *Twentieth Century Folk Art*, Museum of American Folk Art, New York, 1970; *Symbols and Images*, American Federation of Arts, 1970; *Black History/Black Vision: The Visionary Image in Texas*, Archer M. Huntington Art Gallery, The University of Texas at Austin, 1989; *Made with Passion: The Hemphill Folk Art Collection*, National Museum of American Art, Smithsonian Institution, 1990; *Passionate Visions of the American South*, New Orleans Museum of Art, 1993; *The Harmon and Harriet Kelley Collection of African American Art*, San Antonio Museum of Art, 1994; *The Wind in My Hair*, American Visionary Art Museum, Baltimore, MD, 1996.

MUSEUM COLLECTIONS
African American Museum, Dallas; The High Museum of Art, Atlanta, GA; The Menil Collection, Houston; National Museum of American Art, Smithsonian Institution, Washington, DC.

PUBLICATIONS
Lynne Adele, "Frank Jones: The Psychology and Belief System of a Black Folk Artist," Master's Thesis, Austin: The University of Texas at Austin, 1987; Lynne Adele, *Black History/Black Vision: The Visionary Image in Texas*, Austin: Archer M. Huntington Art Gallery, 1989; Lynda Roscoe Hartigan, *Made with Passion: The Hemphill Folk Art Collection*, Washington, DC: National Museum of American Art, Smithsonian Institution, 1990; Chuck and Jan Rosenak, *Museum

of American Folk Art Encyclopedia of Twentieth-Century American Folk Art and Artists*, New York: Abbeville Press, 1990; Alice Rae Yelen, ed., *Passionate Visions of the American South*, New Orleans: New Orleans Museum of Art, 1993; *The Harmon and Harriet Kelley Collection of African American Art*, San Antonio: San Antonio Museum of Art, 1994.

H. O. KELLY

EXHIBITIONS
H. O. Kelly. . . . An Exhibition of His Paintings, Dallas Museum of Fine Arts, 1950; *H. O. Kelly: Retrospective Exhibition*, Dallas Museum of Fine Arts, 1960; *Paintings by Grandma Moses, Clara Williamson and H. O. Kelly*, Fort Worth Art Center, 1961; *A Survey of Naïve Texas Artists*, Witte Museum, San Antonio, 1980.

MUSEUM COLLECTIONS
Dallas Museum of Art; Texas A&M University, College Station; Amon Carter Museum, Fort Worth.

PUBLICATIONS
William Weber Johnson, *Kelly Blue*, College Station: Texas A&M University Press, 1979 (reprint of 1960 edition published by Doubleday, Garden City, N.Y.); Cecilia Steinfeldt, *Texas Folk Art: One Hundred Fifty Years of the Southwestern Tradition*, Austin: Texas Monthly Press, 1981.

JEFFERSON DAVIS MCKISSACK

EXHIBITION
The Wind in My Hair, American Visionary Art Museum, Baltimore, MD, 1996.

PUBLIC COLLECTION
The Orange Show, Houston.

PUBLICATIONS
Francis Edward Abernethy, ed., *Folk Art in Texas*, Dallas: Southern Methodist University Press, 1985; John Beardsley, *Gardens of Revelation: Environments by Visionary Artists*, New York: Abbeville Press, 1995.

IKE MORGAN

EXHIBITIONS
Rambling on My Mind: Black Folk Art of the Southwest, Museum of African American Life and Culture, Dallas, 1987; *The Cutting Edge*, Museum of American Folk Art, New York, 1990; *Twentieth-Century Texas Folk Art*, Sewall Art Gallery, Rice University, Houston, 1992; *Fresh Visions/New Voices: Emerging African American Artists in Texas*, Museum of Fine Arts, Glassell School, Houston, 1992; *Contemporary American Folk Art*, Art Museums of Abilene, 1993; *Made in the USA*, Collection de l'art brut, Lausanne, Switzerland, 1993; *Outside/In: Outsider and Contemporary Artists in Texas*, Laguna Gloria Art Museum, Austin, 1994; *The Harmon and Harriet Kelley Collection of African American Art*, San Antonio Museum of Art, 1994.

MUSEUM COLLECTION
African American Museum, Dallas

PUBLICATIONS
Chuck and Jan Rosenak, *Museum of American Folk Art Encyclopedia of Twentieth-Century American Folk Art and Artists*, New York: Abbeville Press, 1990; Texas Fine Arts Association, *Outside/In: Outsider and Contemporary Artists in Texas*, Austin: Texas Fine Arts Association, 1994.

EMMA LEE MOSS

EXHIBITIONS
Fourth Annual Exhibit, Texas Watercolor Society, The Witte Museum, San Antonio, 1953; *Minority Cultures Collection*, University Library, University of Texas at Arlington, 1983; *The Harmon and Harriet Kelley Collection of African American Art*, San Antonio Museum of Art, 1994.

PUBLICATIONS
Janet Kutner, "Painting, natural style," *The Dallas Morning News*, February 25, 1983, Section C, pp. 1-2; Douglas K.S. Hyland, ed., *The Harmon and Harriet Kelley Collection of African American Art*, San Antonio: San Antonio Museum of Art, 1994.

CARL NASH

EXHIBITIONS
Texas Folk Art, Sewall Art Gallery, Rice University, Houston, 1992; *Outside/In: Outsider and Contemporary Artists in Texas*, Laguna Gloria Art Museum, Austin, 1994; *Tree of Life*, American Visionary Art Museum, Baltimore, MD, 1995.

PUBLICATIONS
Outside/In: Outsider and Contemporary Artists in Texas, Austin: Laguna Gloria Art Museum, 1994; Rebecca Hoffberger, Roger Manley, and Colin Wilson, *Tree of Life*, Baltimore: American Visionary Art Museum, 1996.

NAOMI POLK

EXHIBITIONS
Art and Culture: The Fourth Ward, Diverse Works Gallery, Houston, 1986; *Handmade and Heartfelt: Folk Art in Texas*, Texas Folklife Resources and Laguna Gloria Art Museum, 1986; *Black History/Black Vision: The Visionary Image in Texas*, Archer M. Huntington Art Gallery, The University of Texas at Austin, 1989; *Twentieth-Century Texas Folk Art*, Sewall Art Gallery, Rice University, Houston, 1992.

PUBLICATIONS
Lynne Adele, *Black History/Black Vision: The Visionary Image in Texas*, Austin: Archer M. Huntington Art Gallery, The University of Texas at Austin, 1989; Chuck and Jan Rosenak, *Museum of American Folk Art Encyclopedia of Twentieth-Century American Folk Art and Artists*, New York: Abbeville Press, 1990; Ruthe Winegarten, *Black Texas Women: A Sourcebook*, Austin: University of Texas Press, 1996.

XMEAH SHAELA'REEL

EXHIBITIONS
It'll Come True: Eleven Artists First and Last, Artists' Alliance, Lafayette, Louisiana, 1992; *Twentieth-Century Texas Folk Art*, Sewall Art Gallery, Rice University, Houston, 1992; *Folk Art from the Collection of Sally M. Griffiths*, Art Museum of Southeast Texas, Beaumont, 1994.

MUSEUM COLLECTIONS
African American Museum, Dallas; Art Museum of Southeast Texas, Beaumont.

PUBLICATIONS
Artists' Alliance, Lafayette, Louisiana, *It'll Come True: Eleven Artists First and Last*, 1992; Chuck and Jan Rosenak, *Contemporary American Folk Art: A Collector's Guide*, New York: Abbeville Press, 1996.

ISAAC SMITH

EXHIBITIONS
Narrative Images, Museum of Southeast Texas, Corpus Christi, 1988; *Texas Folk Art of the Twentieth Century*, Sewall Art Gallery, Rice University, 1992; *Deep in the Heart: Personal Passions of Contemporary Folk Artists*, Texas Tech University, Lubbock, 1992; *Contemporary American Folk Art*, Museums of Abilene, 1993; *Outside/In: Outsider and Contemporary Texas Artists*, Laguna Gloria Art Museum, 1994; *Folk Art from the Collection of Sally M. Griffiths*, Art Museum of Southeast Texas, Beaumont, 1994; *Pictured in My Mind: Self-Taught Art from the Collection of Dr. Kurt Gitter and Alice Rae Yelen*, Birmingham Museum of Art, 1995; *Animals with Attitude: Sculpture by Isaac Smith*, Dallas Museum of Art, 1997.

MUSEUM COLLECTION
African American Museum, Dallas.

PUBLICATIONS
Outside/In: Outsider and Contemporary Texas Artists, Austin: Texas Fine Arts Association, 1994; Gail Andrews Trechsel, ed., *Pictured in My Mind: Contemporary Self-Taught Art from the Collection of Dr. Kurt Gitter and Alice Rae Yelen*, Birmingham: Birmingham Museum of Art, 1995; Chuck and Jan Rosenak, *Contemporary American Folk Art: A Collector's Guide*, New York: Abbeville Press, 1996.

FANNIE LOU SPELCE

EXHIBITIONS
Texas Folk Art: One Hundred Fifty Years of the Southwest Tradition, San Antonio Museum Association, 1981; *Handmade and Heartfelt: Contemporary Folk Art in Texas*, Laguna Gloria Art Museum, 1987; *Twentieth-Century Texas Folk Art*, Sewall Art Gallery, Rice University, Houston, 1992.

PUBLICATIONS
Patsy and Myron Orlofsky, *Quilts in America*, New York: McGraw-Hill, 1974; Herbert W. Hemphill, Jr. and Julia Weissman, *Twentieth Century American Folk Art and Artists*, E.P. Dutton & Company, Inc., 1974; C. Kurt Dewhurst, Betty MacDowell and Marsha MacDowell, *Artists in Aprons: Folk Art by American Women*, New York: E.P. Dutton & Co., Inc., 1979; Cecilia Steinfeldt, *Texas Folk Art: One Hundred Fifty Years of the Southwest Tradition*, Austin: Texas Monthly Press, 1981; C. Kurt Dewhurst, Betty MacDowell and Marsha MacDowell, *Religious Folk Art in America: Reflections of Faith*, New York: E.P. Dutton & Co., Inc., 1983; Jay Johnson and William C. Ketchum, Jr., *American Folk Art of the Twentieth Century*, New York: Rizzoli International Publications, 1983; Chuck and Jan Rosenak, *Museum of American Folk Art Encyclopedia of Twentieth-Century Folk Art and Artists*, New York: Abbeville Press, Inc., 1990.

DAVID STRICKLAND

EXHIBITIONS
Passionate Visions of the American South: Self-Taught Artists from 1940 to the Present, New Orleans Museum of Art, 1993; *Pictured in My Mind: Contemporary American Self-Taught Art from the Collection of Dr. Kurt Gitter and Alice Rae Yelen*, Birmingham Museum of Art, Birmingham, AL, 1995; *Tree of Life*, American Visionary Art Museum, Baltimore, MD, 1995; *The Coca-Cola Olympic Salute to Folk Art*, Atlanta, GA, 1996.

PUBLICATIONS
Alice Rae Yelen, ed., *Passionate Visions of the American South: Self-Taught Artists from 1940 to the Present*, New Orleans: New Orleans Museum of Art, 1993; Gail Andrews Treschel, ed., *Pictured in My Mind: Contemporary American Self-Taught Art from the Collection of Dr. Kurt Gitter and Alice Rae Yelen*, Birmingham, AL: Birmingham Museum of Art, 1995; Rebecca Hoffberger, Roger Manley, and Colin Wilson, *Tree of Life*, Baltimore: American Visionary Art Museum, 1995.

REV. JOHNNIE SWEARINGEN

EXHIBITIONS
The Eyes of Texas: An Exhibition of Living Texas Folk Artists, University of Houston, 1980; *"I Make Pictures": Paintings by Reverend Johnnie Swearingen*, The University of Texas Institute of Texan Cultures at San Antonio, 1985; *Handmade and Heartfelt: Folk Art in Texas*, Laguna Gloria Art Museum, Austin, 1986; *Black History/Black Vision: The Visionary Image in Texas*, Archer M. Huntington Art Gallery, The University of Texas at Austin, 1989; *Passionate Visions of the American South: Self-Taught Artists from 1940 to the Present*, New Orleans Museum of Art, 1993; *Pictured in My Mind: Contemporary American Self-Taught Art from the Collection of Dr. Kurt Gitter and Alice Rae Yelen*, Birmingham Museum of Art, 1995; *Tree of Life*, American Visionary Art Museum, 1995; *The Wind in My Hair*, American Visionary Art Museum, Baltimore, MD, 1996.

MUSEUM COLLECTONS
African American Museum, Dallas; Chappell Hill Historical Society, Chappell Hill.

PUBLICATIONS
Gaye Hall and David Hickman, *The Eyes of Texas: An Exhibition of Living Texas Folk Artists*, University of Houston, 1980; Lynne Adele, *Black History/Black Vision: The Visionary Image in Texas*, Archer M. Huntington Art

Gallery, The University of Texas at Austin, 1989; Chuck and Jan Rosenak, *Museum of American Folk Art Encyclopedia of Twentieth-Century American Folk Art and Artists*, New York: Abbeville Press, 1990; Alice Rae Yelen, *Passionate Visions of the American South: Self-Taught Artists from 1940 to the Present*, New Orleans Museum of Art, 1993; Gail Andrews Treschel, *Pictured in My Mind: Contemporary American Self-Taught Art from the Collection of Dr. Kurt Gitter and Alice Rae Yelen*, Birmingham Museum of Art, 1995; *Tree of Life*, Baltimore, MD: American Visionary Art Museum, 1995.

VELOX WARD

EXHIBITIONS
Velox Ward, Amon Carter Museum, Fort Worth, 1972; *Texas Folk Art: One Hundred Fifty Years of the Southwestern Tradition*, San Antonio Museum Association, 1981; *Twentieth Century Texas Folk Art*, Sewall Art Gallery, Rice University, Houston, 1992.

MUSEUM COLLECTIONS
Amon Carter Museum, Fort Worth; National Museum of American Art, Smithsonian Institution, Washington, D.C.

PUBLICATIONS
Donald and Margaret Vogel, *Velox Ward*, Fort Worth: Amon Carter Museum, 1972; Cecilia Steinfeldt, *Texas Folk Art: One Hundred Fifty Years of the Southwestern Tradition*, Austin: Texas Monthly Press, 1981; Chuck and Jan Rosenak, *Museum of American Folk Art Encyclopedia of Twentieth-Century American Folk Art*, New York: Abbeville Press, 1990.

WILLARD WATSON, "THE TEXAS KID"

EXHIBITIONS
Bicentennial Map of the United States, Dallas, 1976; *Texas Naïve Artists*, The Witte Museum, San Antonio, 1978; *The Eyes of Texas: An Exhibition of Living Texas Folk Artists*, University of Houston, 1980; *Willard Watson: Life Cycle Drawings*, Dallas Museum of Art, 1985; *Rambling on My Mind: Black Folk Art of the Southwest*, Museum of African American Life and Culture, Dallas, 1987; *Black History/Black Vision: The Visionary Image in Texas*, Archer M. Huntington Art Gallery, The University of Texas at Austin, 1989; *Black Art—Ancestral Legacy: The African Impulse in African American Art*, Dallas Museum of Art, 1989; *Willard "The Texas Kid" Watson*, The Kennedy Center for the Performing Arts, Washington, DC, 1991; *Twentieth-Century Texas Folk Art*, Sewall Art Gallery, Rice University, Houston, 1992; *Outside/In: Outsider and Contemporary Artists in Texas*, Laguna Gloria Art Museum, Austin, 1994; *Tree of Life*, American Visionary Art Museum, Baltimore, MD, 1995.

MUSEUM COLLECTIONS
African American Museum, Dallas; Dallas Museum of Art; The Menil Collection, Houston; Museum of International Folk Art, Santa Fe, NM.

PUBLICATIONS
Lynne Adele, *Black History/Black Vision: The Visionary Image in Texas*, Austin: Archer M. Huntington Art Gallery, 1989; Alvia J. Wardlaw, ed., *Black Art—Ancestral Legacy: The African Impulse in African American Art*, Dallas: Dallas Museum of Art, 1989; Willard Watson and Janelle Ellis, "The Seven Wives of the Texas Kid," *Dallas Life Magazine, The Dallas Morning News*, August 29, 1993; *Outside/In: Outsider and Contemporary Artists in Texas*, Austin: Texas Fine Arts Association, 1994; John Beardsley, *Gardens of Revelation: Environments by Visionary Artists*, New York: Abbeville Press, 1995; Rebecca Hoffberger, Roger Manley, and Colin Wilson, *Tree of Life*, Baltimore: American Visionary Art Museum, 1996; Chuck and Jan Rosenak, *Contemporary American Folk Art: A Collector's Guide*, New York: Abbeville Press, 1996.

GEORGE W. WHITE, JR.

EXHIBITIONS
The World of George W. White, Jr., Waco Creative Art Center, 1975; *Texas Folk Art: One Hundred Fifty Years of the Southwest Tradition*, San Antonio Museum Association, 1981; *Black Folk Art in America 1930-1980*, Corcoran Gallery of Art, Washington, DC, 1982; *Twentieth-Century Texas Folk Art*, Sewall Art Gallery, Rice University, Houston, 1992; *Outside/In: Outsider and Contemporary Artists in Texas*, Laguna Gloria Art Museum, Austin, 1994; *Folk Art from the Collection of Sally M. Griffiths*, Art Museum of Southeast Texas, Beaumont, 1994; *Tree of Life*, American Visionary Art Museum, Baltimore, MD, 1995.

MUSEUM COLLECTIONS
National Museum of American Art, Smithsonian Institution, Washington, DC; The Witte Museum, San Antonio.

PUBLICATIONS
The World of George W. White, Jr., Waco: Waco Creative Art Center, 1975; Cecilia Steinfeldt, *Texas Folk Art: One Hundred Fifty Years of the Southwest Tradition*, Austin: Texas Monthly Press, 1981; John Beardsley and Jane Livingston, *Black Folk Art in America 1930-1980*, Washington: Corcoran Gallery of Art, 1982; Chuck and Jan Rosenak, *Museum of American Folk Art Encyclopedia of Twentieth-Century American Folk Art and Artists*, New York: Abbeville Press, 1990; *Outside/In: Outsider and Contemporary Artists in Texas*, Austin: Texas Fine Arts Association, 1994; Rebecca Hoffberger, Roger Manley, and Colin Wilson, *Tree of Life*, Baltimore: American Visionary Art Museum, 1996.

CLARA MCDONALD WILLIAMSON

EXHIBITIONS
Two Hundred Years of American Painting, Dallas Museum of Fine Arts, 1946; *American Painting of Today*, Metropolitan Museum of Art, New York, NY, 1950; *American Contemporary Natural Painters*, Smithsonian Institution, Washington, DC, 1953-54; *American Primitive Paintings*, organized by the Smithsonian Institution for travel in Europe and Scandinavia, 1954-55; *Paintings by Grandma Moses, Clara Williamson and H. O. Kelly*, Fort Worth Art Center, 1961; *The American Woman as Artist, 1820-1965*, Owen Fine Arts Center, Southern Methodist University, Dallas, 1966; *The Paintings of Clara McDonald Williamson*, Amon Carter Museum of Western Art, Fort Worth, 1966; *Twentieth-Century Texas Folk Art*, Sewall Art Gallery, Rice University, Houston, 1992; *The Wind in My Hair*, American Visionary Art Museum, Baltimore, 1996.

MUSEUM COLLECTIONS
Dallas Museum of Art; Museum of Modern Art, New York, NY; Wichita Art Museum, Wichita, KS.

PUBLICATIONS
Donald and Margaret Vogel, *Aunt Clara: The Paintings of Clara McDonald Williamson*, Austin: University of Texas Press, 1966; Cecilia Steinfeldt, *Texas Folk Art: One Hundred Fifty Years of the Southwestern Tradition*, Austin: Texas Monthly Press, 1981; Selden Rodman, *Artists in Tune with Their World*, New York: Simon and Schuster, 1982; Chuck and Jan Rosenak, *Museum of American Folk Art Encyclopedia of Twentieth-Century American Folk Art and Artists*, New York: Abbeville Press, 1990.

ONIS WOODARD

EXHIBITION
Folk Art from the Collection of Sally M. Griffiths, Art Museum of Southeast Texas, Beaumont, 1994.

Selected Bibliography

Abernethy, Francis Edward, ed. *Folk Art in Texas*. Publications of the Texas Folklore Society, no. 45. Dallas: Southern Methodist University Press, 1985.

Adele, Lynne. *Black History/Black Vision: The Visionary Image in Texas*. Austin: Archer M. Huntington Art Gallery, 1989.

———. "Frank Jones: The Psychology and Belief System of a Black Folk Artist." Master's thesis, The University of Texas at Austin, 1987.

Art Papers. Vol. 18, no. 5 (September–October 1994). [Special issue on folk/self-taught/outsider artists.]

Beardsley, John. *Gardens of Revelation: Environments by Visionary Artists*. New York: Abbeville Press, 1995.

Beardsley, John and Jane Livingston. *Black Folk Art in America, 1930–1980*. Washington, D.C.: Corcoran Gallery, 1982.

Cardinal, Roger. *Outsider Art*. London: Studio Vista, 1972.

Carter, Pat. "'Fox' Harris: A Forest of the Spirit," *Spot* [publication of the Houston Center of Photography] (Spring 1991): 12–13.

Castle, Lynn P. "A Conservation Crisis: The Work of Felix 'Fox' Harris, A Case Study," *Folk Art* [magazine of the Museum of American Folk Art] (Spring 1994): 50–53.

Cerny, Charlene and Suzanne Seriff, eds. *Recycled Re-Seen: Folk Art from the Global Scrap Heap*. New York: Harry N. Abrams, Inc., 1996.

Folk Art, [Quarterly magazine of the Museum of American Folk Art, New York] (Began as *The Clarion* 1971–1992), 1992 to present.

Frantz, Joe B. *Texas: A History*. New York: W.W. Norton & Co., Inc., 1976.

Hall, Gaye and David Hickman. *Eyes of Texas: An Exhibition of Living Texas Folk Artists*. Houston: University of Houston, 1980.

Hartigan, Lynda Roscoe. *Made with Passion: The Hemphill Folk Art Collection in the National Museum of American Art*. Washington: Smithsonian Institution Press, 1990.

Hoffberger, Rebecca, Roger Manley, and Colin Wilson. *Tree of Life*. Baltimore: American Visionary Art Museum, 1996.

Johnson, William Weber. *Kelly Blue*. College Station: Texas A & M University Press, 1979.

Keerl, Claire Roderick. *Eddie Arning*. New York: Hirschl & Adler Folk, 1988.

Luck, Barbara R. and Alexander Sackton. *Eddie Arning: Selected Drawings 1964–1973*. Williamsburg, Virginia: The Colonial Williamsburg Foundation, 1985.

McEvilley, Thomas. "The Missing Tradition," *Art in America* Vol. 85, No. 5 (May 1997): 79–85, 137.

Mhire, Herman, ed. *Baking in the Sun: Visionary Images from the South*. Lafayette: University of Southwestern Louisiana Art Museum, 1987.

Milwaukee Art Museum. *Driven to Create: The Anthony Petullo Collection of Self-Taught and Outsider Art*. Milwaukee, 1993.

The Newark Museum. *A World of Their Own: Twentieth-Century American Folk Art*. Newark, New Jersey, 1995.

New Art Examiner Vol. 22, No. 1 (September 1994). [Special focus issue on self-taught art.]

Paulsen, Barbara. "Eddie Arning: The Unsettling World of a Texas Folk Artist," *Texas Journal* (Fall–Winter 1985): 35–38.

Quirarte, Jacinto and Rolando Hinojosa–Smith. *Mystical Elements/Lyrical Imagery: Consuelo González Amézcua 1903–1975*. Del Rio, Texas: Del Rio Council for the Arts, 1993.

Raw Vision. Nos. 1–16 [International journal of intuitive and visionary art], 1989 to present.

Richardson, Rupert N., Ernest Wallace, and Adrian N. Anderson. *Texas: The Lone Star State.* Englewood Cliffs, N.J.: Prentice-Hall, 1970.

Rosenak, Chuck and Jan Rosenak. *Contemporary American Folk Art: A Collector's Guide.* New York: Abbeville Press, Inc., 1996.

———. *Museum of American Folk Art Encyclopedia of Twentieth-Century American Folk Art and Artists.* New York: Abbeville Press, Inc., 1990.

Smither, Murray. *The World of George W. White, Jr.* Waco, Texas: Waco Creative Art Center, 1975.

Steinfeldt, Cecilia. *Art for History's Sake: The Texas Collection of the Witte Museum.* San Antonio: Witte Museum, 1993.

———. *Texas Folk Art: One Hundred Fifty Years of the Southwestern Tradition.* Austin: Texas Monthly Press, 1981.

Texas Fine Arts Association. *Outside/In: Outsider and Contemporary Art in Texas.* Austin, 1994.

Trechsel, Gail Andrews, ed. *Pictured in My Mind: Contemporary American Self-Taught Art.* Birmingham, Alabama: Birmingham Museum of Art, 1995.

Vogel, Donald and Margaret Vogel. *Aunt Clara: The Paintings of Clara McDonald Williamson.* Fort Worth: Amon Carter Museum of Western Art, 1966.

———. *Velox Ward.* Fort Worth: Amon Carter Museum, 1972.

Wardlaw, Alvia, ed. *Black Art—Ancestral Legacy: The African Impulse in African American Art.* Dallas: Dallas Museum of Art, 1989.

Yelen, Alice Rae, ed. *Passionate Visions of the American South: Self-Taught Artists from 1940 to the Present.* New Orleans: New Orleans Museum of Art, 1993.

Lynne Adele	Assistant Curator of Education
Paige Bartels	Assistant Director for Public Affairs
Jonathan Bober	Curator of Prints and Drawings
Linda Briscoe	Assistant Curator of Latin American Art
Annette DiMeo Carlozzi	Curator of American and Contemporary Art
Samantha Cheek	Public Relations Assistant
Kerri Madden Curtis	Education Intern
Virginia Fay	Coordinator, Rockefeller Residency Program
Rosana Garcia	Assistant to the Curators
Tracy Grimm	Conservation Technician
Tina Harrison	Intern, Latin American Art
Patricia Hendricks	Curator of Exhibitions
Jessie Otto Hite	Director
George Holmes	Photographer
Sue Ellen Jeffers	Art Registrar
David Johnson	Assistant Business Officer
Stephan Jost	Intern, Prints and Drawings
Judy Lister	Assistant to the Director
Anna McCourt	Membership Assistant
Sara McElroy	Conservator
Dennis Medina	Research Assistant
Rebekah Morin	Curatorial Assistant, Prints and Drawings
Suzanne Najarian	Membership Coordinator
Mari Carmen Ramírez	Curator of Latin American Art
Tiffany Rasco	Coordinator of School Programs, Tours, & Resources
Tim Reilly	Curatorial Associate, Prints and Drawings
John Sager	Technical Staff Assistant
Patrick Sheehy	Technical Staff Assistant
Susan Sternberg	Curator of Education
Meredith Sutton	Associate Registrar
James Swan	Head of Installation
Donna Vliet	Museum/School Educator
Tanya Walker	Business Officer
Edith Wolfe	Curatorial Assistant, Latin American Art

Archer M.
Huntington
Art Gallery
Staff